STORIES AND ART FROM A WORLD TRAVELLER

GREAT CATS

SIMON COMBES

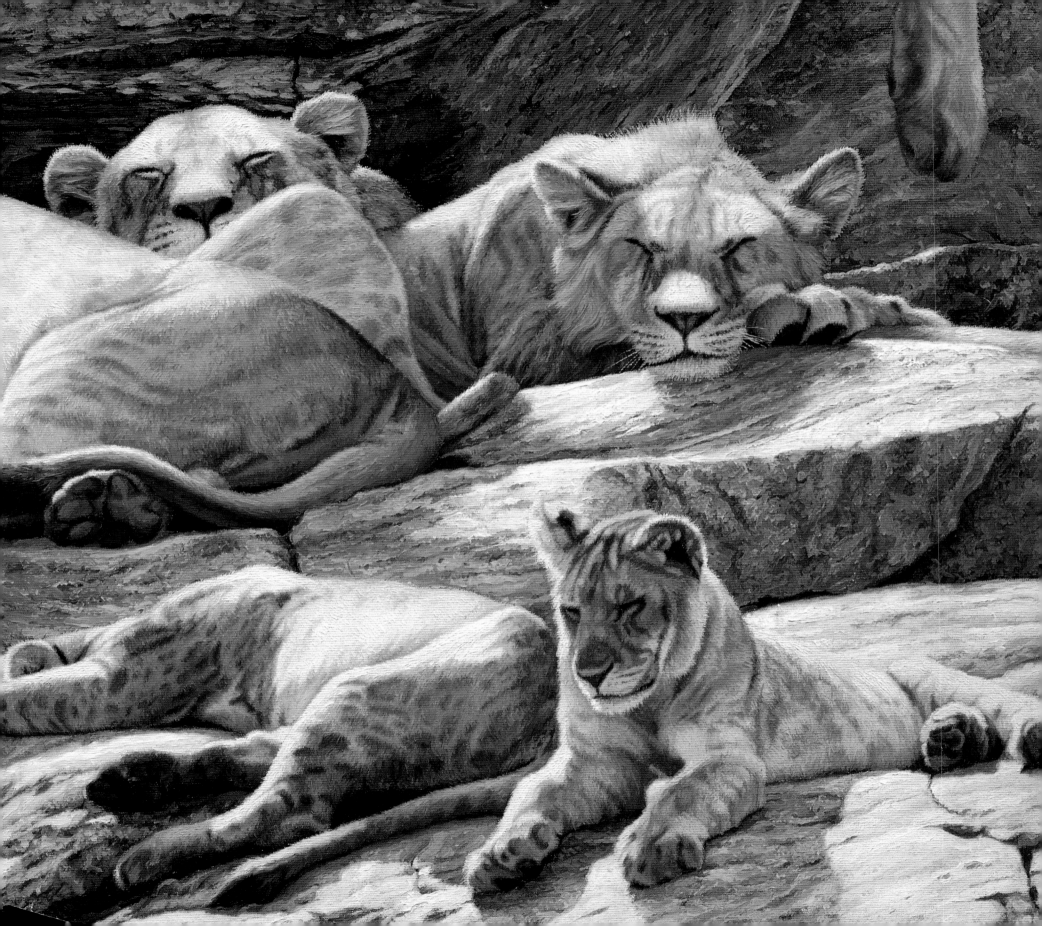

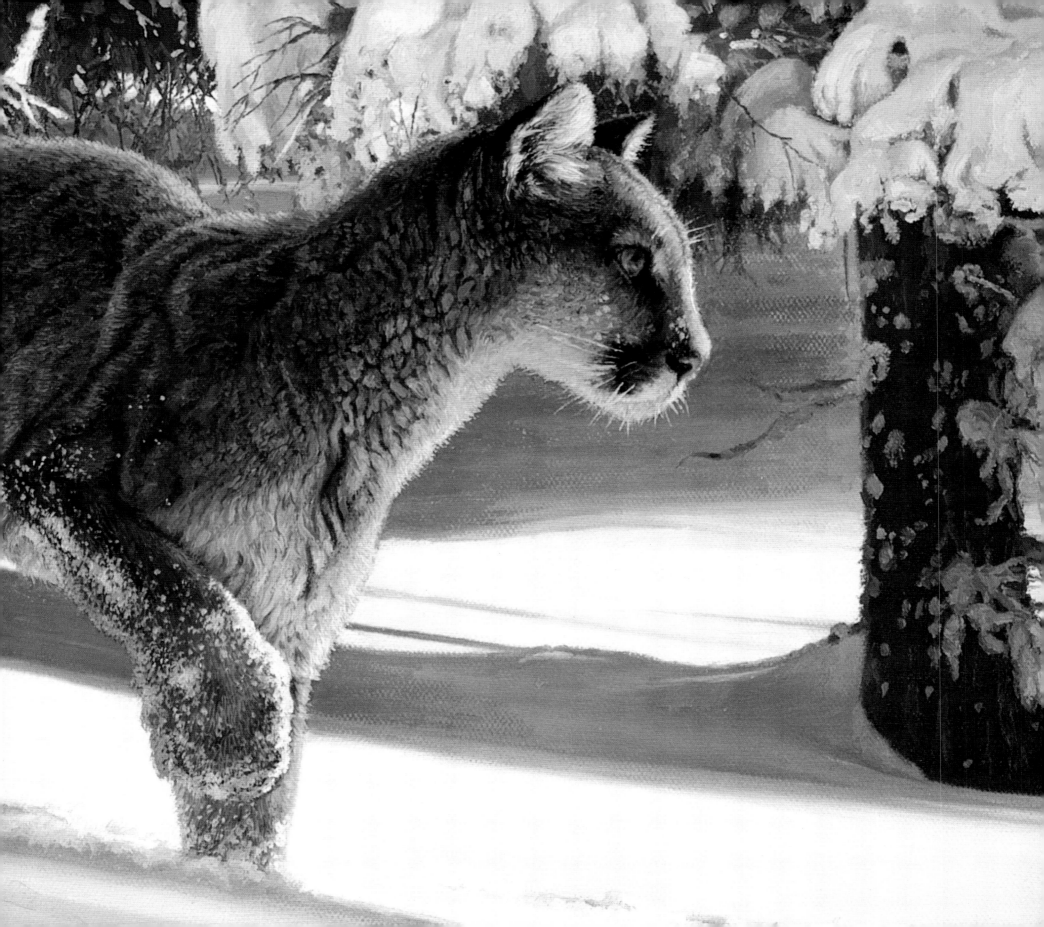

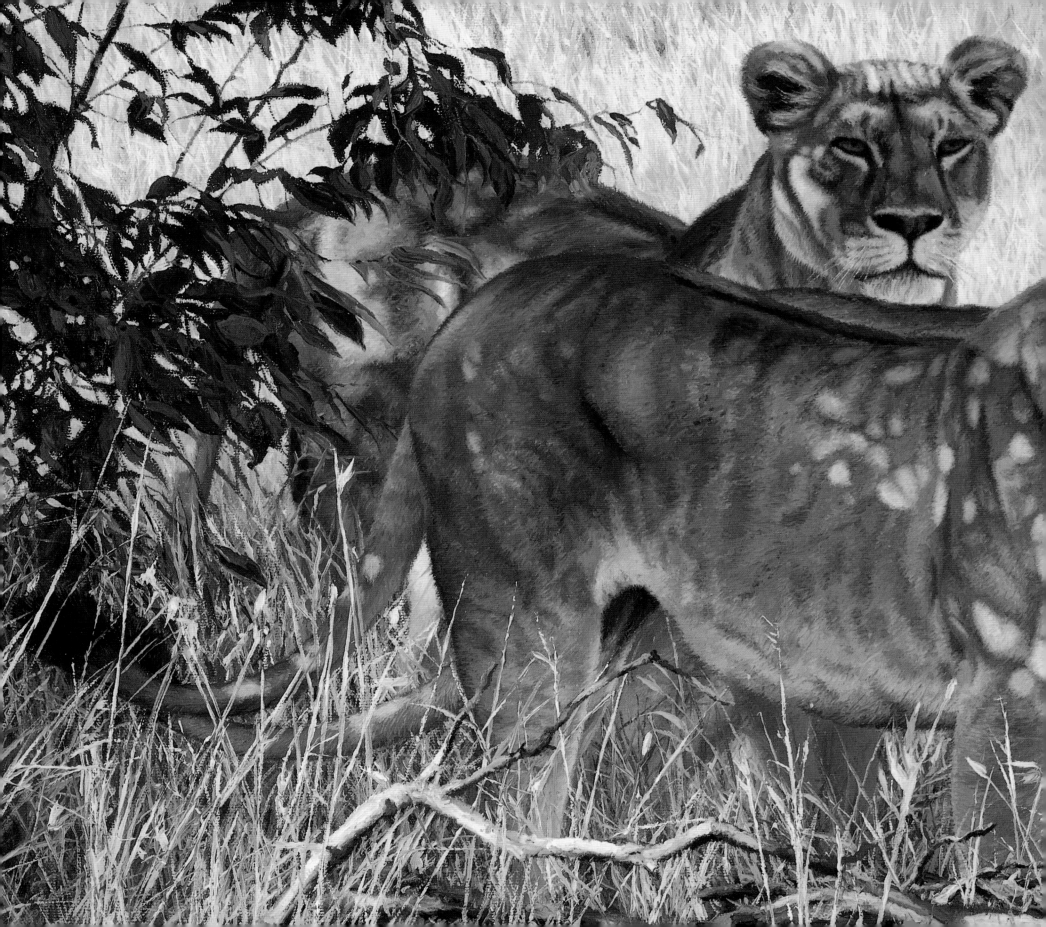

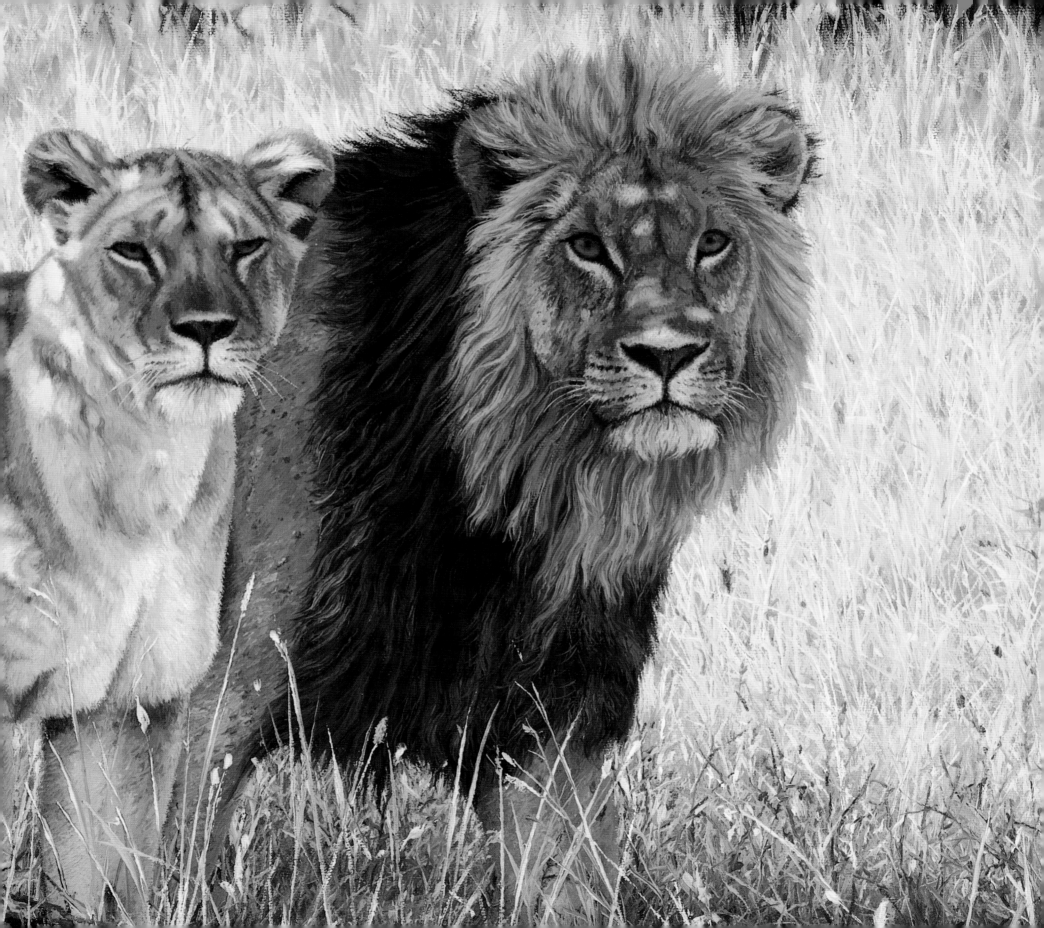

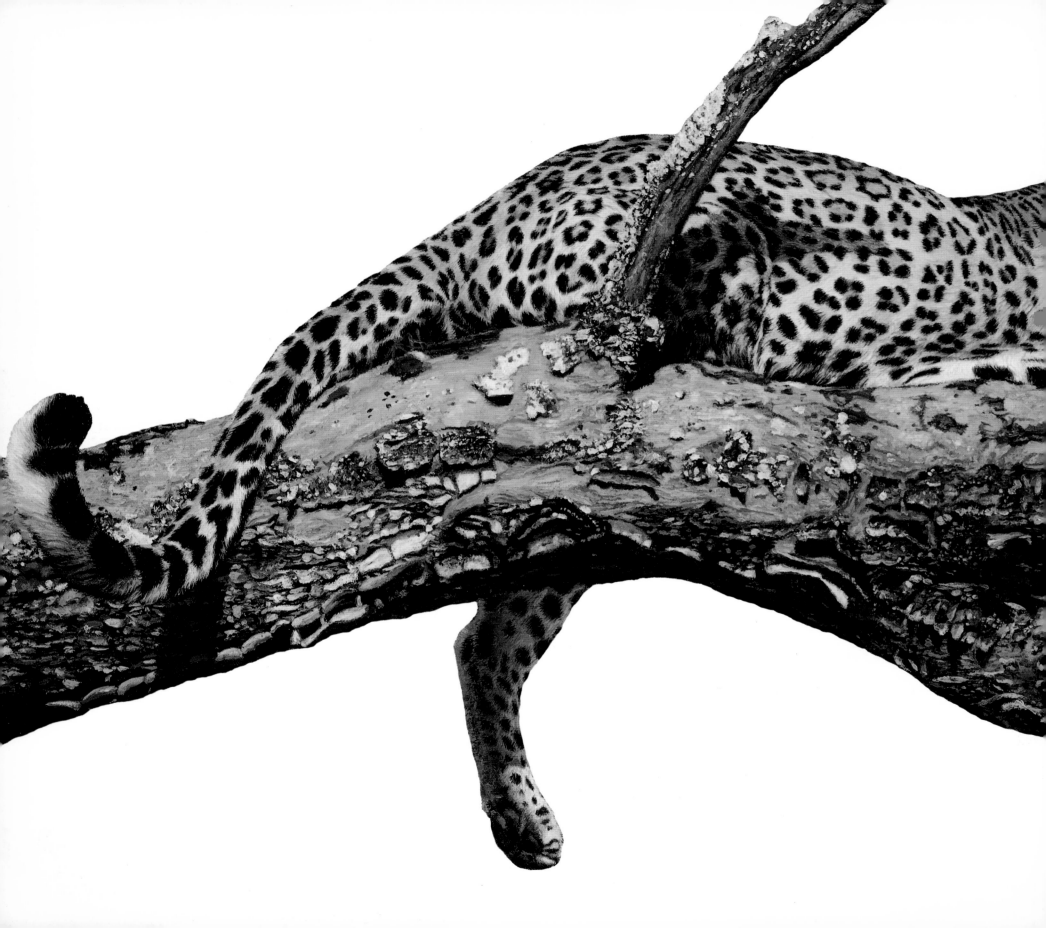

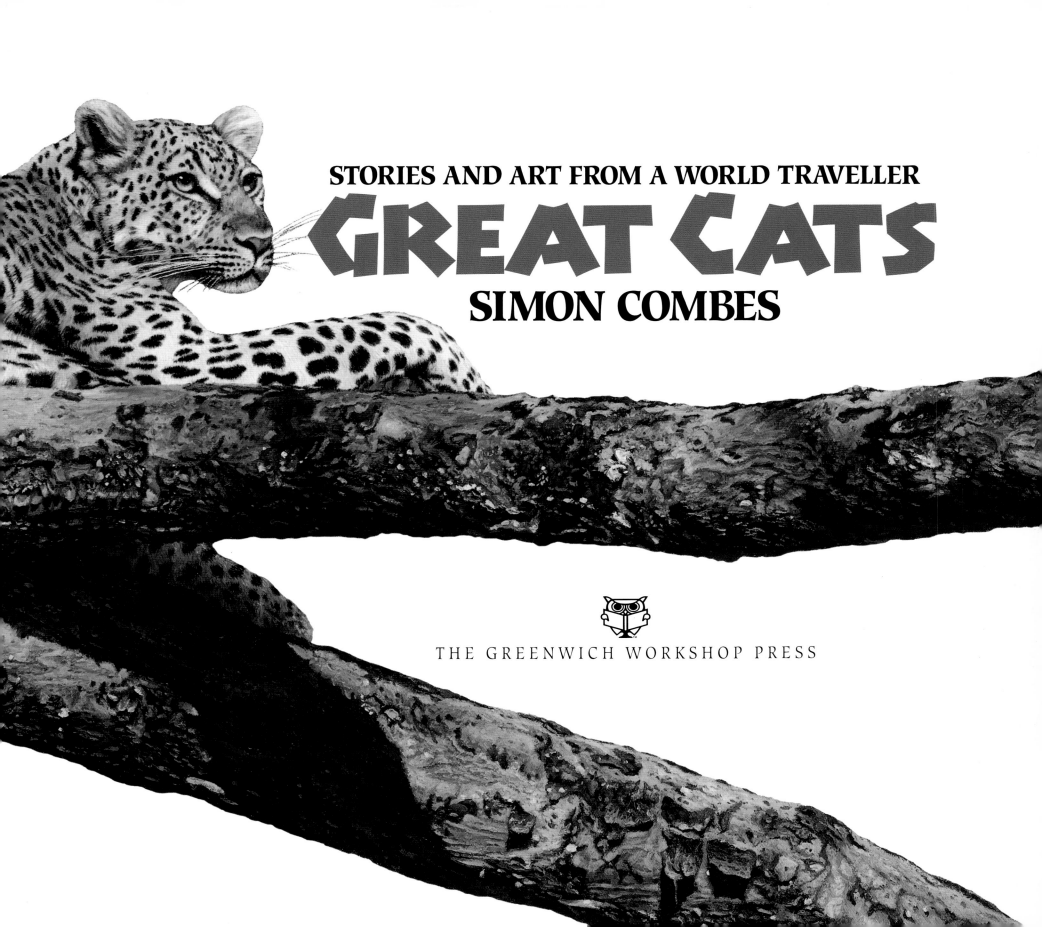

STORIES AND ART FROM A WORLD TRAVELLER

GREAT CATS

SIMON COMBES

THE GREENWICH WORKSHOP PRESS

To my father, Jim; my brother, Rob; and my friend Dave Usher,
who all shared my excitement at the start of this adventure.
I wish they were still here to read about it.

AUTHOR'S ACKNOWLEDGMENTS

Without the enthusiasm and support of Dave Usher and his team from The Greenwich Workshop, this adventure would never have happened. To them all, I am supremely grateful.

George Amato enabled me to carry out invaluable research at the Bronx Zoo and introduced me to George Schaller, whose counsel on snow leopards was much appreciated. Al Rabinowitz gave sound advice on clouded leopards; and Rodney Jackson, on snow leopards. Peter Jackson, as head of the Special Cat Unit of the IUCN, was a fount of knowledge on all cats.

Tom McCarthy was my host in Mongolia and led me to a truly wild snow leopard. Boris Kaminsky added spice and colour to the jaguar quest in Venezuela. Nanda S.J. Rana helped provide many marvellous opportunities to study tigers and leopards in India. Mike Jones was a wonderful guide and host in Thailand. Dr Maurice Hornocker has my deepest gratitude for inviting me to Siberia and for helping to get this whole project going. His efforts to save the largest and rarest cat in the world, the Siberian tiger, desperately needed funds, so in 1995 I painted *The Siberians*, two young tigers patrolling a snowy landscape, and donated it for auction, where it raised $42,000. This was the least I could do to repay the extraordinary and wonderful experiences of the preceding three years, and I wished I could do the same for all the other cats which were my subjects.

Despite his insults, often-inane banter, evil practical jokes, phobias, allergies, lack of stamina and endless belly-aching, Terry Begg has been an enthusiastic and inspirational travelling companion. We have laughed our way round the world.

Lastly, but by no means least, my thanks to Susie, my wife, for her stoical endurance of my many long absences and her patient understanding of my harebrained ideas.

A GREENWICH WORKSHOP PRESS BOOK

Inquiries should be addressed to The Greenwich Workshop, Inc., One Greenwich Place, P.O. Box 875, Shelton, Connecticut 06484-0875. For information about the art of Simon Combes, please write to The Greenwich Workshop, Inc., at the address at left, or call 1-800-577-0666 (in the U.S.) to be directly connected with the authorized Greenwich Workshop dealer nearest you.

Library of Congress Cataloging-in-Publication Data:
Combes, Simon, 1940–
Great cats : stories and art from a world traveller / Simon Combes.
p. cm. ISBN 0-86713-048-2 (hardcover : alk. paper).
1. Combes, Simon, 1940– —Themes, motives.
2. Felidae in art. 3. Wildlife painting.
I. Title.
ND497.C647A2 1998 759.2—dc21
98-16870 CIP

• • •
FRONTIS ART
2–3 Detail from *Lion About*
4–5 Detail from *Snow Tracker*
6–7 Detail from *Pride*

• • •
Photography by Simon Combes
Photograph page 138 by Maurice Hornocker
Book design by Judy Turziano
Manufactured in Italy by Mondadori
First Printing 1998
98 99 0 9 8 7 6 5 4 3 2 1

CONTENTS

PROLOGUE

The great wildebeeste migration had reached south-western Kenya, and once more, for the resident lions, it was a time of plenty. So much easier to charge from ambush into the packed herds and, in the ensuing mayhem, pull down a panic-stricken wildebeeste, than to tackle at great danger one of the local Cape buffalo. It had been a profitable night's hunting, and by an hour after sunrise, members of the pride had gorged themselves and flopped down, full-bellied and comatose. The close presence of a safari vehicle caused little more than the lazy opening of a few amber eyes. The vehicle circled and passed the pride again, but this time one of the cubs looked up, its attention attracted by movement and rustling in the grass behind the car. The cub's alertness somehow communicated itself to its two siblings, and all three now stared intently. The object of their rapt attention was a tow-rope which I was dragging slowly past the pride for a second time in an attempt to generate a bit of action. On the third pass, it worked. Unable to resist, one of the cubs rose and, very tentatively, padded towards the rope. I stopped. Reassured, the cub crept closer, now followed by the others, and cautiously, every muscle and sinew taut with apprehension, stretched to sniff the rope. I inched forward; the rope twitched, and all three leapt back in alarm but soon resumed their stalk when there seemed no apparent danger. The bravest now patted its 'prey' with a big paw. No reaction from the rope, which kept moving right along through the grass, so, throwing caution aside, the cub pounced and its extended claws locked in. Instinctively resisting the rope's forward movement, the first cub was soon assisted by the other two. This small activity had been noticed by a large lioness. She stalked over and joined in the tug of war, soon followed by the three remaining lionesses and, finally, by his lordship in person: a great, shaggy, black-maned lion.

Inside the car, there was a growing element of panic. At the wheel, my friend reversed hurriedly to prevent both me and the rope from disappearing through the roof hatch, whilst the lions now started to pull not only against the car but also against each other. In desperation, I looped the rope round the roof-rack and we drove off at speed, scattering aston-

ished lions in all directions as they vainly struggled to hold on, and very nearly dislodging the rack from the roof.

• • •

This incident happened a long time ago, and it took place outside the boundaries of the Masai Mara Game Reserve. Although all parties had a bit of fun, it was quite irresponsible and definitely not to be recommended. Nevertheless, it was a somewhat more exotic version of the games I used to play at home with my own domestic cats and perhaps illustrates the fascination I have always had for felines of every shape and size.

From an early age, I have been intrigued by them: their sheer beauty, such an amazing variety of coat patterns and markings, and the way they keep themselves so clean; the eyes—large and alert—so many different colours of the iris, and the extraordinary way that the pupils can rapidly dilate and contract. I admire their agility, their hunting stealth and their self-contained independence. I envy their ability to appear so utterly relaxed. Cat body language constantly interests me: how mood and intent can be expressed by the slightest subtle movement of the ears (a cat has about thirty different muscles in its ears; man has six), widening of the eyes or lowering of the head, and how the body itself can display aggression, submission, anger, fear and a range of other feelings.

When I played with our cats, I was inadvertently studying and recognizing signs, noting that even the laziest, fattest, sleepiest cat could not possibly resist instant pursuit if a moving 'prey' object disappeared from view; seeing how a stalking cat would freeze if the 'prey' stopped moving and how it could move with belly close to the ground and head raised just enough to keep the quarry in view, the ears flattening outwards to further reduce its profile; wondering at the intensity of concentration and the unaccountable significance of the constantly twitching tail. These characteristics, I later discovered, were basically common to all cats, and so my subconscious studies served me well in later years when researching Africa's big cats for my paintings. I recognized and could sometimes predict a cat's intentions and therefore was better prepared for action when it happened. Close observation made it possible to portray accurately a cat's mood and thus give the painting more meaning.

I am not alone with my obsession. Throughout time, man has feared, admired, even deified the cat, and especially the great hunting cats. In Eastern folklore and mythology, the tiger has always been accredited with great strength, power and ferocity. Alas, this might be its downfall and possibly will accelerate its extinction unless the Chinese can be persuaded that concoctions made from powdered tiger bones and other body parts are not the ultimate elixir and cure-all.

In East Africa, where I come from, the Masai tribe required a young man to take part in a ritualized lion hunt (now forbidden by law) to qualify for warriorship. Their cousins, the Samburu, hand down, from generation to generation, tiny lion-skin slippers to be worn by infant boys that they might be imbued with great strength and courage. Other tribes will confine themselves or even their dogs in a small hut and burn a piece of lion skin in the hope that inhalation of the smoke will make them fierce and invincible. Even English-speaking cultures call the lion 'King of the Beasts'.

• • •

In 1974, I gave up my career as a soldier and became a full-time wildlife painter. Since I was living in Kenya, it was logical that most of my subjects would be African animals and, given my interest in cats, understandable that the big cats would predominate.

Three years into this new career, I was fortunate to be offered a contract with a small fine-art publishing company, The Greenwich Workshop. I met the founder and owner, Dave Usher, in New York, and my ten-minute

interview stretched to two hours as we discovered much in common and instantly became firm friends. My first two published paintings were a lion and a leopard, and over the next sixteen years, most prints that followed were of Africa's big cats.

I often wondered about painting the world's other feline predators—tigers, jaguars, snow leopards, etc.—but considered myself quite unqualified. As my career progressed, I developed a relatively 'tight' style, faithfully accurate both in main subject and landscape, and sometimes described as 'photographic', a comment which always left me unsure as to whether to be flattered or, inwardly, to wince. My obsession with accuracy and authenticity made me shelve any subject matter beyond Africa's borders unless the opportunity to study a species in its own habitat arose in the future.

Fate, good fortune and coincidence intervened. Terry Begg, who owns an art gallery in Idaho, had sold many of my prints over the years. We became good friends, and I enjoyed his frequent, imaginative and creative, rambling ideas to further my painting career and market my work. In 1992, he met Dr Maurice Hornocker of the Hornocker Wildlife Institute, based in Idaho.

Maurice, who is the world's leading expert on cougars, described his latest project in Siberia where, jointly with Russian scientists, he was capturing Siberian tigers and fitting them with radio collars to assist urgent research on this rapidly vanishing animal. Terry's excitement was infectious as he urged me to consider a series of big cat paintings after Maurice had intimated a possible trip to Siberia as his guest.

Not long after this, at a meeting with Dave Usher, I was wondering how to broach the subject of a big cat series when he pre-empted me and asked if I had ever considered such an idea. Surely, this was fate. I resisted the obvious counter-question about the Pope being a Catholic (or some similar but much more irreverent remark) and merely replied that it was something I had dreamed about for years but had always considered out of the question unless I could actually visit every location where these animals lived.

After an interminable pause, he said, 'Let's do it.'

• • •

So began the fulfillment of my dream—but the euphoria was short-lived as I soon realized the magnitude of the task I had undertaken. Much research was required, and some important decisions had to be made.

Firstly, which cats to choose? Nowhere is there an instruction or code which specifies those cats that are 'big' and those that are not. That decision had to be mine. Ultimately, I decided on nine, and these, in turn, divided neatly into three that I would paint in the snow (snow leopard, cougar and Siberian tiger), three in a jungle setting (jaguar, clouded leopard and Bengal tiger) and three African cats (lion, leopard and cheetah). The tenth painting in the series would be the largest, the 'flagship' of the collection, and would depict a whole pride of lions.

I have often been asked why the white tiger and black panther were excluded, and the answer is simple: neither is a distinct species. White tigers are Bengal tigers with a recessive white gene, and black panthers are melanistic leopards or jaguars.

The second question was how to find these animals. The African cats would be easy, since locating them was something I had been doing for years, but the remaining six were far from being that simple. All were under pressure, heavily persecuted and harassed, and most were severely endangered. Dr Maurice Hornocker provided the

ideal springboard. We arranged to meet and got on well together, and I was immediately invited to Siberia to observe his tiger project, and also to the part of Idaho where he researched cougars. Furthermore, he provided invaluable advice on how to go about finding the last four cats.

I met George Amato, who was at that time head of genetics at the New York Zoological Society, through his sister on the Greenwich Workshop staff. Through George, I met other notable experts on the big felines, and I was on my way to a powerful introduction into this field about which I knew so little. Gradually, after much reading and consultation with experts, I put together a rough programme and schedule.

• • •

I realized that many of these rare cats would be extremely difficult, if not impossible, to see, and therefore I would have to rely on captive animals as a substitute. This would test my knowledge and experience to the utmost, for I would need to convert my captive cats into their wild equivalents and introduce them on the canvas to the real habitat from which their forebears originated.

Most zoo animals are descended from generations of captivity and, even in such a comparatively short time span, have evolved characteristics which are different from those of their wild cousins. No matter how expert and conscientious a zoo programme, if a traditionally active animal such as a big cat is confined in a relatively small space, it will lose its innate wildness, usually put on weight and develop sagging folds of skin beneath the chin or belly. Such physical blemishes are relatively simple for the artist to remove by simply paring off excess with a brush or knife, but not so the more subtle lack of wildness. This applies mainly to the face. A cat which is confined and has no need to defend itself or hunt for a living will only fractionally use the myriad tiny muscles which control the ears and surround the eyes and nose. Hence the face will become chubby, lax and bland, and, particularly, the eyes will gaze benignly out at the world with none of that customary feline intensity. To change a face from that into its wild equivalent requires almost an instinct since it is so difficult to pin-point exactly what needs to be done. I could only hope that my long experience painting truly wild cats in Africa had given me that knowledge and instinct.

• • •

Dave Usher and I decided that each of the nine cats would be 'captured' in a large oil painting—at least 1,100 square inches—and that each painting would be reproduced as a limited edition print. Here was a daunting thought: how to maintain a quality as high as, or higher than, the first painting I produced? Had I bitten off more than I could chew? Only time would tell, and that was estimated at two years. What misguided optimism—it actually took three and a half.

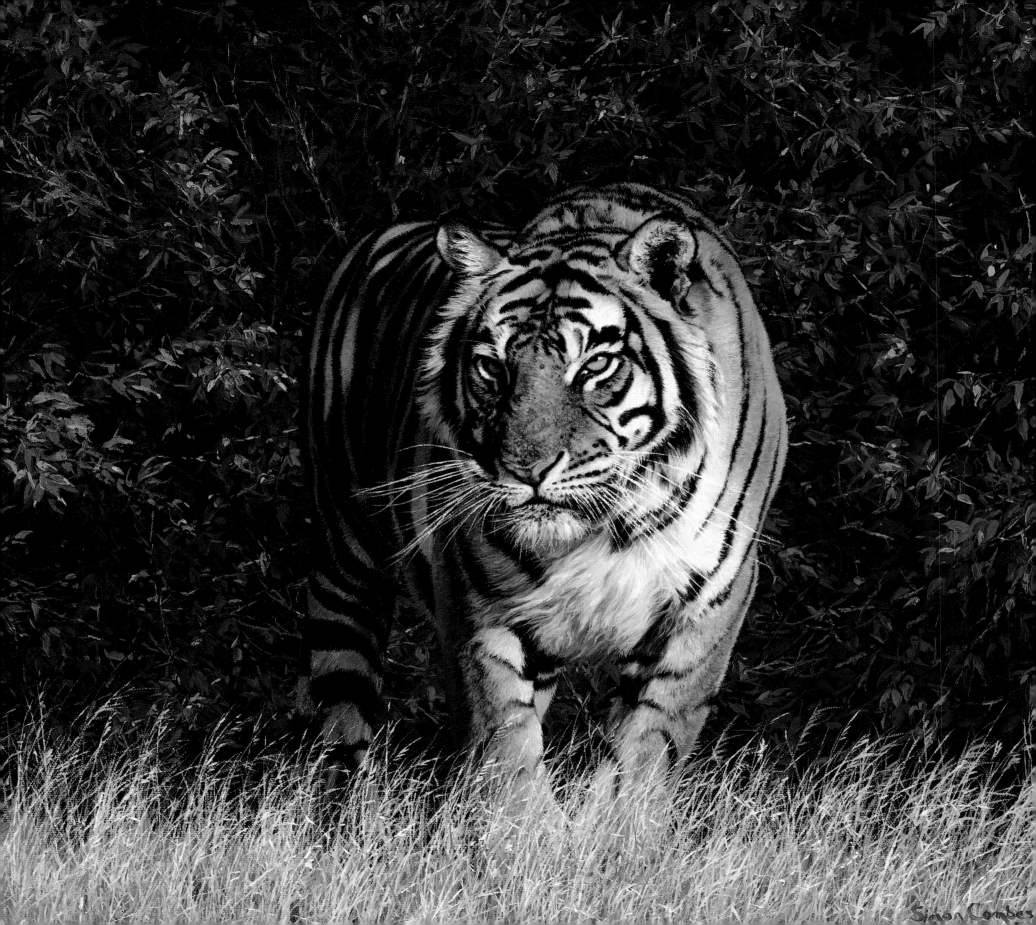

CATS OF

THE JUNGLE

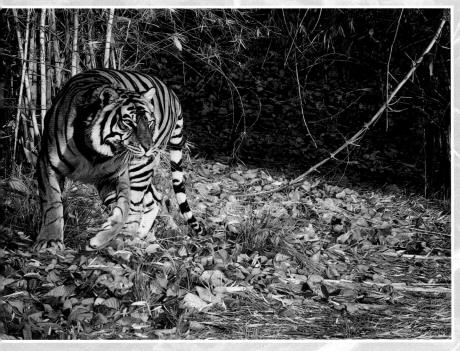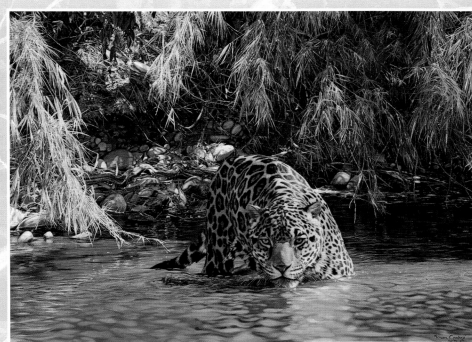

CLOUDED LEOPARD • BENGAL TIGER • JAGUAR

CLOUDED LEOPARD

NEOFELIS NEBULOSA

In the early stages of planning this great cat adventure, one of my first problems was selecting which cats to paint. We had decided to do nine and had no difficulty in choosing the first eight; the last became a choice between lynx, bobcat and clouded leopard, all considerably smaller than the others. In the end, I picked the clouded leopard because it is marginally heavier than the other two and, perhaps subconsciously, because I felt that its name put it in the same group with the big boys.

That decision was the easy one. The next step was to learn more about this strangely named, curious, elusive and little-known animal. Eventually, I tracked down one of the world's leading experts, Dr Al Rabinowitz. I called him at his New York home and asked for advice on how to locate clouded leopards in the wild with a view to a painting. He just laughed. This was disconcerting but understandable as he went on to describe the elusiveness of this nocturnal, arboreal cat. In fact, in all his years of research, he had never seen one in the wild. This illustrates not so much their rareness, but their ability to hide and melt away into the jungle. It also explained Al's mirth at my preposterous proposal.

I learned that the clouded leopard is a cat of south-east Asia—Malaysia, Borneo, Thailand, Burma (now Myanmar), Vietnam, Cambodia and even Nepal. Very widespread, but very secretive. A mysterious cat. Al explained that he had carried out his research in Thailand and recommended this to be as good a place as any to try my luck.

At a zoo in England which specializes in rare species, I found six clouded leopards and a kindly head keeper who allowed me close access to his charges. Four things struck me about this curious animal: first, its beautiful coat with large, irregular spots, dark on one side fading to a paler colour at the other, like clouds, hence the name; second, its almost disproportionately long tail which acts as a counter-balance for climbing; third, its very large canines which have evolved to enable the animal to hold heavy prey whilst hanging high in the branches; and fourth, its extraordinary agility as it moved at

DESCRIPTION AND BEHAVIOUR: The clouded leopard is named after its distinctive markings—ellipses partially edged in black, with the insides a darker colour than the background colour of the pelt, and sometimes dotted with small black spots. Pelt colour varies from ochraceous to tawny to silver grey. The limbs and underbelly are marked with large black ovals, and the back of its neck is conspicuously marked with two thick black bars. The tail is thick and plush, encircled with black rings, and very long. The legs of the clouded leopard are short, but its canines are relatively the longest of any felid's and have a very sharp posterior edge. Wild adults have weighed 11–20kg (24–44lbs). The clouded leopard has extraordinary arboreal talents: in captivity, it has been seen to run down tree trunks head-first, climb about on horizontal branches with its back to the ground and hang up-side-down from branches by its hind feet. Prey has been reported to consist of birds, primates and small mammals, as well as larger animals, such as porcupines, deer and wild boar.

LONGEVITY: Average 11 years, up to 17.

HABITAT AND DISTRIBUTION: The clouded leopard is usually most closely associated with evergreen tropical rain forest, but it also makes use of other types of habitat. In Burma and Thailand, its presence has been reported from relatively open, dry tropical forest, and in Borneo from mangrove swamps. Clouded leopards swim well and have been found on small islands off Sabah and Vietnam. They are widely distributed in China, south of the Yangtze, and have been recorded in the Himalayan foothills up to 1,450m (4,757ft) and possibly as high as 3,000m (9,843ft). They are remarkably secretive creatures for their size; in 1989, four animals turned up in different areas of Nepal after more than a century's hiatus in official observation, having last been recorded in the country in 1863. In Taiwan, there have been only a handful of sighting reports from hunters since the 1960s; none of them have been substantiated.

POPULATION STATUS: Its elusiveness, arboreality and forest habitat make the clouded leopard a difficult subject to study, and there has been no in-depth investigation beyond interviews with local residents or forestry workers. Although it has a wide range in China, suitable forest habitat is generally fragmented in small patches. The status of the clouded leopard is probably healthiest on the island of Borneo, possibly related to the absence of tigers and leopards.

PRINCIPAL THREATS: Deforestation is the foremost threat. Also, the clouded leopard is widely hunted for its teeth and pelt, and for bones for the Asian medicinal trade. In Taiwan, where clouded leopards are now either very rare or extinct, small numbers of pelts are sold to aborigines for making traditional ceremonial jackets. Clouded leopards have also been featured on the menus of some exclusive restaurants in China and Thailand.

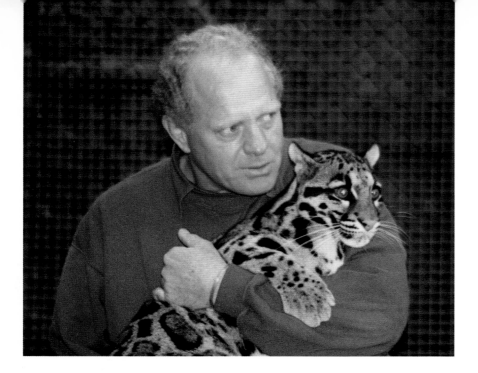

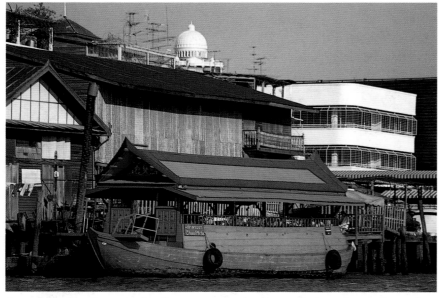

In a zoo in southern England, I was given the chance to learn more about the clouded leopard. A friendly keeper allowed me to handle, observe and sketch this young female. Below: This Bangkok waterfront is close to the famous Oriental Palace hotel, which refused to admit me because I was wearing flip-flops.

speed through the high branches of its enclosure, sometimes even running upside-down along a bough. It seemed obvious that, for my painting, this cat would have to be situated in a tree.

• • •

There was no kind field researcher in Thailand whom I could ask for assistance. Al Rabinowitz gave me some contacts, but none of these could hold my hand out in the field—and with limited time at my disposal, this was so important. Most of his research had been done in Kaeng Krachan National Park, south-west of Bangkok in the mountainous peninsula which Thailand shares with Burma. I was only too aware of the difficulties I would have in finding this cat, but at least I could get a good feel for the habitat if I could pick somebody's brains about how to actually get there. But who?

When I was a small boy in Kenya, my father befriended a young British Army officer who was posted there at the time. Mike Jones became a frequent visitor to our farm and went on to complete a long military career, most of it in the SAS (Special Air Service). After that, he concentrated his business efforts in the Far East, especially Thailand, so I called him at his home in Wales to ask advice. I was sent pages of notes and a promise that he, in person, would be my guide.

• • •

Terry Begg and I arrived at Bangkok Airport in the early hours one morning in March 1992, via Seoul, Korea. From -5°C to +32°C. Somewhere along the way, our bags had been rifled, but luckily nothing vital was lost. Our flight had been exceptionally turbulent, so all we wanted was to get away from airports—but the Thai authorities were convinced, with my Kenya passport, that I was the carrier of many sinister and dangerous African diseases. Bureaucracy had caught up with me.

At last we were through, and there was Mike, patiently waiting, looking every inch the archetypal British gent. His disconcertingly diffident manner sometimes disguises a wicked sense of humour, great enthusiasm and a single-minded determination. In true military fashion, we received a briefing, particularly on how to treat the Thai people: one should always look them in the eye when speaking, and never, on any account, lose one's temper. This will simply make them freeze and completely switch off.

Even at 2 A.M., Bangkok traffic is a nightmare. By the time we reached the city, Mike had the light of battle in his eyes; his manoeuvering, cutting in, carving up, fist-waving and foul oaths made the recent lecture on winning the hearts and minds of the gentle Thai people seem completely pointless.

Feeling somewhat shell-shocked, we were ensconced at last in a small, comfortable hotel run by a Swiss couple just two blocks from Bangkok's notorious red-light district which, at that particular time, certainly did not pose any kind of temptation.

• • •

After just three and a half hours' sleep, Mike called at the hotel to take us to breakfast at one of the country's true colonial relics—the British Club—and then on to the Foreign Correspondents Club on the top floor of one of Bang-kok's tallest buildings, with wonderful panoramic views of this crazy city.

In the afternoon, a death-defying drive through Bangkok's traffic eventually took us not far from the city centre, to a small yard owned by a young American who is a collector and breeder of rare animals. We were shown a pair of clouded leopards, two golden cats, two leopard cats and various other smaller animals. The cages were very small; the animals, uncomfortably overweight. I sketched and photographed, but inside I was angered that these beautiful, sad creatures could not be back in the wild trees and mountains where they truly belonged.

• • •

The next day, in a small rented car, we battled once more with Bangkok's traffic, heading west to find the Kaeng Krachan National Park. By mid-afternoon, we arrived at the park headquarters, which was some distance from the park itself and situated on the shore of a large reservoir. We rented a bungalow for twelve dollars a night—very basic, hard beds with one flat pillow and one blanket each, and a hole-in-the-floor toilet.

We decided to use the remaining time that day to actually find the park itself. Our hand-drawn map issued by park HQ was beyond the combined capabilities of the SAS and Kenya's airborne elite, and the first wrong turn brought us to a high, razor-wired gate across the road. As we gazed at this with some perplexity, we were quietly and quickly surrounded by a group of extremely tough-looking men. Mike broke out his pidgin Thai and their grim faces relaxed a bit; you could see them thinking—just a bunch of idiot *farang* (foreigners). These were men from Thailand's Special Forces. They were very polite and gladly gave us directions. I reflected that a similar situation in parts of Africa could have had very different consequences; my late

brother was once beaten senseless and thrown into a military jail for taking a wrong turn and stopping at one of Idi Amin's army barracks.

At last we found the park entrance, situated in the foothills of the mountains which rose up toward the border with Burma a little way to the west. A young guard rested in the grass reading a book on Thailand's birds. Interpreter Mike asked if we could enter the park. Oh, no. Only national park buses with an official guide could do that, and they only ran on certain days. Not to be deterred, Mike produced from the car my first book, *An African Experience*, and proceeded, in his broken Thai, whilst displaying the pages, to set me up as an eminent scientist, a world-renowned artist, a friend of people in high places—in fact, someone who should never suffer the indignity of having to rub shoulders with a bunch of common tourists in a *bus*. He went on to explain how experienced we all were in national parks and how just one quick peek on this particular evening, when no-one else was about, would surely not be a problem. . . .

How could the young man resist such persuasion? He opened the gate and waved us through, insisting that we be out by 7 P.M. Soon we were driving through a lush jungle of huge hardwood trees, brilliant foliage, palms, ferns, orchids, bamboo, an extraordinary variety of tropical butterflies, and many strange and beautiful birds. My mouth was watering at the prospect of painting this vivid habitat—what a change from the dry colours of Africa! It was difficult to tear ourselves away, but we dutifully reached the gate at 7 P.M. and gave the guard fifty *baht* (about two dollars) as a thank-you for his

understanding, saying that we would be back the next morning and hoping there would still be no objection to our independent plans.

We dined that night at a small alfresco restaurant at Phet Bun, on the edge of the lake near our bungalow. The food was good, cheap and plentiful. The hostess was small, loud and bossy—and the wife of the warden in charge of the park. A tame hornbill hopped around our feet, and a caged mynah bird chattered away in several different languages. Several Thai beers later, we repaired to the bungalow, where I spent the rest of the night listening to my two companions imitating a pair of giant forest hogs, an accusation which, the next morning, they vociferously and indignantly denied.

Mike revealed a weakness: he is hopelessly absent-minded. Terry, being

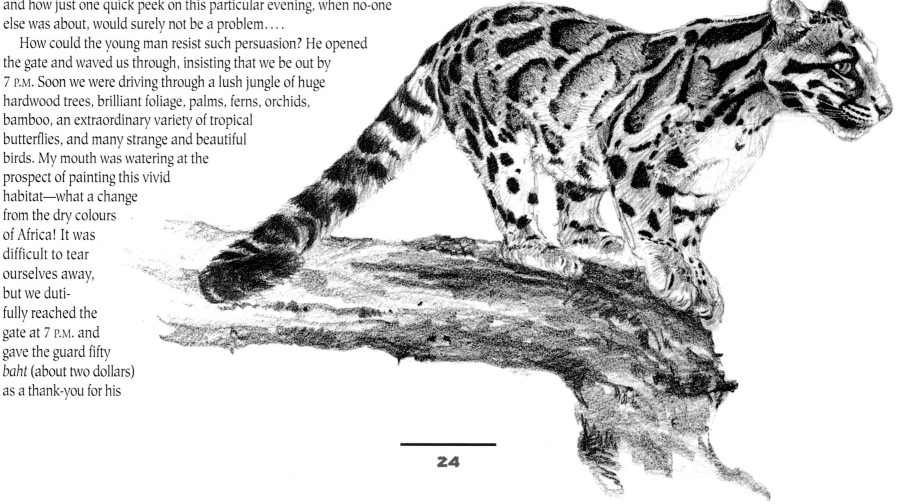

the arch practical joker that he is, had been exploiting this unmercifully, and already Mike had mysteriously lost his passport, his socks, his radio and his trousers. However, he soon cottoned on and slyly started to retaliate. I could see that I might have problems with these two.

Kaeng Krachan is Thailand's largest national park, yet it is the least developed. Its western boundary adjoins a vast wild area of Burma so that wildlife can cross the international border to wilderness on both sides.

Kaeng Krachan covers 1,814 square miles (compared, for instance, to Yellowstone's 2,145 square miles). Within its borders exists an astonishingly wide variety of animals and birds, including wild elephant, tiger, clouded leopard, leopard, Malayan sun bear, Asiatic black bear, Malayan tapir, wild dog, wild pig, gaur and a number of different species of deer. There are crocodiles in the remote swamps and, according to the Karen tribesmen, Sumatran rhinos in the rugged mountains near the Burma border. There are more than 250 species of birds, including the endangered woolly necked stork.

Early in the morning, the park was still pleasantly cool, a welcome relief from the muggy humidity which comes as the day wears on. We drove high into the mountains and crested a ridge to look west over serried ranks of forested hills to the border with Burma. As we relished this view, a loud, haunting call like the slow first half of a wolf whistle started from high in the trees to our right. Another joined in, then another and another until the hillsides all around were echoing with this wonderful sound. Through binoculars I detected the source: gibbons feeding on fruit in the tall trees and proclaiming their territory to the world and all other gibbons.

Monitor lizards waddled awkwardly across the dirt track as we drove deeper into the park. Occasionally, there would be a flash of white as a deer flicked up its tail in alarm before disappearing into the dense undergrowth. Wreath-necked hornbills flapped clumsily from tree to tree; mynah birds, lyres and countless other exotic species skulked in the bushes.

From time to time, I stopped to reconnoiter, peering at the loose soil beside the track in the hope of finding the tell-tale pug marks of a big cat. At one place there were indeed some footprints, but very old and scuffed. They

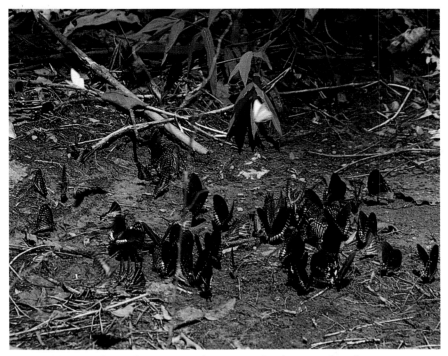

Colourful butterflies take moisture from a patch of wet mud in the Kaeng Krachan National Park.

could even have been those of a small tiger, for those cats, too, lived in this wilderness. I walked away from the track, all the time searching for that special tree branch or fallen log which would fit the vague image I had in my mind for the clouded leopard's perch. It is dangerous to do this—to have too fixed an idea—because the search could then go on forever.

Clouds of large, brilliantly coloured butterflies hovered near a patch of moisture on the trail, disturbed by our passing. They soon returned to settle, and the ground resembled a vivid, psychedelic carpet. I took more pictures; maybe this could be included in the painting.

We stopped near the most westerly point of the park—probably only a stone's throw from Burma—and walked around in the forest, still not finding what I was searching for. Here were dense thickets of bamboo, open glades

and many signs of wild elephants. It was reminiscent of the Kenya highlands. Then it was time to turn for home.

Twenty kilometers later, however, there was a cry of anguish from Mike: 'Where's my hat?'

'What, that silly old cream thing?' we asked. 'Where did you leave it? When did you last see it? Surely it can't be that important.'

Mike started to get very huffy. It transpired that the hat had very special significance; it was given him by his children and had been his constant companion through thick and thin for many years. So we relented. Muttering and grumbling, we drove all the way back to where we had turned, and, sure enough, there was the hat lying beside the road. Mike was happy.

On our second attempt to return, I caught sight of a thin, four-foot-long, green snake in some bushes beside the road and stopped the car to investigate. Terry started gibbering and winding up the windows, and I discovered, to my delight, that he was terrified of snakes. This one was a krait and had an evil, long, diamond-shaped head. I touched it with a twig, and it reacted with lightning speed. More pathetic howls from Begg, much to the delight of Mike

Terry Begg and me outside the Royal Palace in Bangkok.

and myself, but I decided to give it a wide berth and we carried on our way.

That was the first day in the park, and I had not found what I wanted. Already a feeling of mild panic was starting, although I had seen much background material.

• • •

Back at Phet Bun, Mike wanted a party. In the little restaurant where we had eaten the night before, there were two men drinking beer. One was a young game ranger; the other, the local fire chief, whose spectacles would put the bottom of a Coke bottle to shame. After our meal, we invited them and the loud, bossy lady owner to join us at our table under the trees. She quickly asserted herself and made clear that her presence depended on the quality of the liquor. Dubiously she peered at the expensive bottle of duty-free Johnnie Walker Black Label whisky that I had purchased in Seoul and started to shake it up and down vigorously like a cocktail shaker. Apparently, the more frothy bubbles in the bottle, the better the quality, and she was happy to point out that ours had passed the test. Generations of proud Scottish distillers were turning in their graves. The local whisky was called Mekong and, by all accounts, was no better than the muddy water from the river of the same name. If you shook it, there was no froth—so the test was valid especially since it was not unknown for an empty bottle of a fine traditional brand to be filled with Mekong.

The game ranger nodded his head wisely when we explained our mission to Kaeng Krachan. 'Pala Uu,' he said with conviction. 'That is where you will find that cat and also some wonderful scenery. Many beautiful waterfalls. The Thai people love waterfalls. That is where you should go tomorrow.' The restaurant owner screeched 'Pala Uu' very loudly, over and over, like some primitive war cry. Obviously, she was well into the party mood.

The three locals drank their whisky with beer chasers and were soon loudly incoherent; we were not much better. Out came my sketch-book, and in the car headlamps I tried to draw portraits—with appalling results. The loud lady explained the three reasons Thai people do not like Europeans: they don't wash enough, they eat cheese which smells and they are too loud. She was a fine one to talk. Her voice rose by several decibels and, to Terry's huge amusement, she started to get amorous but fortunately kept

The teeming waterfront along the Menam River includes many intriguing eating houses where diners can sit and watch the river traffic go by.

falling off her chair. The fire chief became more and more ponderous as he conducted a very serious monologue in Thai, punctuated frequently with loud utterances of what sounded like 'FOCKYU'. Terry and I had hysterics each time it was shouted. The ranger was clumsily reading Mike's copy of my book upside-down whilst Mike himself was threatening physical violence if the slightest mark appeared on any page.

Our hostess decided that the next day, she would close the restaurant and join us on our travels. That announcement instantly cut short the Welshman Mike's sad rendition in the Thai language of the Irish ballad 'Danny Boy'. The party suddenly broke up, and we all went back to the bungalow for a council of war. No way was she coming. No way. We decided that if we rose and left quietly at cock's crow, we might sneak away without her.

• • •

Early in the morning, three sorry figures attempted to pack, load the car and sneak quietly past the restaurant, but, to our dismay, Madame was standing in the road dressed to kill in outlandish silks and satins. Mike staggered over to a tree, slumped to the ground and slid into some kind of dark, Celtic depression which involved opening his camera and viciously removing yards of exposed film. Terry sulked in the back of the car, looking into space and muttering foul curses under his breath. The hornbill, thinking my bootlace

Sunset over the Phet Bun Reservoir. Below: This young elephant was the main attraction at a Thai restaurant. I showed it my African elephant T-shirt.

was a snake, attacked and hurt my foot. The mynah bird refused to say a word. It was not a good day. The loud lady, slowly becoming aware that she was not exactly wanted, started to boil up a full head of steam until I rummaged in my bag and produced the sorry dregs of a once-proud bottle of fine scotch. As she was contemplating with some skepticism the contents of this timely gift, I hustled the other two into the car and we disappeared in a cloud of dust, bound for Pala Uu.

• • •

Pala Uu, in the south of the park, was a very different situation from what we had seen before. Up to now, within the park, we had seen no other vehicle or people, but here was a well-used car park and evidence of many visitors. The river came down from the mountains over a series of small but beautiful waterfalls, and a footpath followed the gorge upward, becoming less and less used the higher you climbed. I would see no clouded leopards here but maybe, with luck, the scenery would be right.

In the lower reaches, it was disappointing to see garbage discarded everywhere. The Thai people surround their spotlessly clean houses with trees and flowers and keep their yards immaculately tidy, but over the fence goes all the trash, and this included the beautiful river at Pala Uu.

We climbed past pools full of large fish and laughing, naked children. Mike decided to swim, and shocked some locals with his naked, hairy farang body.

As expected, the wildlife here was sparse, but the places where I could picture a clouded leopard crouched were many. Heavy, horizontal branches festooned with parasitic plants, moss and orchids; large, exotic leaves and lush jungle backdrops. There was much to sketch and photograph, and my spirits rose as a vague plan began to formulate.

• • •

In Cha Am beach resort south-west of Bangkok, a friend of Mike's lent us his beach house—an elegant structure on stilts, cool and relaxing after the sweatiness of the jungle.

Impressions of Cha Am: the skinniest, mangy dogs I have ever seen; monks walking the streets in their saffron robes, some of them just small boys; an entire rotisserie on a bicycle—charcoal fire, roasting chickens and fish, deep-fried vegetables, the lot; picturesque, old, traditional houses

nestling cheek by jowl with hideous high-rise hotels and apartment blocks; drinking iced beer in a warm sea.

We left this peaceful haven to return to the madness of Bangkok.

• • •

Three men clad decorously in loincloths lay side by side, face up, laughing hysterically as three small Thai girls administered, with their feet and elbows and knees and fists, a two-hour, traditional Thai massage. NO EXTRAS. Whenever I relate this story, the men all give knowing looks and the women click their tongues, but, honestly, we did the proper thing—and no extras.

It was very relaxing and needed to be, after a day spent indulging Mr Begg's passion for shopping. My temper and patience wore dangerously thin as Mike and I watched him haggle over yards of silk, ceramic pots and expensive jewelry. Worse was to come. He decided to ship all his purchases to the U.S.A. using DHL, but when, eventually, we found the right building, their offices were on the twenty-first floor. Unfortunately, a Chinese movie crew was shooting a scene where a fight breaks out in an elevator car, and when we arrived, they had already tried about thirty takes. Every time we wanted to use the elevator, the Chinese started their next take. At last, Terry squeezed into a crowded car only to find, on arriving at the twenty-first floor, that DHL's offices had closed. I believe he ended up employing a former secretary of Mike's to handle the problem.

We did all the proper tourist things—took a ferry on the river, visited the Royal Palace and the Oriental Hotel (where we were refused entry because I was wearing flip-flops) and then the massage.

It was time to go. With much arm-waving and cussing, Mike lost the way while driving to the airport. However, we managed to make the check-in on time and said a fond farewell to one of the world's characters: Mike Jones.

He left us in purgatory. Bangkok airport, and a flight to catch for India. The air was stifling and became more so when we contemplated the situation to our front. There was no line, just a heaving mass of shouting, gesticulating Sikhs who had been on some kind of tour in Thailand and were now trying to return to Delhi—on our flight. These people do not know the etiquette of standing in line. Each of them seemed convinced that if he personally were not checked in instantly, he would undoubtedly miss the flight. My only relief was to witness Terry fuming with rage and demanding that someone 'do something about these people'. Patience was what Mike had advocated, and we certainly needed it that night.

• • •

I titled my clouded leopard painting *Jungle Phantom*. It seemed appropriate for this mysterious cat. The painting portrayed the cat on one of the Pala Uu tree branches, peering down to the forest floor from amongst the orchids and tropical leaves. I wonder if one had actually ever been in that tree....

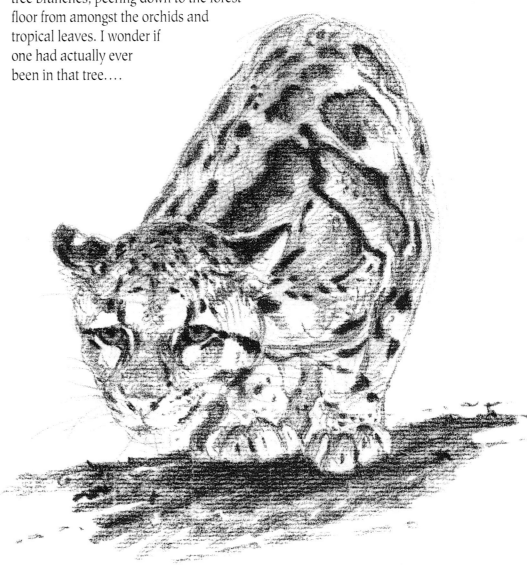

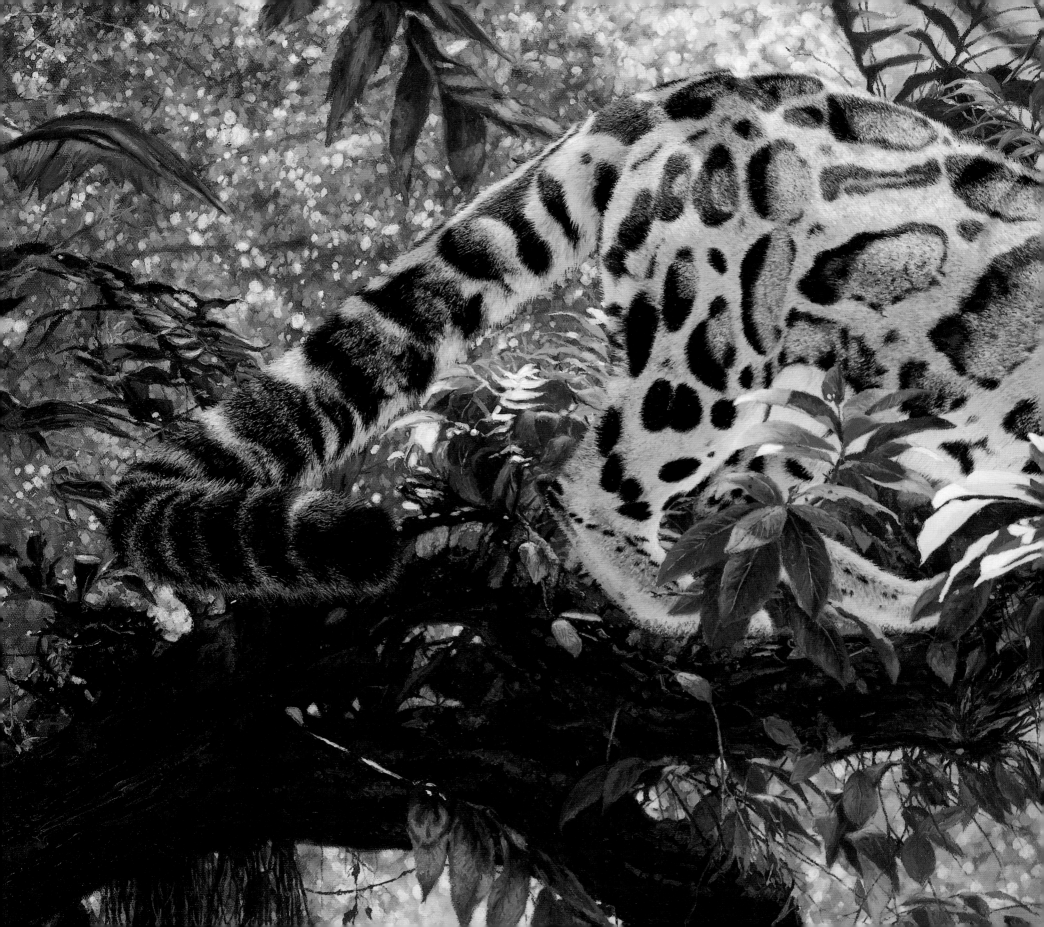

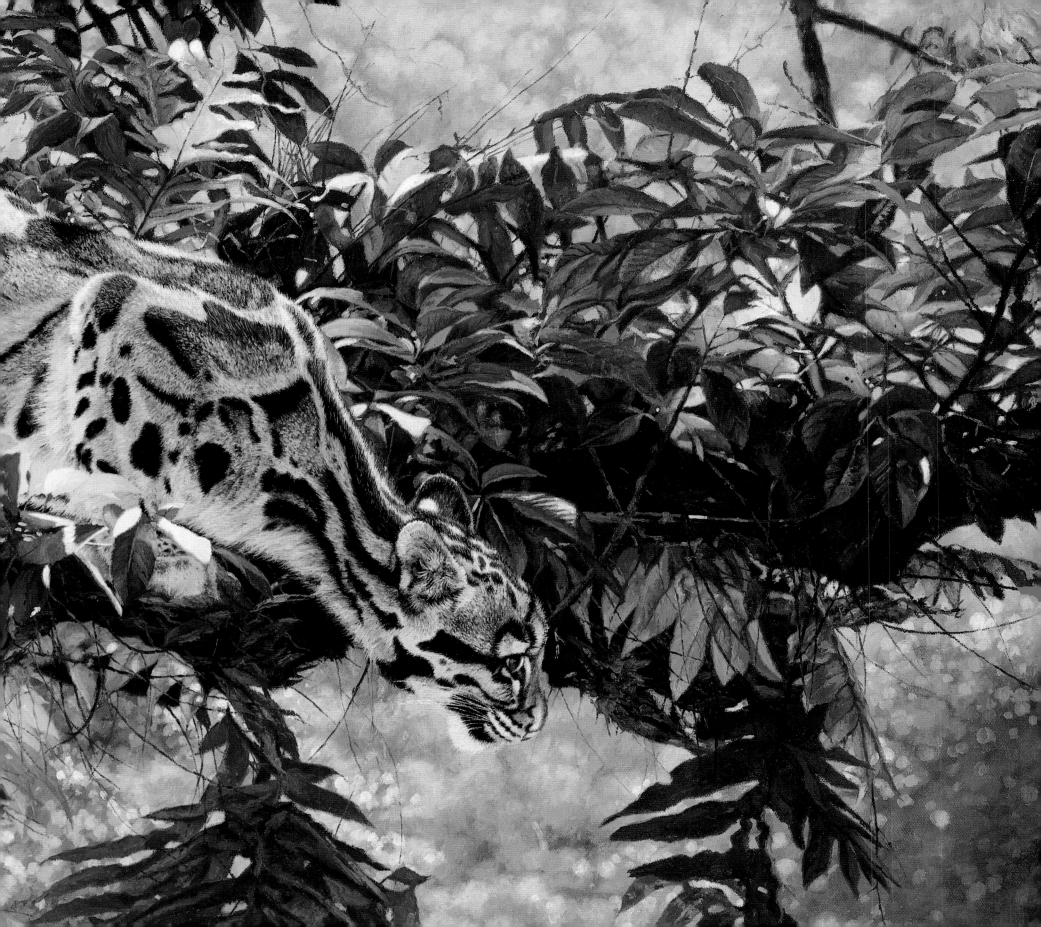

BENGAL TIGER

PANTHERA TIGRIS TIGRIS

Of all the great cats I undertook to paint, the Bengal tiger was the one I looked forward to with most excited anticipation. Apart from the lion, with its 'King of the Beasts' title, the tiger is the animal that instantly springs to mind if mention is made of the world's largest predators. It has played a major part in the legend and history of the East, and I well remember as a boy eagerly reading the books of Jim Corbett, Rudyard Kipling and John Masters. I could not wait to get to India.

Terry Begg and I arrived in Delhi directly from the clouded leopard search in Thailand. After four and a half hours of being thrown around the sky, we landed at around midnight. The previous day, there had been an unsuccessful hijacking attempt, and not long before that was a devastating bomb blast in Bombay so, not unexpectedly, airport security was rigid and India's infamous bureaucracy even more ponderous. Luckily, we were met by the Abercrombie and Kent 'minder', Mr Sanjay, who whisked us efficiently and quickly through the formalities and into a waiting taxi—the ubiquitous, Indian-manufactured Morris Oxford look-alike.

At 3 A.M., ensconced in some style in the Taj Mahal Hotel, we switched on the TV and watched, with a feeling of unreality, the Hong Kong seven-a-side rugby tournament. Ringing in my ears was Mr Sanjay's warning that he would be collecting us from the hotel at 6 A.M.— just three hours away.

Months previously, I had researched the various locations in India where wild tigers are still found. Ranthambore had been at the top of my list, but someone reliable told me that most of the tiger population which made that beautiful park so famous had, over the past few years, been decimated by poachers.

Of the three best alternatives, Bandhavgarh National Park (in Madhya Pradesh State) seemed the most promising, so I decided to spend all my time there instead of taking my chances with a few days in each of the other recommended locations.

As with the clouded leopard in Thailand, I had very limited time and therefore could not afford to waste it setting things up and making contacts on the ground. I needed to get straight to the sharp end as soon as possible after my arrival. In this case, lacking any good contacts, I took a chance and went as a tourist, hoping that, once I arrived, I could persuade the relevant people in charge to give

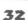

DESCRIPTION AND BEHAVIOUR: The tiger is largest of the extant cats and is comparable in size to the biggest of the fossil felids. Its reddish-orange to yellow-ochre coat with black stripes and white belly is immediately recognizable. No two tigers have the same markings, and stripe patterns differ from one side of the cat's body to the other. Unlike many other cat species, tigers readily enter water; they will lie half-submerged in lakes and ponds during the heat of the day. In some regions of India, they constantly swim creeks and broad rivers. They are also known to kill and eat crocodiles.

A tiger eats 18–40kg (39–88lbs) of meat at a time and, if undisturbed, returns to its kill to feed for 3–6 days. Tigers also eat carrion readily. They hunt mainly between dusk and dawn, but in secure conditions have been observed to hunt during the day. They usually attack large prey with a stalk from the rear, ending with a rush and, sometimes, a spring. The principal prey across their range consists of various species of deer and wild pigs, and sometimes gaur. Tigers will also attack the young of elephants and rhinos, and take smaller species, including monkeys, birds, reptiles and fish. They sometimes kill and eat leopards and their own kind, as well as other carnivores, including bears. Although lions and leopards also kill humans, tigers have the greatest reputation as man-eaters, especially in India.

LONGEVITY: One female was killed in Chitwan (Nepal) when at least 15.5 years old; some tigers up to 26 years old have been reported.

HABITAT AND DISTRIBUTION: The geographic distribution of the tiger once extended across Asia from eastern Turkey to the Sea of Okhotsk. Currently, tigers survive only in scattered populations from India to Vietnam, and in Sumatra, China and the Russian Far East. *P. t. tigris*, the Bengal tiger, is found on the Indian subcontinent. The tiger is found in a variety of habitats: from the tropical forests of southern Asia to the woodlands of Siberia, the swamps of the Sunderbans, the dry thorn forests of north-western India and the jungles at the foot of the Himalayas.

POPULATION STATUS: There may have been 100,000 tigers at the end of the 19th century; a 1993 mail survey and literature review concluded that the current number is probably less than 6,500. Three races—the Caspian, Bali and Javan tigers—have become extinct since the 1950s. Including 'unofficial' institutions such as circuses, there are probably more tigers in captivity in the world now than in the wild. India has by far the largest number of tigers. A 1993 census estimated 3,750, but official population estimates in India suffer from large margins of error. The total population of Bengal tigers is probably not more than 4,500.

PRINCIPAL THREATS: Commercial poaching, declining prey base and loss of habitat are all contributing factors in the tiger's decline. Also, tiger body parts are coveted for use in traditional Chinese and Korean medicines.

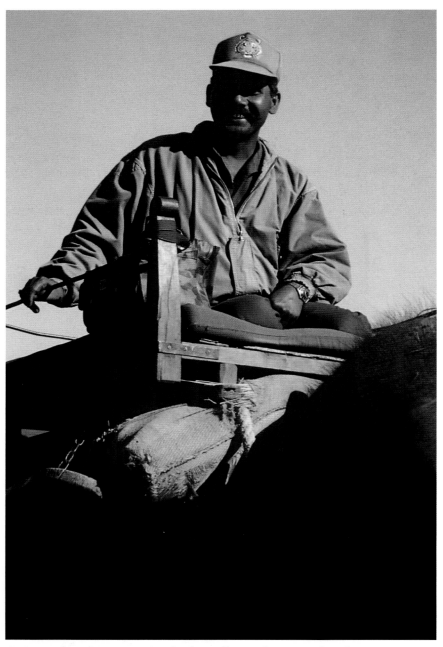

Senior mahout *Kuttapan Singh of Bandhavgarh National Park.*

me some concessions. So I used the services of Abercrombie and Kent, the tour operators for whom I had worked on occasion as a safari guide in Africa.

• • •

Bleary from lack of sleep, Terry and I were dragged back to the airport by the ever-efficient Sanjay at dawn the next morning. Our plan: to fly Air India via Agra to the ancient city of Khajuraho with its erotic temples. There we would meet a driver and travel the rest of the day to Bandhavgarh by car.

At 7 A.M., I was standing in line for check-in, my brain fully in neutral, when a voice behind me inquiringly asked, 'Simon?'. Turning in disbelief, I found that the couple behind me were Kirsty and Phil, close friends from Vancouver, bound for the Taj Mahal at Agra. Was the old cliché 'small world' ever so apt?

Our next A and K contact was in Khajuraho, a Mr Rafik, who introduced us to our driver and car—yet another Morris Oxford. The driver was short and skinny with a crop of long, spiky hair beneath which he wore a perpetual, manic grin. In answer to every question, he replied, with an even wider grin, 'Yes, please!'—his only words of English. I was reminded instantly of the Muppet character 'Animal', which is what we called him from then on and to which he answered, 'Yes, please!' with huge delight.

Animal drove with studied calm, his left arm draped ever so coolly across the top of the steering wheel, his right hand almost constantly on the horn and his right foot flooring the accelerator. A fine lesson in technique and style to any racing driver, he leaned physically and elegantly into every corner, causing a small, fluffy, plastic bird stuck on the rear window to squeak at each swerve. Anything on the road was fair game to Animal—except for trucks and buses, which give way to no-one, and cows, which are sacred.

For seven hours we careened through the Indian countryside to the accompaniment of the squeaking bird and Animal's horn, passing Panna, Satna and Amarpatan until, at last, in late afternoon, we arrived at Bandhavgarh. The landscape and people looked almost biblical. It was harvest time. Peasant farmers were cutting their grain with scythes and propping it in the fields in stooks; women, donkeys and oxen were carrying enormous bundles to be threshed, which involved an ox yoked to a pole walking round and round on the freshly cut stalks, trampling out the grain. Other

people lifted the trampled grain high to pour it down onto large cloths, allowing the wind to blow away the chaff.

We drove through an imposing, but now somewhat worn, gateway into a large, walled garden. This was the former hunting lodge of the Maharajah of Rewa but now the site of the jungle camp where we would stay. Parked in the driveway was a jeep with no doors and the windscreen folded down. Leaning elegantly against it was a man wearing a perfectly shaped khaki slouch hat (complete with *puggaree*), dark shades, a worn brown-leather bomber jacket, red silk scarf round the neck, immaculately cut khaki trousers and brown chukka boots. Levering himself away from the vehicle, he sauntered over and announced, 'I am Nanda. I am in charge here. You want to see tiger now?'

Having managed with some difficulty to drag our lower jaws back to the shut position, we nodded enthusiastically. Nanda issued rapid instructions; our bags were taken from Animal's taxi and whisked away to our accomodation whilst Animal himself was ordered to return one week hence.

• • •

In fifteen minutes we were through the gates of the park and, a short while later, parked beside a flat, swampy plain watching an elephant approach through the tall grass. On its back was a *howdah* (platform), and sitting just behind its head, the *mahout* (driver). Obediently, the elephant moved alongside the jeep, and Terry and I climbed up onto the howdah, a simple wooden platform with a low rope barrier round the edge. We sat facing outwards with our legs under the rope, dangling over the edge.

At the mahout's command, the elephant moved off into the long grass, tearing up clumps with its trunk and stuffing them into its mouth. No more than two hundred yards farther on, the elephant stopped. Following the mahout's pointed finger, we saw two tigers lying in the grass about twenty yards away, gazing at us with casual interest. I was quite overcome. The tall, reed-like, yellow grass was a perfect backdrop to these two magnificent cats as they lay watching us in the evening sunlight. This made up for the disappointment of Thailand. This was very, very special. I shot two rolls of film almost without drawing breath. That is my policy on occasions like this. Shoot lots of film first and then, if the subject is still there, start thinking about the

sketch-book. However, it was getting late, and the mahout indicated that we should leave before the park closed.

There were many varieties of other animals everywhere—sambur and cheetal (spotted deer), langur monkeys, wild boar and peacocks. What a start. What a day.

• • •

'Nanda, do you have any other names?' I asked.

'Oh, yes. My full name is Nanda Shumshere Jambahadur Rana.'

'Then you must be from Nepal. Are you related to a Prabal Shumshere Jambahadur Rana?'

'Oh, yes,' he said. 'He is my uncle and a very senior general in the Nepal army.'

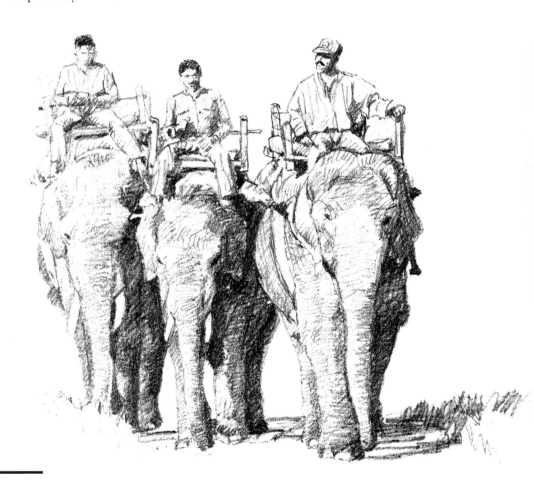

'I know him well,' said I. 'He was a classmate and close friend at Sandhurst [Royal Military Academy] in the early sixties.' This was the second small-world incident in just one day. Terry shook his head in wonder.

Nanda was delighted and, with his girl-friend, Jasmine, entertained us in style during our first evening at his camp. We were to sleep in tents erected on the grounds but would eat in the main building, the former hunting lodge. Inside, the walls were hung with old paintings (including a David Shepherd print), and against one wall was a stuffed tiger in a glass case. Sepia-coloured photos showed pre-war tiger hunts—richly clad men stand-

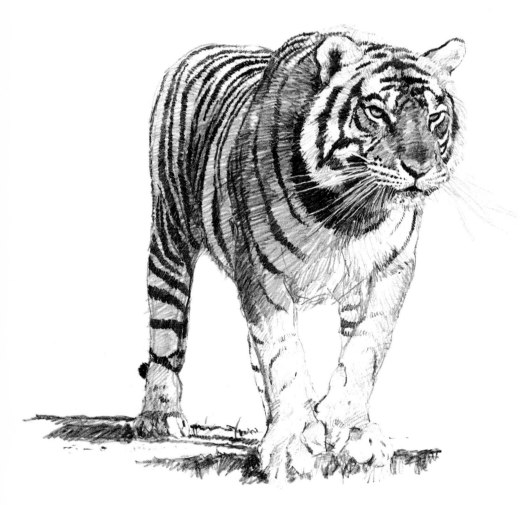

ing proudly with their rifles behind a long row of tiger corpses, the product of just a day's shoot. How times have changed. The Maharajah gave his hunting preserve to the Indian government in 1968, and in 1975 the land was made into a national park. It covers 185 square miles. Now he owns only the lodge, and his grandson, Raj, was there that first night.

• • •

Dominating the whole of this national park is a high plateau which towered a thousand feet or more above us, with cliffs surrounding most of its summit. Only a narrow trail affords access to the top, where there are ruins of a once-extensive fort. Combined with the natural cliff barriers, this was, in ancient times, an almost impregnable fortress for the Maharajah and his forces.

Now, the only inhabitant was a fierce-looking old priest who descended from his eyrie every few days, plodding fearlessly through tiger-infested bush and jungle to fetch supplies and beg for alms. If he met the big cats, he would hurl stones and loudly abuse their ancestry. He visited our camp and handed round small sweetmeats and nuts in exchange for a ride to the bottom of the hill where he lived. While he stood implacably watching us, I sketched his gnarled, weathered hands as they rested on his staff.

At the base of the hill, where the track led up to the temple, was a clear, man-made, rectangular pool some twenty paces in length. Reclining on its back in the water was a large, stone statue of the god Vishnu, with a seven-headed serpent entwining his body; it dated back to A.D. 200. All around the base of the hill was a network of caves dug centuries ago by slaves and workmen and then inhabited by holy men. Their writings could still be seen on the walls, but now the only occupants were thousands of horseshoe bats and the occasional snake or tiger.

Many streams flow between steep ridges from the great plateau down to flat plains and swamps with elephant-high grass.

We were there in April, the dry season. Water was becoming scarce, so the animals were forced to congregate and were therefore easier to see. I was excited by the colours. The Bengal tiger would be painted for the 'Cats of the Jungle' section (with the jaguar and clouded leopard), which presupposed a lush, green habitat, but this was far from it. Certainly, there was much thick undergrowth, but the dryness created golds, ochres, yellows, reds,

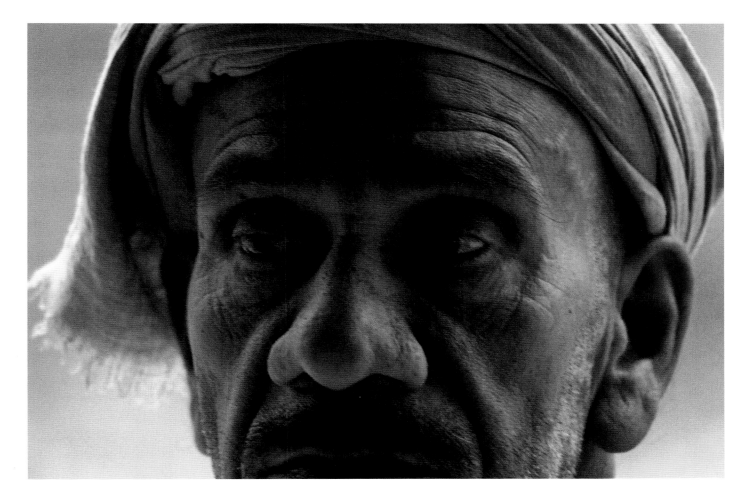

The old priest came from the temple atop a plateau which dominated Bandhavgarh National Park. He never smiled and seldom spoke, but was known to loudly abuse any tiger he met along his way.

pinks and browns reminiscent of Africa and, to my mind, eminently paintable.

• • •

There were two other guides who assisted Nanda: Sanjay, also from Nepal, was a bird expert and never stopped smiling; Butch was short and stocky, with a Scottish father and Tibetan mother. Both were initially bewildered by the Begg humour but soon joined in and became inseparable. Everyone wanted to travel in our jeep because we never seemed to stop laughing and because we had phenomenal luck with tigers.

The second morning, we met with the elephants, climbed aboard and, within a few minutes, watched a single male tiger walk through the grass. Accompanying us this time were Raj and a young British couple, Rupert and Emma, who spoke with immaculate, posh English accents. On our way to the tiger, Nanda pointed out a spotted deer and Rupert was heard to say, 'Hello, Mr Spotted Deer.' I glanced nervously at Terry and noted with misgivings the evil grin on his face. Sure enough, a little way down the road, as we passed a group of langurs, a voice from the rear, in an appalling attempt

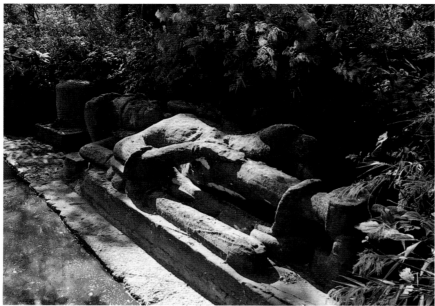

Ancient statue of the god Vishnu, in Bandhavgarh National Park. The sculpture depicts him lying in a pool of water with a great serpent entwining his body.

at a British accent, shouted, 'Hello, Mr Monkey.' And so it went on, relentlessly, all day. Poor Rupert.

The senior mahout was Kuttapan Singh. Nanda told the story of how, one day, three middle-aged English ladies were taken on Kuttapan's elephant to see one particularly belligerent male tiger which charged as soon as they came near, roaring, snarling and causing the elephant to trumpet in alarm. Quickly, they returned to the jeep, where the shaking ladies climbed down, the last one struggling to descend from the howdah with her back to the elephant. Kuttapan looked round and, in a loud voice, announced, 'Sahib. Somebody has wet my howdah.'

That evening, we were summoned again, this time to investigate a leopard which the mahouts had found feeding on a spotted deer. We managed only a glimpse through dense undergrowth, but this was an unexpected and exciting surprise. I had leopards on my list but never expected to see one in India and was anxious to find out whether it differed in any way from the African leopard. What little I could see suggested this one was a smaller animal, but it was impossible to say whether this was a characteristic of the species or simply immaturity.

• • •

I speak good Swahili and was intrigued to discover that many words in that language probably derived from Hindi. The British imported cheap Indian labor to build East Africa's railways at the turn of the century, so this was where the words must have originated. Such words as 'ice' and 'gun' were obviously not part of Africa's vocabulary before foreigners invaded that continent.

On a large, flat piece of sandstone near one of the caves which had been inhabited by monks so long ago, I found four parallel rows of cup-shaped holes just discernible after centuries of erosion by wind and water. The Africans play an ancient game called *bau* using small, round pebbles in similar cup-like indentations carved out of a plank of wood or simply in the beaten earth outside their houses. Could this be the same? On which continent did this game originate?

In the garden of the hunting lodge were large, shady trees which bore small, waxy, heavy-scented flowers. Indian women were collecting the fallen flowers in *karais* (basins) and taking them away, balanced on their

heads. I asked Sanjay what they were for and was told that the women would ferment them to make a potent liquor. The name of the tree was *mahua*, which means 'flower' in Swahili. Coincidence?

• • •

The next day, the leopard was still on its kill and in much better view. I took many more photos.

In a thick clump of tall grass was a fourteen-foot python which had just swallowed a young spotted deer. Goodness knows how the mahouts found it, for all we could see was a patch of gold-and-black, patterned skin. After much debate, we cautiously climbed down from the elephant, located the snake's tail and dragged it, furiously hissing and writhing, out into the open. Half-way down its length was a huge bulge—the poor, unfortunate spotted deer—but the reptile was so large at this point that it could not reach the man who was holding its tail. It reminded me of a fat man who cannot tie up his shoelaces. One of the mahouts was actually standing on tiptoe on top of his elephant's head, shouting, 'No! No! No! No!' as if he expected the snake to slither up the elephant's trunk and get him. It seemed ridiculous that a man who could control such a huge animal should worry about a mere snake and seemed reminiscent of the traditional housewife standing on the kitchen table with her skirts held high whilst a small mouse ran across the floor.

Again we found tigers, this time a female and her mature male offspring. They were completely relaxed despite our proximity, so I was able to sketch—not an easy task from the back of a moving elephant, and, inevitably, I dropped my pencil overboard. Tapping the mahout on the shoulder, I explained in sign language what had happened. He smiled and said something to the elephant, which moved back a pace or two, felt around in the long grass with its trunk, found the pencil and passed it up to me on the howdah. Amazing. What did he say to the animal? 'Pick up that pencil?'

The team-work between these animals and their handlers was marvellous. Each elephant had been raised by one man since it was a small calf, and could now understand up to eighty different commands. As we moved through thick bush, the elephant—without any bidding—would gently grasp low-hanging branches and lift them over our heads as we passed under. Back

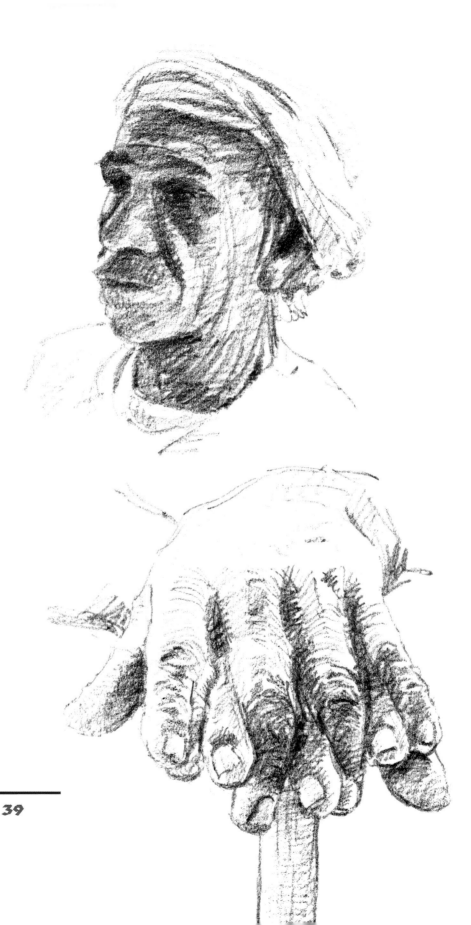

at the camp, we walked down to the river to watch them being washed. They lay on their sides in the water and sighed in ecstasy as the mahouts scrubbed their thick hides with abrasive stones. The only thing that upset me were the heavy chains which hobbled their forelegs when they were not working.

• • •

Our fifth day there saw the start of the religious festival Ram Nawami, and thousands of pilgrims started arriving outside the park. The old temple on the plateau had some particular significance, so over the next few days the hordes would invade the wilderness to file up the hill past old Vishnu's statue.

Deciding to distance ourselves from the mob, we visited the far extremes of the park. We were joined by some newcomers to the camp, Lucy and Sarah, two girls from London who had to endure the now familiar but sorry ritual of coming to terms with Terry Begg's humour.

This was a day of variety. We saw wild cattle, which Nanda called bison but the book described as gaur, a big, wild ox, reputedly the world's largest bovine and an animal which the tigers take pains to avoid. Nilgai (or blue bull) also went on the list, as did jungle cat—just a quick flash—and mongoose. We also saw beautiful birds, many of them similar to those in Africa.

The Indian wilderness struck me as curious for its noise. Africa, by comparison, is very quiet but this place was nearly deafening, especially if a tiger appeared. Spotted deer were rutting, the males' call a loud, piercing challenge; peacocks were screaming, langur monkeys whooping, crows cawing. Red-wattled lapwings uttered their screeching call, 'kee-kee-krrrr,' and mynah birds added their varied, loud vocabulary to the general din.

We stopped to talk to a family of pilgrims. A small boy carrying a pet rhesus monkey watched in wide-eyed astonish-ment as I filled his cupped hands with 'Calypso Mix'—nuts and dried fruit which comprised our emergency rations from a recent, previous trip. Both boy and monkey devoured them in ecstasy.

Lucy won top marks by spotting a leopard lying in a patch of dry leaves lit by the evening sun only twenty yards from the track. Very quietly, we watched as the cat lost its initial wariness and relaxed. The light was perfect, and cameras clicked frantically for all of twenty minutes. Suddenly, the leopard stopped cleaning itself and froze; eyes widened, ears pricked up, it stared fixedly at the track to our rear. Coming towards us were two Indians, blissfully unaware that we were watching a leopard. I nudged Nanda, pointing at them with my chin, and he let loose a stream of invective which, unfortunately, only made them edge closer to see what was holding our attention. It was too late. The leopard had melted away. I found it hard to understand how the authorities could allow people to wander around amongst these wild animals in a national park. Small wonder that they had a poaching problem.

As dusk settled on this particular day, we drove towards the exit gate and passed several car-loads of over-excited Indians, shouting loudly at each other and pointing and gesticulating at a young male tiger which stood with complete lack of concern beside the track. This maintained our 100 percent record for seeing tigers every day. Add to that, three leopard sightings, and Nanda was shaking his head in wonderment at our luck.

• • •

We met a man called Ashish Chandola and his English wife, Joanna. Ashish was making a documentary film about Bandhavgarh's tigers for Anglia Survival. He had been in the area for well over a year and had managed to shoot all the tiger footage he could use. Now he was looking for subsidiary material to pad out the production. We found him with his camera set up to cover a pair of jackals

which had just killed a young spotted deer. As we watched, they were chased off by two crowned eagles which, in turn, were mobbed and removed by a flock of noisy crows. Meanwhile, Egyptian vultures patrolled the fringes, picking up scraps. At this point, we started swapping notes about mutual acquaintances and filming in Africa when, suddenly, there was a shout as a sounder of wild boar trotted into the clearing, grabbed the deer carcass and disappeared into the bush. Ashish was justifiably furious. It would have made an excellent sequence, and I felt very guilty for distracting him at such a crucial moment.

• • •

The festival of Ram Nawami coincided with a public holiday in India. Returning to the jungle camp on Friday evening, we found it filled with well-to-do city dwellers who had come to the wilds for the long weekend. These were mostly Indians but very sophisticated and, in most cases, very affected. They spoke English with a lazy drawl and just a hint of the singsong Indian accent. They wore designer clothes and wraparound shades; they strutted and preened, and the pungent smell of marijuana wafted occasionally past my nose.

We burst onto this scene straight from the park where, that day, we had seen just about everything. Nanda was proud of his efforts, and they questioned him excitedly about their chances the next day. Terry and I sat in the bar, drinking a refreshing beer. He was in one of his noisy moods—'Hello, Mr Lizard!' and all that nonsense. From across the room, an exceptionally smooth businessman from Bombay asked in a loud drawl, 'Terry, are you the typical ugly American?'

Spluttering and choking on his beer, he cried, 'I'm not a effing American, I'm a effing Canadian.' What was I going to do with this person? But the evening developed into another party, and in due course I was urged to tell my jokes. The frosty aloofness of some of the other guests began to thaw.

Later, Terry created a crisis. At the end of the evening, when most of the guests had retired to their tents, he wanted to buy the barman a drink. Not only that, but he insisted that the barman join us on our side of the bar. Grave mutterings from the Indians. That is impossible; but Terry was adamant and demanded to know why he could not exercise his generosity

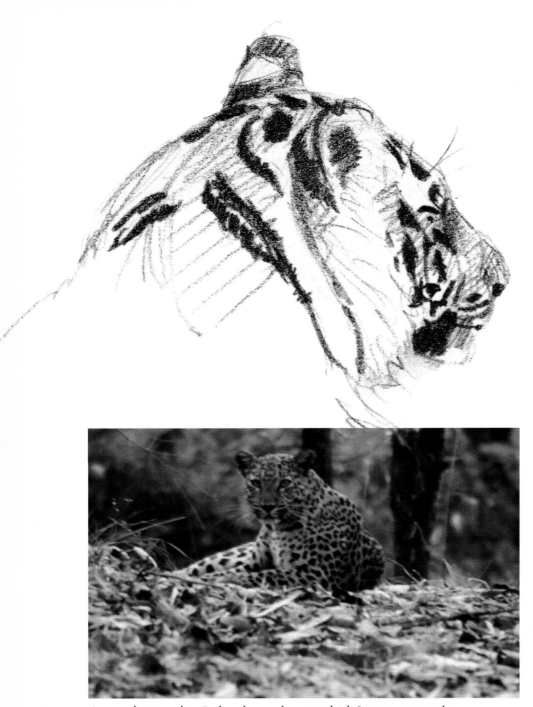

A rare glimpse of an Indian leopard, a cat which I never expected to see because they are so elusive and scarce.

just as he would back in the U.S. of A. I pulled him aside and explained the strange complexities of the caste system in India. The barman was from a lowly caste, and under no circumstances could he drink in the same room as the others. Terry refused to listen and rambled on about the equality of man and what sort of a country was this anyway and how could he be expected to drink with a bunch of bigots and so on. They were very patient and eventually reached a compromise: the barman could come round to our side, but he would have to drink Terry's drink while squatting on the floor, out of sight, behind us. Terry was reluctantly mollified.

• • •

The next morning, Nanda was faced with several tricky situations. Word was around that we were ace tiger spotters, so everyone in the camp wanted to travel in our jeep. Indeed, one young woman, the Dutch wife of a Venezuelan diplomat, had parked her elegant self in the front seat and completely refused to move. Nanda tried to explain that the other two guides were equally accomplished, but to no apparent avail.

Then there was the forceful, wealthy Bombay businessman, with his mousy little wife and spoiled eight-year-old son and a young man who was the child's constant minder. He did not want to see tigers or leopards or any other animal except an elephant. All he wanted was for his son to spend the day riding one. Nanda was stamping up and down asking under his breath why the hell he didn't go to the zoo.

At last, we set off for the park, with the assembled company—some having massive fits of the sulks—evenly distributed between the three jeeps. In our car was a young person of uncertain sexual persuasion, although I think it was male. He, if indeed it was he, was accompanied by two stunning girls who must have been models because they were always posing for him to take artistic shots from various different angles. He smoked something exotic and pretended fawning interest when he learned that I was an artist. Begg, he completely ignored. Around his shoulders he wore a tasseled, *Out of Africa*–style shawl which flapped in the wind and flicked me in the face. That and the smell of his weed made my eyes get narrower and Terry's grin, bigger.

The final passenger that day was a compulsory game ranger from park headquarters who hung precariously out of the back of the jeep, wild-eyed

and red-mouthed from chewing betel nut. He hawked and spat and sounded like a pig at a trough as he uttered loud and unintelligible identifications of birds and animals. I don't know if betel juice is an intoxicant but, if not, he was on something truly powerful. Perhaps fortunately, we saw nothing which required caution and silence.

● ● ●

Our last day in Bandhavgarh was a Sunday and we rose early, hoping to beat the inevitable throng of holiday week-end visitors into the park. Terry spotted three tigers on top of a small cliff some twenty yards from the track. The elephants were in the vicinity so Nanda called them in on the radio— modern technology invades the natural world. By the time we were on board and heading towards the cliff, other vehicles had homed in on our discovery, so we knew that our time with these particular cats would be limited. In such circumstances, it is difficult not to feel selfishly proprietorial.

The elephants were not too happy about climbing quite a steep gradient to the base of the cliff, but the mahout's none-too-gentle urging brought rewards; the tigers had moved into a small cave and were lying at the entrance only ten feet away, at the same level as ourselves. These poses were some of the best from the whole trip. However, as predicted, our time was cut short by a loud English voice demanding rudely that we give

A young male tiger relaxing in a low cave in Bandhavgarh.

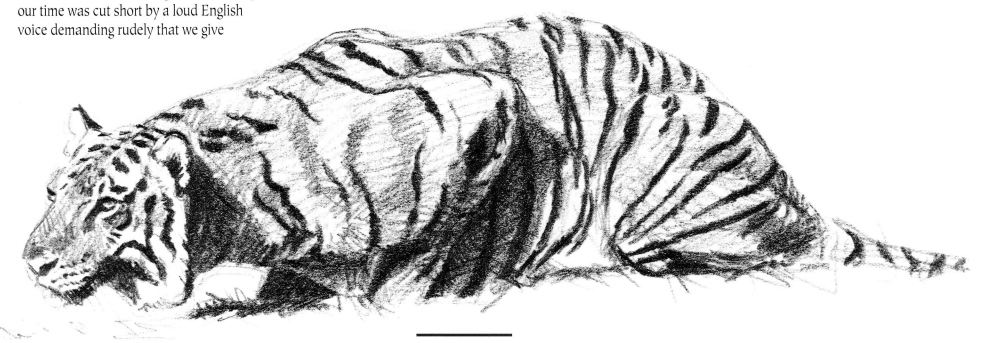

43

way and let some other people have a chance. This from a fat, red-faced, scowling British lady exhibiting all the worst symptoms of road rage. And I thought the Indians were pushy....

As we drove off, more cars were arriving. Poor tigers. Poor elephants.

By now, we had become close friends with Nanda and Jasmine, and on this last day, it seemed appropriate to stop on a high ridge, relax in the sunshine and take in the magnificent view of almost the whole of Bandhavgarh. I had collected some priceless material on the tigers as well as many exciting ideas about background. So much was inspirational: the shifting light, the contrasts, the reflections of autumnal colours in mirror-like pools. So here, in this peaceful setting, listening to the sounds of the bush, I vowed to

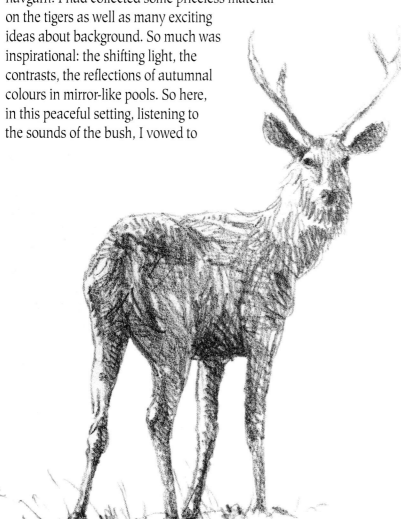

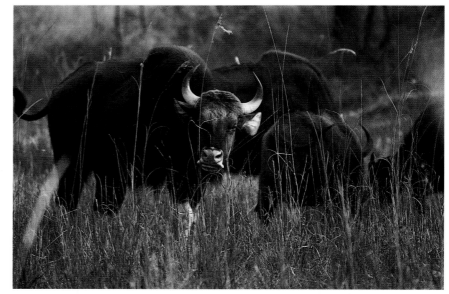

India's wild ox, the gaur, is the world's heaviest bovine. Even hungry tigers avoid them, unless they are desperate.

make every effort to return to India and looked forward eagerly to painting this particular big cat. So many factors combined to make it an exciting prospect: the animal itself has a power and beauty almost without rival. I had looked into the yellow eyes of a truly wild tiger and hoped I could rise to the challenge of portraying this magnificent beast in all its natural splendour.

Such dreamy, peaceful thoughts were shattered when we drove back down the road to where we had last seen the tigers. Ahead was a static convoy of more than thirty vehicles stretch out along the track. Three elephants were virtually sprinting back and forth the thirty yards between tigers and vehicles. One-minute maximum viewing time for each howdah-load, and the people were stacked on like asparagus stalks in a tin. Those in the vehicles were shouting advice, demanding attention, offering bribes and loudly describing what they had seen whilst others, on the side away from the tigers, were wandering off behind bushes to answer the call of nature. Minipantomimes were being enacted—grandmothers were lifted bodily from the

tops of vans onto the backs of elephants; small children, who evidently thought they were destined for some kind of pagan sacrifice, were kicking, struggling and screaming louder than a hundred peacocks as they were slotted forcefully into place. People were making it into a social occasion by breaking out their picnics, and paper and plastic bags were being discarded by the roadside. Cars whose occupants had seen the tigers were trying to work their way back through the bush with revving engines and hooting horns. It was a scene from hell, and I marvelled that every tiger within fifty miles had not fled to the neighbouring state.

Maybe it was time for us to move on.

• • •

Animal arrived with the dawn. We could tell it was him because he hooted the horn as he drove through the gates. We had a wager that he would do the same before he left the compound. As we approached the gates, waving good-bye to our wonderful hosts, a small boy ran out to watch, and the ever-predictable Animal stood on the horn.

• • •

Indian Summer was the title I gave to the painting. I was spoiled with choice of background but settled on something which I felt was typical and characteristic of Bandhavgarh: bamboo. It is not an easy subject and makes excellent material for a masochist like me. To compound this complication, I chose to paint the cat standing ankle-deep in dried leaves. There is a type of ficus tree in Bandhavgarh which, at that time of year, had shed most of its broad leaves, and the colours and texture of these, as they lay sun-bleached on the ground, was irresistible. Live leaves growing on a plant or tree have a certain pattern and symmetry which enables a painter to achieve a kind of rhythm, but lying dead on the ground, they are a haphazard jumble, and each leaf in turn has to be painted individually. Despite the painstaking nature of this task, I felt it was worth it. The wonderful colours of the tiger's coat blended beautifully with the dead leaves, and the animal's black stripes seemed to complement the vertical stalks of the bamboo.

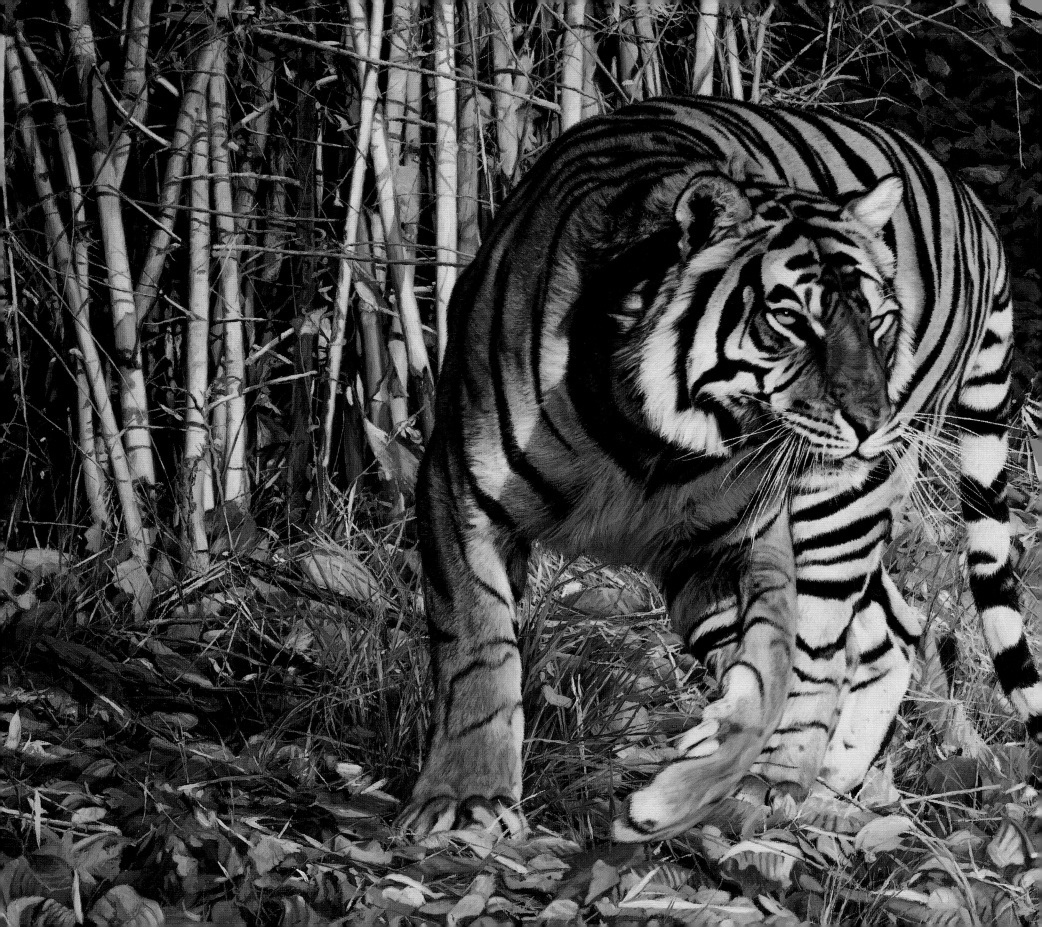

JAGUAR

PANTHERA ONCA

My prior knowledge of the jaguar was limited to a few bare facts: it inhabits the jungle areas of Central and South America; it is a powerfully built animal and seems to live close to water; although it is widespread, it has been hunted mercilessly as vermin in most countries and would therefore be extremely difficult to research in the wild.

This was not encouraging, and I had no idea of the best place to go. During my previous travels, I had had the good fortune to meet Peter Jackson, who runs the Special Cat Unit in Geneva for the IUCN (International Union for the Conservation of Nature). He told me to get in touch should I need advice on any of the big cats so, without further ado, I gave him a call. He advised either Belize or Venezuela. In the former, they had set up nature reserves where jaguars were sometimes seen and, of course, everyone spoke English. Not so in Venezuela, but there were several places which sounded promising, mostly on private land where the owners were attempting to conserve their wildlife.

I decided to go for Venezuela and started to research the possibilities in that country. Peter gave me a few contacts, and from them, in time, I received much useful information. Meanwhile, Dave Usher, the founder and owner of the fine-art publishers The Greenwich Workshop, had been hearing about our adventures in Asia. He decided that, since his company was footing a large part of the bill, he didn't want to miss any more trips and would accompany us to Venezuela. The company took over much of the leg-work regarding our itinerary and came up with a plan which would take in four different stops in the comparatively short period that we had at our disposal. Venezuela is a large country with probably more fresh water than most others in the world—huge rivers (the Orinoco and all its tributaries), lakes, lagoons, all creating a serious movement problem for a wide-ranging trip over a short period. It was decided, therefore, that we should rent a light aircraft.

• • •

Our adventure began at the Hilton Hotel at John F. Kennedy Airport in New York. It was the rendezvous for Terry Begg, Dave Usher and myself. A February snowstorm raged outside, and the tropical heat of a South American jungle seemed, at that moment, a very long way away. But the next day it happened, and we landed in Caracas in late morning.

DESCRIPTION AND BEHAVIOUR: The jaguar, or *tigre* in Spanish, is the largest cat of the Americas and the only living representative of the genus *Panthera* found in the New World. The jaguar's pattern differs from that of the leopard by having larger, broken-edged rosettes around small black spots. It has a large head and stocky build, with relatively shorter limbs. More than 85 species have been recorded in the jaguar's diet. Large prey, such as peccaries, tapirs and deer, may be preferred, but a jaguar will eat almost anything it can catch; in the rain forest, it will take mammal prey species in proportion to their occurrence. In many areas, cattle are ranched on what is essentially prime jaguar habitat, and cattle have been the most frequent prey species documented in several analyses of jaguar diet in Brazil and Venezuela. Jaguars are the only big cats which regularly kill prey (especially capybaras) by piercing the skull with their canines. The massive head and stout canines of the jaguar may be an adaptation to 'cracking open' well-armoured reptilian prey, such as land tortoises and river turtles. Although jaguars have been characterized as primarily nocturnal, radio-telemetry has shown that they are often active during the daytime, with activity peaks around dawn and dusk.

LONGEVITY: Average 11–12 years, sometimes up to 20 years.

HABITAT AND DISTRIBUTION: The jaguar, which swims well, is strongly associated with the presence of water. Habitats meeting this requirement range from rain forest to seasonally flooded swamp areas, pampas grassland, thorn scrub woodland and dry deciduous forest. Although jaguars have been reported from elevations as high as 3,800m (12,467ft), they typically avoid montane forest.

The historical range of the jaguar extended from Arizona, New Mexico and Texas in the United States, south to either the Rio Negro (40°S) or Rio Santa Cruz (50°S) in Argentina. In the North, the jaguar's range has receded southward about 1,000km (621mi) and has been reduced in area by about 67 percent. In South America, the jaguar's range has receded northward by well over 2,000km (1,243mi) and has been reduced by about 38 percent.

POPULATION STATUS: The Amazon basin rain forest, some 6 million km² (2.3 million sq mi) in extent, is the key stronghold of the species, and densities may be as high as one resident per 15km² (5.8sq mi). This refuge is of sufficient size and integrity to conserve the species in large numbers for well into the forseeable future, even if densities are lower.

PRINCIPAL THREATS: Deforestation rates are highest in Latin America, and fragmentation of forest habitat isolates jaguar populations so that they are more vulnerable to the predations of man. While commercial exploitation of jaguar skins is no longer a factor, people compete with jaguars for prey, and jaguars are frequently shot on sight, despite protective legislation.

Dawn on the Ventuari River, a major tributary of the great Orinoco in Venezuela. In this river, we found fresh-water dolphins.

Once more, my Kenya passport caused problems. Whilst all the other passengers where whisked through immigration with barely a glance, I was directed to a small room and told to wait. No amount of insistent pointing at my London-issued visa would change their minds, and it wasn't until the whole passenger complement had been processed that they came back to me. It was decided that more money was needed so, under escort, I bought some Bolivars and had more stamps put in the passport before being allowed to leave.

Outside the airport at last, we were met by John Salazar of Lost World Adventures, the tour company which was to handle our arrangements. It all sounded very romantic.

My first evening on the South American continent was spent in a waterside restaurant, eating a very large lobster washed down with rum and Coke. Terry, who is allergic to seafood, chose a steak. His first bite produced an astonished expression and a string of curses. This cow must have been chased by jaguars all the way from the Amazon basin to Caracas; we all had a go at chewing through it but had to admit that it would be better used to protect the soles of our feet.

• • •

John Salazar collected us from our hotel in Macuto at 5 A.M. (Macuto is on the coast, twenty miles from Caracas.) Half asleep, we drove through that vast, sprawling city (population 6 million) as dawn was breaking. Some miles further on, we reached Charallave airport, situated dramatically on top of a high ridge. Alongside the runway were many parallel rows of identical light-aircraft hangars with some very expensive airplanes in residence. Apparently, this is oil wealth, but I suspect another trade besides.

Here we were to meet our pilot and guide for the next five days. Boris Kaminsky, owner of Kaminsky Air Safaris, was a sixty-three-year-old Croatian who emigrated to Venezuela in 1954. Our brochure praised his experience and knowledge. As we were unloading our luggage, Boris arrived—medium height, stooped, skinny, thinning hair, piercing eyes peering through thick, rimless spectacles, and wearing a faded flying suit and baseball cap.

His tirade started immediately, and at anything that happened out of the ordinary, he would exclaim, 'Caramba!'. Dave and Terry were standing by their bags, wearing shorts. They were ordered to remove them and change into long pants—something to do with protection against insects. Our luggage, which I thought was the bare minimum, had to be halved: only one small bag per person. All this in an unfriendly, heavily accented voice liberally interspersed with 'carambas'. Dave and Terry went strangely silent; mutiny was in the air.

After John left with our jettisoned belongings, we climbed aboard an aging, six-seater Piper Aztec with Boris grumbling and muttering

about it not being his normal aircraft; his much-loved Aero Commander was away being serviced. When Boris bawled him out for leaning too heavily on the door, Dave's lips were pressed so tightly together that his mouth almost disappeared. Caramba!

Boris fussed about us like an old hen, packing the aircraft with our now-meagre belongings and a large stack of his own bits and pieces, including two big cool-boxes. Was there no food where we were going? We hoped that all these mysterious supplies were equally for our benefit.

We strapped ourselves in, hardly daring to touch anything whilst our captain muttered on about useless travel companies which cannot give proper instructions to their clients. Dave was sitting in what Boris described as the 'copulate's' seat—I think he meant co-pilot. There was some complication with the door on that side; for some reason it would not seal properly when closed, so Dave was directed to do it manually. A rubber tube encircling the door frame had to be pumped up by hand using a device similar to a doctor's catheter; then, it was necessary to stuff a number of Boris's non-too-clean handkerchiefs into the gap between the door and frame, the whole operation requiring consid-

Hodi Indians use the blowpipe, which fires a poison-tipped dart, to hunt birds and small mammals. Below: A typical Hodi hut.

erable dexterity and frequent needling advice from the pilot, who seemed more concerned with this than flying the aircraft. Dave kept glancing round at us with an expression on his face of bemused disbelief. Well, Mr Usher, you wanted adventure.

At last we took off, climbing fast over a deep ravine at the end of the runway into thick cloud cover and heading south-south-west. Dave pumped and Boris fussed over his instruments, all the time grumbling that we were not normal in wanting only to find jaguars. Soon we were above the clouds and leaving the mountains. Below us was a vast, flat countryside with seemingly few signs of population. I was immediately struck by the many lakes and rivers, some of which appeared to be as much as a mile wide.

During the flight, we learned more about our eccentric pilot. He was quite the philosopher—'A bad deal is better than a good fight' and 'Those without work are politicians'. In the course of our conversation, he learned that I had left my passport with John Salazar; it was a snap decision I had made under pressure to lighten my luggage.

'Caramba! You are eediot! You canno' go anywhere in thees crazy country with no passport. They throw you in the jail. Venezuela jail are very bad. I know. I been there. The food is no good. Eet make you go crazy. And the people, they f––k you.' Obviously, I was now relegated to half-wit status, and a small part of my mind worried about what was in store.

• • •

Our first destination was Hato el Frio, a 125,000-acre ranch in Barinas/Apure Provinces in the south-west of the country. One of the few places in Venezuela where serious efforts were being made to protect the wildlife, it boasted a biological station where conservation could be studied. The area, known as the Orinoco Grasslands or Llamo or Savannah, was very flat and marshy. At that time it was relatively dry, and movement by wheeled vehicle was extensively possible. However, by April, when the rains started, large areas would become flooded and accessible only by boat.

We landed on a rough grass strip and unloaded our bags. Boris, still complaining, decided to return to Caracas because he was unhappy about some aspect of the aircraft and wanted to have it repaired. He promised to return the next day. So now I was in the middle of South America without a passport.

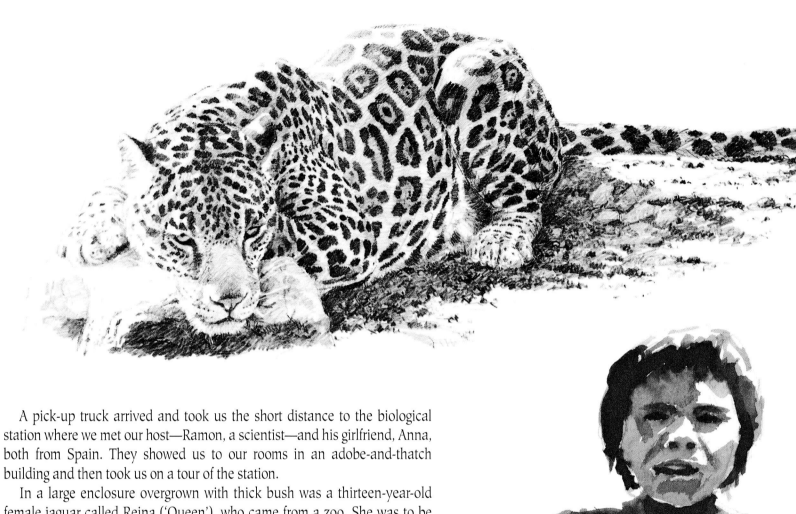

A pick-up truck arrived and took us the short distance to the biological station where we met our host—Ramon, a scientist—and his girlfriend, Anna, both from Spain. They showed us to our rooms in an adobe-and-thatch building and then took us on a tour of the station.

In a large enclosure overgrown with thick bush was a thirteen-year-old female jaguar called Reina ('Queen'), who came from a zoo. She was to be mated with the former inmate of this place, a big male who had been captured on a local ranch. The plan had been to mate them and release their progeny into the wild, but shortly before Reina's arrival, the male escaped. Perhaps understandably, she was elusive and bad-tempered. Growling ferociously at our approach, she charged out of her shelter and launched herself, snarling and spitting, at the wire mesh fence.

Until now, I had been concerned that there would be little difference between jaguar and leopard, but first sight of this one confirmed that there would be no problem. This was a bigger animal, much more thickset, with

powerful forelegs and a heavy head and jaws. The coat was short, shiny and a rich russet-gold colour. The spots were bold, and those on the flanks were large, rough circles with several black dots inside—very different from a leopard's rosettes. Finally, compared to the leopard's beautiful, long tail, this animal's was much shorter with a rather nondescript, tapering tip. Mental note: avoid full exposure of the ugly tail in the painting.

Reina was unco-operative and sulky, hiding away in her little hut, so we toured the rest of the camp to see where they were breeding the rare Orinoco crocodile for subsequent release. In another enclosure was a female ocelot with its kitten. (The ocelot is such a beautiful cat—too small to include in my Great Cat collection, but one that I must paint someday in the future.) A male of the species crouched impassively nearby in a release box. He had been living comfortably off the ranch foreman's chickens until a cowboy lassoed him and brought him to Ramon, who had decided that day to release him. We accompanied this expedition and were amazed that the chicken killer was let go no more than three miles from the scene of his former crimes. No question that he would be back at the chickens before too long.

• • •

As the day cooled, we drove far out onto the grasslands and marvelled at the profusion of wildlife. Iguanas scuttled in an ungainly fashion away from the road whilst others rested in the branches of trees. Every pool held a large

A cayman from the swamps of the Orinoco grasslands cools itself by lying with its mouth open. At our approach, it slithered into the water.

population of turtles and flocks of water birds—ducks and geese, spoonbills, bitterns, herons, egrets, Jabiru storks, cormorants and the outrageously coloured scarlet ibis. In larger stretches of water were groups of capybara, the world's largest rodent and probably number-one prey in that part of the world for the jaguar. Apart from being ugly, they appeared to be really stupid, and in both those respects they reminded me of Africa's wildebeeste, which I consider to be one of the dumbest animals in the world. On reflection, I realized that both animals have their eyes set high in the skull, maybe so high that there is little room left for a brain. My apologies to wildebeeste and capybara fans.

Caymans were much in evidence, lying on the banks with their mouths agape. They seemed relatively unconcerned at the closeness of the vehicle. I was told that jaguars also consider these to be fair game, along with anacondas and turtles; the latter, they crunch like popcorn in their powerful jaws. My respect for this cat was growing.

In a clump of tall mango trees, we saw a noisy flock of screeching, squawking, scarlet macaws and, hidden in the topmost branches, a small troop of howler monkeys with their pitifully sad faces. Nearer the track,

The outrageously coloured scarlet ibis congregate in huge flocks and mix with the white ibis to roost, creating a striking contrast of colours as darkness falls.

scuttling through the grass like a clockwork toy, was an armadillo which rolled into a tight ball when we came too close.

Further on, the driver braked and jumped from the vehicle, excitedly waving his arms and sprinting towards a wide lagoon some fifty yards from the track. Suddenly, we saw the object of his animation: a large, black-and-white, long-haired animal running towards the reeds at the water's edge. This was a giant anteater—something of a rarity, we were told. In Africa's parks, you stick to the rules and stay in your car. Here, the rules are different—anything rare or unusual must be chased. . .on foot.

We headed towards the edge of a vast marsh which seemed to stretch to the horizon. Wild asses and deer cantered through the tall grass; a fox slunk away in the distance and some small burrowing owls stood at attention close to their holes, glaring at us in wide-eyed indignation. Dusk was approaching as we drew up to a slight rise at the edge of the marsh, seemingly the only high ground for miles in any direction. It was topped by a number of stark, guano-stained trees which already were beginning to fill with roosting birds. As the light faded, more and more egrets, scarlet ibis and cormorants flew in formation towards these trees to roost for the night. The sound of thousands of birds arguing about who should sleep where and with whom and generally discussing the day's business grew to a roar as the sun gradually slipped below the horizon. I have an enduring impression of trees full of snow-white and bright scarlet birds glowing dramatically in the evening light. It was breathtaking.

• • •

At first light, I was hoping to catch Reina in a more co-operative mood. She was not in her little hut,

but eventually I located her in dense undergrowth in the center of her enclosure. How could I ever see this animal in the wild with such camouflage? From ten yards she was almost invisible—only the flicker of an ear gave away her position. Sunlight filtering through the branches onto her dappled coat blended her perfectly into the background.

Finally, patience paid off and she moved to a more open part of the enclosure. If I moved suddenly, she snarled a warning, and if I approached too close, she would fling herself at the wire, eyes wide open and bulging with fury, ears laid flat against her head. If this animal had been raised in captivity, it should have been more amenable to humans. Her behaviour made me wonder if, perhaps, she had been mistreated at some point.

Not knowing if the next few days would reveal a jaguar in the wild, I took as much film as possible and filled several pages of the sketch-book with quick drawings.

After breakfast we were taken fishing. Our guide stopped at a lake, removed his shoes, rolled up his pants, waded in knee-deep and whirled a chunk of raw meat on the end of a hand line into deeper water. In seconds, he tugged at a bite but missed. I was on my way to join him but thought I had better ask what we were fishing for. 'Piranha,' he said nonchalantly. I started moving back towards the shore, but he grinned and reassured me that at that time of year, when the water was still quite high, the fish were not dangerous. Only when levels got really low and competition for food intensified, would they sink their vicious little teeth into anything.

We caught several, taking extra care when removing the hooks from their mouths, and those, together with a few catfish, were fed to the ocelots when we returned to camp.

• • •

Boris returned and, at the hottest time of the afternoon, supervised the stowing of luggage in the aircraft prior to take-off for our next destination.

We climbed aboard and sweltered as he carried out his checks: engines started, a final glance at the instruments, wiggle the rudder and ailerons—BANG! Caramba! Several objects hit the starboard propeller and flew off to the rear of the plane. Boris closed down the engines, a look of consternation on his face, and Terry, Dave and I went very quiet. It seemed that our finicky captain had failed to close the luggage compartment in the nose of the aircraft, so the wind blew it open as the props reached take-off speed, and out came some smaller items—luckily, nothing of ours and nothing vital. We reflected on the consequences had this happened once we were air-bourne and decided that they did not bear thinking about. Terry was now in his element. He was giving poor Boris all kinds of flak, relishing the chance to repay some of the carping and sniping that our pilot had been handing to us since we left Caracas. Boris took the teasing well and then concentrated on our flight, which took us eastwards across the great Orinoco, through a heavy tropical downpour to a dirt strip on the edge of the jungle. This was Camani. Three Indians in a Toyota Land Cruiser drove out to meet us as we taxied to the end of the strip. We were taken to the very smart Camani Amazonas Lodge on the banks of the Ventuari River, one of the Orinoco's tributaries, and shown to our individual cabins by Gisela, the camp manager. This place was owned by a wealthy Italian and run specifically for fishermen, who came to catch the famous rainbow bass and catfish which can grow to reach 150 pounds.

No time to look around—straight down to the river bank and into a long canoe driven by a forty-horsepower outboard. This was much more the kind of terrain I had expected. The river itself was about 175 yards wide at that point—an enormous volume of brown, sluggish water. The banks were steep, and tall trees grew right to the edge. We could see no wildlife—save the occasional bird—as the Indian boatman headed fast upstream.

After half an hour, we turned into a narrow tributary, cut the speed slightly and nosed through a tunnel of undergrowth. It was now late afternoon and the light was going fast, but here was the kind of situation that I had pictured in my mind for the jaguar painting. Here was the dark, tropical, riverine undergrowth where I imagined that this tough cat would lie in ambush for its unsuspecting prey. Herons, disturbed at our approach, rose on silent wings and flew away into the gloom. Occasionally a splash was heard, and widening ripples showed where a cayman had slid into the water leaving just its eyes exposed to monitor our progress. But I needed better light than this and asked if we could return the next day. Boris complained that we were crazy and should forget this jaguar madness. Why not go fishing or visit the beautiful waterfalls which he could show us, half a day's boat ride away? I wished we had the time.

This was a true, hot, steamy jungle in every sense of the word. When I lifted the toilet cover, several small, brightly coloured frogs leapt in all directions. The air was alive with insects and loud, exotic bird calls, including that of the spectacular toucan.

After several iced beers drunk whilst lounging in the tepid swimming pool, we were treated to Kaminsky's specially mixed gin and tonics to accompany Gisela's gourmet creation of catfish and peacock bass.

• • •

At 5.30 A.M., we were summoned to the kitchen area behind the camp. In the semi-darkness, a wild tapir with its half-grown calf had emerged from the jungle to eat bananas which the cook left out the night before. They had been coming there for a long time and had finally learned to trust man.

Before sunrise, we were taken through the jungle to a small hill on top of which a lookout post had been built. One of our Indian guides had observed a jaguar from this place when he spent the night there not long before, but this time we were not so lucky. The steep climb was a brutal reminder of how unfit we all were, but the view from the top, looking over the treetops

toward the great river as the sun appeared over the horizon, was worth the effort. Monkeys were chattering in a nearby tree, and a toucan flew close to show us its immaculate markings.

I was intrigued to see jacaranda, guava and frangipani trees growing wild in this jungle. I grew up with these all around me in Africa and tend to forget that they were imported originally from South America. Our Indian guide found a carania tree and on its trunk made a foot-long, diagonal gash from which a white, sticky sap started to flow. The sap is used to heal wounds and, indeed, smelled much like the Germolene ointment with which my mother used to anoint my many cuts and abrasions. Our guide also lit some on the ground and showed us how it burned like kerosene. Next was the pendare tree, which produces a rubber-like sap that the Indians chew like chewing gum.

We trudged through the sticky heat to a lake which was supposed to be full of crocodiles. The Indians called them by using their lips to make loud sucking noises which were supposed to sound like young crocs. Like a chronic case of tinnitus, cicadas kept up their constant, monotonous whine; macaws screamed, herons croaked, kingfishers scolded and monkeys growled. The jungle's cacophony.

We returned to the small tributary of the previous evening, and this time the light was good. There were many places at the water's edge where I could picture my jaguar, but would we see the cat itself?

We found a part of the river bank which had been burned, and it was explained that this was where a group of indigenous Indians had probably carried out a recent hunting foray. A hunting party will move into a suitable area, set nets and then drive all the animals

toward them using noise and fire. They will also drive fish up these smaller streams into nets which have been pegged across their width. After several days of this they will paddle their canoes, laden with fresh meat and fish, back to their permanent villages.

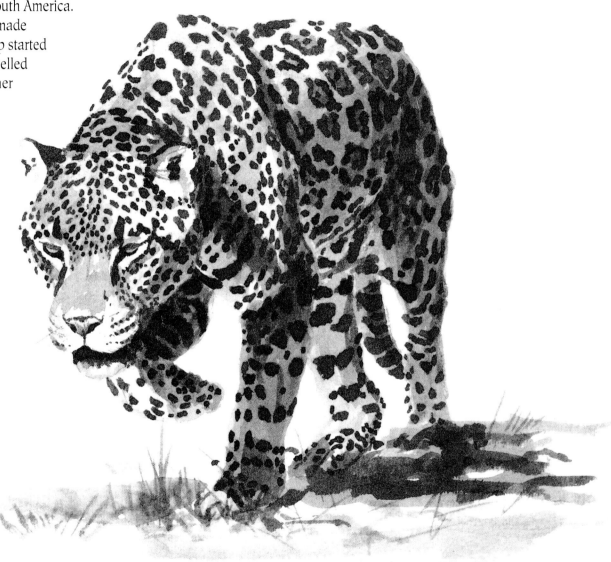

We left Camani and flew without mishap the twenty-five minutes to Yavi, a 20,000-acre cattle ranch owned by a renowned jaguar hunter. At the end of the strip were an ancient DC-3 and an outlandish jeep painted with zebra stripes, with rows of seats in the back under a striped awning—a sort of mechanized Surrey-with-a-Fringe-on-Top. We were met by Lars, a young Danish mechanic, and driven the short distance to a kind of game lodge where we were introduced to the owner, Herman Zingg.

Herman was an interesting character. He answered my polite question about his ranch and cattle by saying that his only reason for keeping them was to provide prey for jaguars so that he could then wait up for and shoot them. The DC-3 was evidently part of his other interest—flying 'freight' to and from the Caribbean and Miami. He had made several hunting trips

to East Africa and named two close friends of mine who had acted as his professional hunter at one time or another. Obviously, his lodge—where we would stay—and the zebra-striped jeep were ideas borrowed from his trips to Africa. I think we were guinea pigs—the first to stay in this place which he hoped would become a much-used safari camp.

Lars and a pair of Indians drove us down to the river which flowed through the ranch, and we set off very precariously in an outboard-powered, dug-out canoe to search for jaguars. We wobbled along dangerously, taking in water, and I began to calculate my options in the event of a capsize. Saving the camera was Plan A but that would be fast forgotten at the first bite from a piranha, which would activate Plan B—to break the world swimming record and to hell with the camera. Caramba! Lars may have been a good mechanic but he was a lousy boatman, and it was a relief to get back to dry land and the zebra-striped monstrosity.

It had been a long day. Boris rounded it off with several Kaminsky Specials, a refreshing but highly intoxicating drink using white rum and grapefruit juice. The rest of the evening was spent going through photo albums of hunting trips and trophies with Herman and his very beautiful wife, Nieves.

• • •

The zebra-striped jeep bounced uncomfortably across country at dawn with Herman, at the wheel, telling us that there was a strong likelihood of seeing a jaguar at this early hour. I squinted into the sunrise as we crashed through scrub and grass, some even taller than the vehicle. Excitement rose at one point when I detected movement half a mile ahead, but the binoculars showed it was only a fox. Strange how dawn's clarity can often distort and make things look larger than they really are.

We found fresh jaguar tracks in the wet mud on a river bank where the animal had swum across. It was confirmation that they were there, but would we ever see one? I had my doubts because both the vehicle and its occupants were so noisy that any sensible cat would have run a mile. Nevertheless, there were times when I had the distinct feeling that somewhere in the shadows a big, spotted cat was watching me.

Our early-morning search became yet another fruitless exercise as far as jaguars were concerned, but the scenery was beautiful. The whole area was

dominated by Yavi Mountain, an impressive, flat-topped, 8,000-foot mass of rock which glowed red in the rising sun.

It was a Saturday, and Herman had invited a group of people to fly in for the weekend from Caracas. Very graciously, he asked us to join his family and so, after breakfast, we set off for the first of the weekend's activities: a picnic at a nearby waterfall. They did things in style at this place. Large hampers of food and drink were taken in the jeeps and carried up to the waterfall along a steep, rugged, rocky trail for about half a mile by Indian servants. These were all short, stocky men who carried the hampers on their backs, some looking even larger than the men themselves. When I offered to help, they looked at me in astonishment.

Along this trail, they showed me the crushed, empty shell of a turtle eaten by a jaguar and, on the trunk of a tree, deep, parallel gouges where the cat had sharpened its claws.

A series of waterfalls cascaded down more than a thousand feet to a large, crystal-clear pool which was refreshingly welcome as the day became hotter. All the time I was still seeking the perfect setting for a jaguar.

● ● ●

Herman described how his father had taught him to call jaguars, so that evening we set off for a place where he said there had been a sighting in the past few days. We positioned ourselves on a rocky outcrop overlooking a still lagoon, and Herman produced the special instrument with which he would call the cat. This was a gourd into which he grunted and growled, the sound being magnified by the vessel's hollowness. He assured us that it would work and cautioned us to sit very still but did not explain what we should do if a large male jaguar arrived to chase the 'intruder' out of his territory.

Every ten minutes, Herman roared to the accompaniment of ten thousand mosquitoes and other assorted bugs which had gratefully discovered four strangely acquiescent meal tickets. After two hours, Herman reluctantly admitted defeat, and we could exercise stiff muscles and scratch a host of itches. Back at the lodge, a couple of Kaminsky Specials soon cured the problems.

The rest of the evening was a study in elegance and high living in the middle of the wilderness. Servants produced the biggest joints of roast beef I have ever seen and jugs full of wine which we all consumed whilst sitting

Jaguar tracks in the muddy bank of a stream near Yavi, Venezuela. Below: The spectacular Angel Falls, one of the world's highest waterfalls.

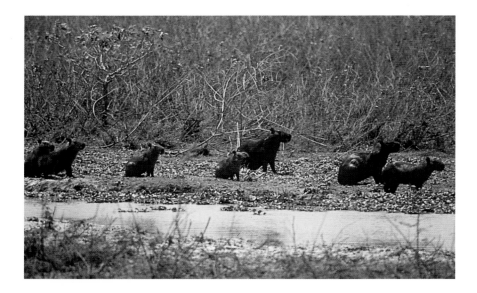

Capybaras, the world's largest rodents, spend much of their lives immersed in swampy water. Below: Our driver braked violently, shouted something in Spanish, flung open the door and set off in hot pursuit of this tiny, inoffensive animal, the armadillo. In East Africa, this would bring instant ejection from the national park, but in this privately owned ranch, they made their own rules.

round a long table on the verandah under the stars. The sophisticated Venezuelan guests told derogatory stories about Cubans, Argentines and other South American peoples. The wine flowed, and I was befriended by their pet spider monkey, Chita, who spent the evening desperately trying to console me after I made one of my special little high-pitched squeaks.

Boris had taken us to one side and given instructions that under no circumstances were we to tell anyone our destination for the next day—which was pointless because we didn't know anyway, but it lent an air of mystery.

• • •

So this was the mystery day. Leaving Yavi behind, we flew just thirty minutes to a small strip hacked out of the jungle. As we circled before landing, Boris explained that this was San Jose de Kayama Catholic Mission in Bolivar State. Looking out the aircraft window, I could see neat rows of huts amongst the trees. Like ants swarming from a disturbed nest, lines of tiny, brown figures were running from the huts towards the airstrip, and when the aircraft drew to a halt, it was immediately surrounded by a chattering throng of naked, excited Indians.

Boris told us that he had been flying to this mission for a number of years and had helped the nuns from time to time by bringing in supplies and medicines. Obviously, he was a familiar figure, and a short distance from the strip was a conical, thatched hut which he had been permitted to build as his own lodge. It seemed that we were quite privileged to be there.

These were people from the dwindling Hodi and Enepa tribes (only between 500 and 1,000 remain), two groups of Paleo-Indians, very primitive and untouched by outside influences. The mission was run by three nuns, one from Venezuela and the others from Columbia. It was emphasized that they were not trying to force an alien way of life on these people; rather, they were there to improve their diet by encouraging the growing of such things as citrus fruit, and, of course, to preach the gospel—which, with great respect, seemed a bit of a contradiction, but that is simply my own opinion.

We carried our bags and food the short distance to Boris's hut with him acting the parts of George Patton and a mother hen. Terry threw a fit of mutinous sulks after Boris bawled him out for some minor misdemeanor, but eventually we all assembled in the hut to be given a schoolmasterish lesson on how to

sling and sleep in a hammock. We had been preparing for this for days, and Terry had talked himself into several nights without any sleep at all.

The hammocks were very large and beautifully made. Each was slung between the hut's central pole and the outer wall. That part was easy, but the complications came in cocooning the entire thing with a mosquito net which must not touch the floor. It was an ingenious contraption and we were told that, after lunch, there would be a compulsory trial.

Meanwhile, we walked the few yards down to the Kayama River and swam with a group of Indian children. They stripped off their skimpy loincloths and, because it is considered rude to flaunt the male organ, concealed it by lifting the scrotum over it and tying the whole thing tight by a string of woven human hair round the waist. This entire operation made my eyes water. I had no idea what the women did because none swam with us—which is just as well because Boris, having none of the Indians' inhibitions, stripped naked and caused much hilarity, not so much for his lack of delicacy but for the inordinate amount of hair that covered his skinny body. Caramba!

After our swim, we crossed the river in canoes and, guided by a gang of naked children, trekked for two hours through the jungle to a beautiful waterfall and rapids. Along the way we came to an Indian house in a clearing where a young man demonstrated his blowpipe. It was a cleverly crafted weapon about ten feet in length, a reed tube carefully and intricately inserted inside a second tube. This gave it a laminated effect and strength and rigidity. The darts were ten-inch-long slivers of bamboo, one end needle-sharp and the other wrapped with a small ball of kapok to ensure a tight fit inside the tube. A twelve-inch-square target was placed at one end of the clearing, and we all managed to hit it first time from a distance of twenty paces. The Indians coat the tips of the darts with curare poison and use them to hunt birds, monkeys and small mammals. In the bushes around the hut were piles of brilliant blue and red macaw feathers, all that remained of the birds which had been shot and eaten. My lasting memory from this incident was Terry Begg, who hit the target and then tried to teach his Indian instructor how to do a 'high five'.

It was an education to walk with these people through the jungle. In the same way that you or I would walk through a supermarket, taking from the

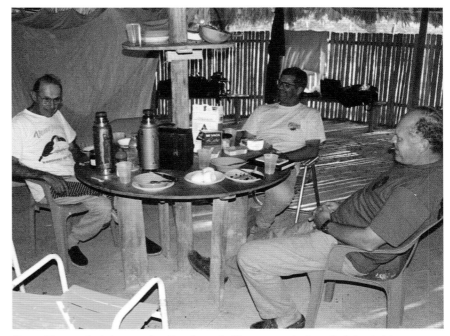

Boris Kaminsky's hut at the San Jose de Kayama mission. Left to right: Boris, Terry Begg and myself.

shelves whatever it was we currently needed, so the jungle was theirs. Certain leaves, bark, fungi, insects—all were collected. At one point, a small boy dashed into the undergrowth and returned with the foot-long, tapered, clay funnel from a termite colony. He bit off a small part of the narrow end, then put the funnel to his lips and gleefully played it like a trumpet.

At the waterfall, we swam again and became aware of a minute but voracious fly which seemed particularly to enjoy biting the thicker skin on one's elbows. It resembled the 'no-see-'ems' of Florida in both size and bite, and before long we were all scratching. Boris was wagging his finger wisely and reminding us of our foolish attempt, back in Caracas, to wear shorts for this trip.

Back in the hut that afternoon, we were ordered to our hammocks by Captain Kaminsky for a compulsory nap. I was surprised to find out that the proper way is to lie at right angles to the direction in which the hammock is

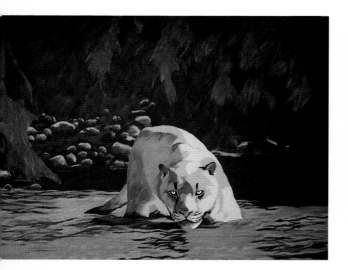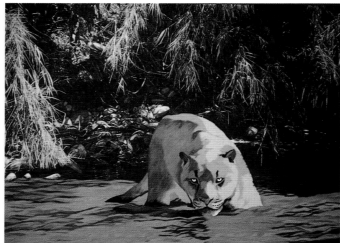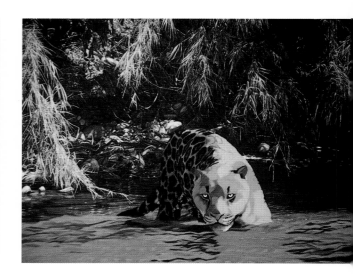

slung and, sure enough, it was extremely comfortable. There was no sag which would have caused serious backache and, of course, these were proper hammocks, wide enough across to enable a person to sleep that way. So we each settled in with noisy, skeptical complaints from Terry that he would never sleep. In less than a minute, however, loud snores were heard coming from the direction of his hammock.

• • •

We invited Sister Theresa and the other two nuns to dinner in the hut, where Boris broke open one of his cold-boxes and produced sirloin steaks. It was a strange evening and quite a cosmopolitan gathering: a Venezuelan of Croatian descent, a Kenyan of British descent, one Venezuelan and two Colombian nuns who spoke no English, an American and a Canadian. We all sat round a small table in the center of the room whilst about thirty Indians watched us from their positions against the walls.

I tried to communicate with some of the children by drawing pictures of monkeys and parrots and jaguars in my sketch-book. They laughed and pointed and then created their own impression of the aircraft and of Boris, which was reminiscent of the Mayan art I had seen in books. It was particularly amusing to see how well they endowed our gallant pilot.

They explored our bags and discovered my hairbrush with bristles mounted on a flexible, convex rubber cushion. This one item caused more interest than any other, and everyone had to have a go at brushing their long, black hair, accompanied by loud shouts of delight.

• • •

We bade farewell to the nuns up at the mission and walked down the hill to the airstrip like a bunch of Pied Pipers trailing a long line of children. Visiting these friendly, happy, innocent, naïve and frighteningly vulnerable people had been a moving experience. I wondered how long they could resist the corruption of so-called civilisation. We flew away in pensive silence, lost in thought over what had been a unique and precious adventure.

• • •

Our last port of call was Uruyen, in an area known as the Gran Sabana. This was simply a lunch stop—a neat thatched building on the edge of a crystal-clear river at the end of a long plain covered with golden-yellow grass. A few miles away were towering mountains shaped like mesas. Boris stripped naked and dived into the river. It appeared that swimming was compulsory, but I was more interested in the bamboo-like undergrowth which hung over the water and inspired imagined jaguar paintings.

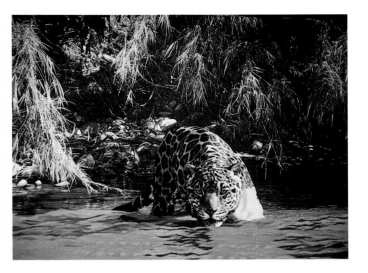
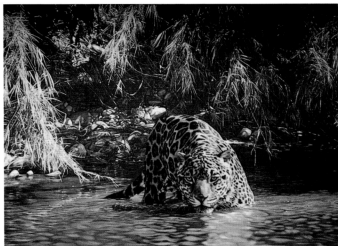

After lunch we took off for the last and most dramatic leg of our long series of flights. We climbed and climbed high into the mountains and, suddenly, ahead of us, there was the most spectacular waterfall plunging thousands of feet into a distant cloud of spray below. This was the famous Angel Falls, and Boris flew in close to give us a sensational view. The fact that he was exercising this manoeuvre whilst peering myopically from very close range at his instruments was a bit disconcerting, but we survived. Definitely, this was a fitting final act.

• • •

I was disappointed not to find a jaguar in the wild. We visited the zoo in Caracas, and my stomach turned to see the conditions in which the big cats were kept—small cages holding big cats which were overweight, lack-lustre and bored. The experience was made more poignant because I had just been in the wilderness where they rightfully belonged, but I had to swallow my prejudice and realize that I needed to work with captive animals in order to create this painting.

In fact, Terry and I found a wonderfully fit, healthy, fierce-eyed specimen back in California the following week, which helped a great deal toward the creation of my jaguar painting, *Eyes of Warning.* The bamboo-like bushes overhanging the river at Uruyen on our last day provided the best background to this chunky, tough cat which I portrayed standing in water and glaring out belligerently as if to say, 'Come no closer'.

A week after returning from Venezuela, Terry and I flew from his home in Boise, Idaho, to California to research captive jaguars. We flew Morris Air, which operates on a first-come, first-served basis. Instead of seat allocation, one is given a number which indicates the order in which you will board the aircraft. We were early so were given low numbers and, indeed, managed to secure a row of three seats. As we sat facing forward and other rows began to fill, it seemed that those passengers boarding late were invariably vastly overweight. Accordingly, we made a quick plan to prevent the next three-hundred-pound human mountain from sharing our space. The Venezuelan 'no-see-'em' bites on our elbows had developed from a mild irritation to an itch so maddening that you wanted to tear the skin physically off your body, and the elbows themselves were covered with a mass of angry, festering lumps—so, as each potential seat-sharer puffed his or her way down the aisle, we casually scratched our heads, with pox-ridden elbows exposed for all to see. It worked perfectly and proved the old adage that some good always comes from adversity.

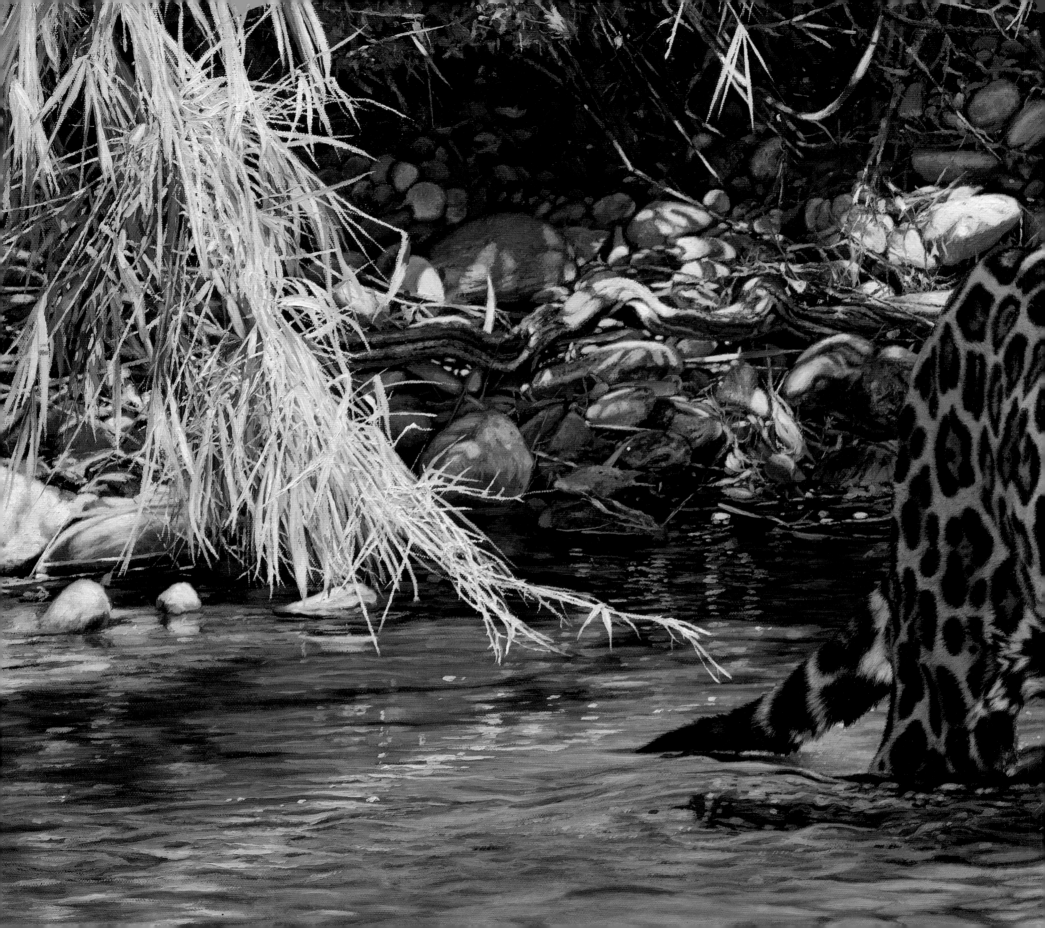

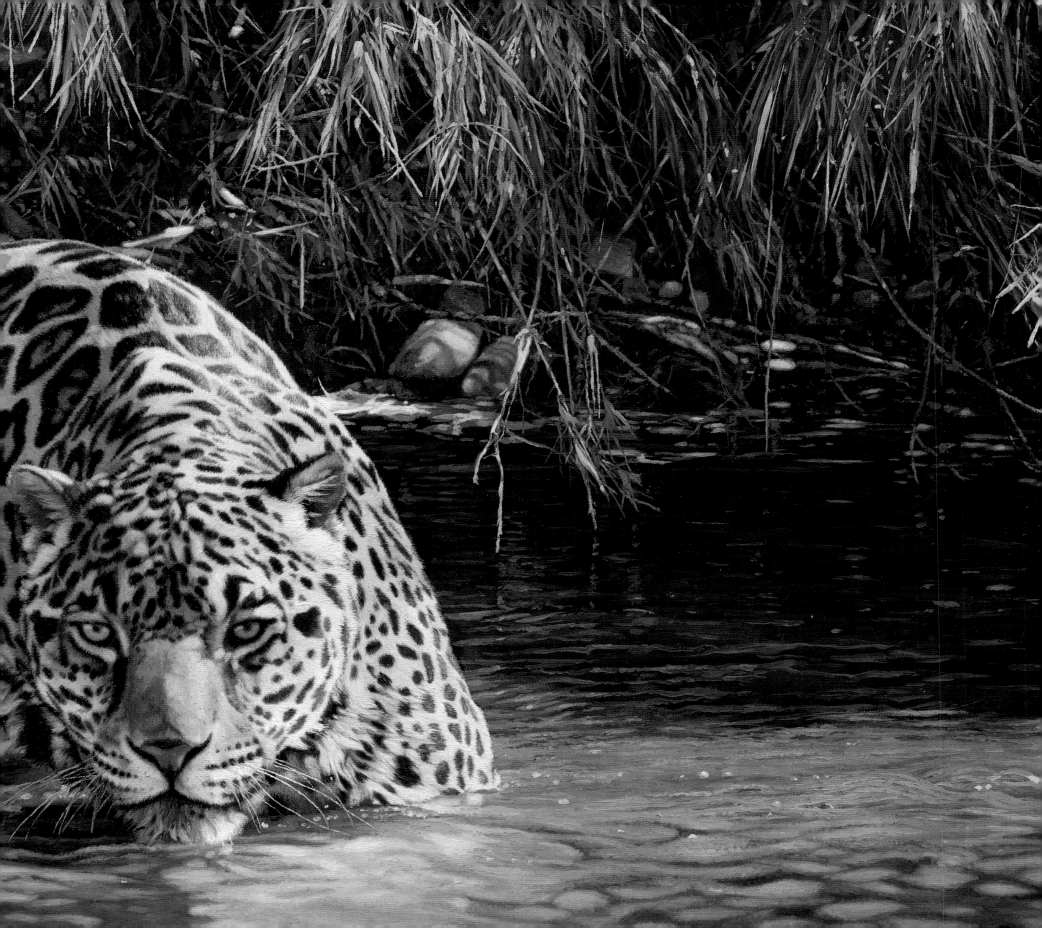

CATS OF

THE PLAINS

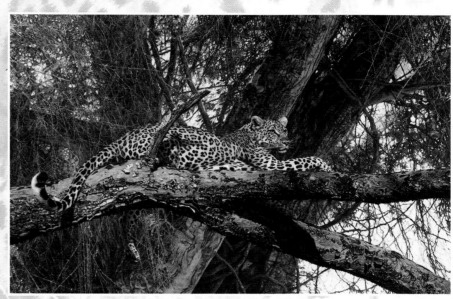

LION • CHEETAH • AFRICAN LEOPARD

LION

PANTHERA LEO

Lions are the only big cats which live in family groups called prides and which have manes and a tassel on the end of their tails. Lions are synonymous with royalty, majesty and nobility, and have been featured in art, legend and folklore since time immemorial. Christians were fed to them in Roman times, and a Masai could qualify for warriorhood only if he had partaken in a successful lion hunt.

I have mixed feelings about the lion's much-vaunted reputation as King of the Beasts. A big, black-maned male in his absolute prime, lying on a rock in the early morning sun with his head held proud and his amber eyes gazing benevolently out over the plains, is indeed a sight to behold—but, in actual fact, he is lazy, a bully, a chauvinist and a lousy hunter, and his table manners are atrocious. Of course, I am indulging in a bit of anthropomorphism in comparing lions' behaviour to that of us humans. I realize that a lion has to behave that way to maintain his status in the pride and save his energy for the more important tasks of procreation and protection of his exalted position. Nevertheless, the male lion often makes a complete ass of himself. I have watched a pride kill a warthog. The male took no part but was quick to arrive on the scene once the prey had been secured. He wanted it all and barged his way through the throng of wives and kids to park his massive body firmly on top of the carcass. Once there, he let the world know that this was all his, growling ferociously and spreading his legs as wide as possible to prevent any other lion from getting near. He didn't eat—he was much too occupied with growling. Gradually, his lionesses crept closer from either side, each inch forward producing terrifying snarls from his lordship, but with great patience, they persisted and slowly started to eat the hog from underneath him until it was almost all gone. What a fool. He was left with a few scraps of skin and bone and, to my mind, his dignity in tatters.

One night, to the north of the Masai Mara Game Reserve, I was invited to accompany an American scientist who had previously recorded on tape the magnificent roaring of lions. He wanted to show me the significance of the roar to proclaim territory and challenge intruders. We switched off engine and lights in the middle of a large plain and began to play back the recording at high volume. Deafening roars

DESCRIPTION AND BEHAVIOUR: Called *simba* in Kiswahili. Adult males (>4 years) average 181kg (399lbs) and adult females, 126kg (278lbs). A male shot near Mount Kenya in 1993 weighed 272kg (600lbs). The record total length (including the tail) for a male lion is around 3.3m (10.8ft). Lions have uniformly tawny coats and are the only cats with tufted tails and manes (males only).

The core unit of the lion's matrilocal society is the pride, which consists of a group of related females (none dominant) and their cubs. Pride sizes (measured by the number of adult females) are smallest in very arid environments (mean 2.2) and otherwise average 4–6. Pride size is positively correlated with lean season prey abundance, and in the Ngorongoro Crater, where prey is abundant year-round, groups of up to 20 adult females have been observed. Pride members often give birth in synchrony, and the young are reared communally, with cubs suckling freely from lactating females. Groups of females do most of the hunting, and males, for the short time that they are living together with the females, concentrate their energy on defending their tenure. A single male or coalition of males (up to 7) holds tenure over one or more prides, and effectively excludes strange males from siring cubs with pride females. Competition among males for pride tenure is intense, and average tenure is only 2–3 years.

LONGEVITY: Males generally 12 and up to 16 years, females generally 15–16 and up to 18 years.

HABITAT AND DISTRIBUTION: Optimal hunting appears to be open woodlands and thick bush, scrub and grass complexes, where sufficient cover is provided for hunting and denning. The lion formerly ranged from northern Africa through south-west Asia, where it disappeared from most countries within the last 150 years; west into Europe, where it apparently became extinct almost 2,000 years ago; and east into India, where a relict population survives today in the Gir Forest.

POPULATION STATUS: Guesstimates range from 30,000 to 100,000. East and Southern Africa are home to the majority of the continent's lions. The countries in which lions are still relatively widespread are Botswana, Central African Republic, Congo, Ethiopia, Kenya, Tanzania and Zambia.

PRINCIPAL THREATS: Lions are generally considered serious problem animals whose existence is at odds with human settlement and cattle culture. Their scavenging behaviour makes them particularly vulnerable to poisoned carcasses put out to eliminate predators.

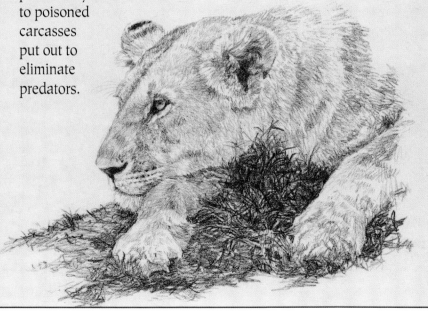

Ngorongoro Crater, viewed from the southern rim. This near-perfect caldera, with its lake bordered with pink flamingos, swamps and plains teeming with animals, is considered one of the natural wonders of the world. Below: A typical kopje in the Serengeti. These extraordinary piles of rock are thought to be the tops of ancient mountains, covered by ash from cataclysmic volcanic eruptions.

emanated from the speakers for a few minutes. The exercise was repeated a couple more times, and then we switched on a spotlight and swung the beam around our position. A hundred yards away, two male lions were running towards us, silent, manes bristling, and obviously busting for a fight. Ignoring us completely, they charged past the car unerringly in the direction from which they thought they had heard the roaring. When they had run about two hundred yards, we switched on some more roars. The result was comical. They stopped dead, spun round and charged back towards us, straight past the car again. We might as well have not been there. These two were only interested in foreign lions. We could have gone on all night, and those two fools would have charged back and forth, back and forth, until they dropped.

But I must not be too unkind to the male of the species. They do have a tough job to perform, and to witness two mature males fighting for their lives and livelihood would soon dispel any doubts about their abilities. This is an awesome event and a fearsome demonstration of sheer power, strength and ferocity, often ending in death for one of the protagonists.

Lionesses, on the other hand, have my complete admiration. They are the hunters and providers. They are the ones I love to paint because they are so often demonstrating the stealth, the alertness, the tension and the intensity which give a composition drama and atmosphere.

• • •

It was February. In partnership with my friend Alan Binks, I was guiding a photographic safari through the parks of Kenya and northern Tanzania.

We circled the rim of Ngorongoro Crater and paused on the western edge to gaze in wonder at one of Africa's most breathtaking views. Fifteen miles away and several thousand feet lower, the jagged scar of Olduvai Gorge cut across our front, disappearing into a flat plain which once was the bed of a great lake. Maybe our early ancestors, whose fossilised remains have been found at Olduvai, lived along the edge of this lake.

Stretching away beyond Olduvai into the distant haze was the vast Serengeti, formed 5 million years ago when massive volcanic eruptions occurred at Ngorongoro, where we now stood, and at adjacent volcanoes. Volcanic ash was blown to the north and west, covering 7,500 square miles and engulfing mountains, valleys, lakes and rivers.

As we descended the slopes of Ngorongoro, the cool, crisp, fresh mountain air changed rapidly to a shimmering, dry heat. At midday we paused at Olduvai, where the wind whistled through stunted thorn scrub and eyes stung with the dust and glare. Nothing, except the occasional crazy tourist, moved at this time of day. Colours seemed bleached by the overhead sun, and the landscape appeared to lose all depth.

• • •

Our temporary home was in the lee of a small *kopje*. This Afrikaans word for 'small head' or 'hill' aptly describes the many small features which dot the Serengeti plains. They are like islands in a sea or oases in a desert and generally occur in groups with such colourful names as Simba, Barafu, Gol and Moru. It has been speculated that they are the tips of mountains which were all but covered by ash from the great eruptions 5 million years ago.

This was indeed the ancient face of Africa. These great boulders, seemingly dumped by some impetuous giant in the middle of the plains, are piled one on top of the other in a manner which defies imagination. Some appear to teeter precariously on the point of rolling off. How did they get there? How did a round boulder weighing thousands of tons come to be balanced so delicately on an even larger but equally rounded rock? Perhaps one could picture an immense upheaval pushing and crumpling the earth's crust, and unimaginable forces piling rocks the size of houses one on top of the other; then, millions of years of erosion by wind, rain and sun wearing them down to round smoothness.

I had read that Lake Victoria (only sixty miles to the west) was three hundred feet higher a mere 1.3 million years ago. I wondered if these kopjes were then surrounded by water. I was also told that some rocks in the Serengeti are more than 3,000 million years old. Maybe I was looking at one now which had witnessed the emergence and evolution of life from the time that the first reptiles developed legs and crawled from the water onto dry land. Maybe this rock was leant upon by a seventy-foot-long *Brachiosaurus* or brushed against

by a *Stegosaurus* with sail-like plates along its back during the Jurassic period some 150 million years ago.

The kopjes are a naturalist's dream. Rain-water gathers in rock pools and attracts many birds and mammals. Seeds deposited by birds over the years and watered by run-off from the rocks have developed into magnificent acacia trees and wild figs, the multitudinous white roots of which cling to the round rocks like the tentacles of an octopus; these, in turn, provide shade and protection for various animals. Lions and cheetahs use the kopjes as lairs or vantage points. Hyrax (sometimes known as rock rabbits or dassies) make their homes in the crevasses, and moisture from their urine and drop-

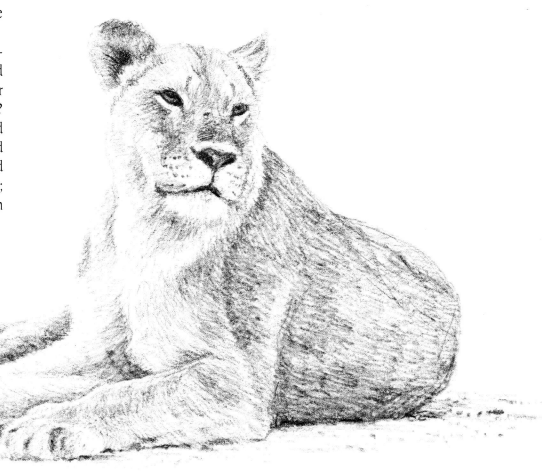

pings over the years drips down the rock faces, creating vivid white and ochre stains. Red-headed, blue-bodied agama lizards scurry across the rock faces performing press-ups to impress the drab, brown females of the species.

• • •

Seronera is roughly in the center of the Serengeti National Park. At that time of year, it was flush with long, green grass and alive with the noise of a multitude of insects and birds, all frantically mating or feeding their young, taking advantage of the abundance of food available after the rain. Impala, reedbuck, waterbuck, buffalo and giraffe were all here, but no wildebeeste. The great herds, for which the Serengeti is so famous, were still eating the short, sweet grass on the plains to the east. Seronera's long grass would keep for drier times when the short-grass plains were eaten flat.

Lions are numerous here but these were hard times. When the wildebeeste migration arrives, the lions live the life of Riley but when they leave, the prides must resort to tougher, more dangerous prey such as buffalo, or more elusive animals like antelopes or warthogs. During our third night at this camp, I was woken at 3 A.M. to the grunts and small moaning calls which lions use to communicate within the pride. Sitting up slowly, I peered through the window of my tent at a landscape lit brightly by a full moon. Two yards away, a lioness stood staring straight at me, and beyond her I could see many other members of the pride; it is at times like this that you become acutely aware of how thin the tent canvas really is. Then, a moment of farce: someone in a neighbouring tent broke wind, and the whole pride took to their heels like so many scared rabbits. I should remember that when I next come face to face with lions, although I would probably produce more than just wind.

The last day of our safari found us in a place which I consider very special—Moru kopjes, some twenty miles south of Seronera. The road is formidable if wet, so we set off with some trepidation, but once past the swamp at Magadi, the worst was over. At this point, Moru kopjes were only a mile or so away and already impressive—so much larger than any others in the Serengeti. These magnificent rocks tower hundreds of feet up and feature some spectacular examples of gravity-defying boulders.

Like Seronera, this place was lush and green and not yet invaded by the annual migration of wildebeeste. Before the Serengeti park was officially established, this was Masai country. We stopped the cars and

climbed a nearby kopje on top of which was a five-foot-high boulder shaped like a slice of cake with the sharp end pointing skywards. Its surface was pitted with saucer-shaped indentations where, for centuries, the Masai had banged the boulder with baseball-sized rocks, making it ring like a gong. The surrounding grasslands still showed circles of a deeper green grass where once there were Masai *manyattas* (villages), although it had been about forty years since the last tribesmen were evicted from the area. What must they have felt to be sent away from such a paradise in order to protect wild animals?

An adjacent kopje had a shallow cave with a smoke-blackened roof and crude Masai paintings of cattle and warriors and shields on the walls. At one point, the low roof still showed the stains of red ochre where the warriors' hair would have rubbed. This would have been a hideaway, a men's club, where the *moran* (warriors) could get away from the women and elders, eat meat and boast of their exploits, real or imagined.

Half a mile further was a long, low kopje with comparatively little vegetation on it. As we approached, a lion's head appeared, peering over the topmost boulder; then another and another. Soon we had spotted more than a dozen. Some of them were draped loosely over large rocks in the shadow of a huge boulder, the surface of which was pitted and stained with rusts, greys, purples and blacks in random and haphazard designs like the creation of a mad surrealist. One or two of the closer lions were in sunlight and silhouetted dramatically against the shaded rock face. Frantically, I started taking photos and, whilst the lions were still co-operating, did some quick sketching. Painting ideas raced through my mind, and I knew that my sleep for the next few nights would be interrupted with plans of colour and composition.

This was a large pride; what did they live on? There were few other animals around. Why not hike ten miles west and gorge themselves on one or two wildebeeste? In a word, the answer to that is territory; to abandon theirs is to invite intruders, and to trespass into someone else's is to provoke open warfare. This Moru pride would have to wait patiently for the time, a few months hence, when the

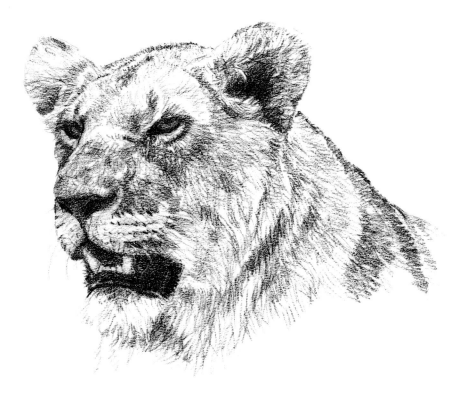

great herds would pass through their territory. Meanwhile, a diet of buffalo, warthog or even hares and hyraxes must suffice.

At last we had to leave Moru, but it seemed to want me to stay. As I reversed away from the lion-laden kopje, one side of the car disappeared into a huge antbear hole. Everyone climbed out rather cautiously, keeping a wary eye on the lions; but they took fright and melted into the undergrowth, leaving us to dig ourselves out.

A mile further, we passed a curious rock formation not much more than ten feet high, consisting of several boulders piled one on top of the other to resemble vaguely a female form with two large breasts. Appropriately, this 'Mother Earth' appeared to stand sentinel over the Moru kopjes, and as we left, I wondered if some of our early ancestors had paid homage to this keeper of paradise.

• • •

Two years later, I was back in Tanzania. There were two couples as my guests and both had visited the area before with other guides, so my ability

would be put to the test. With some trepidation, and in accordance with the latest government directive, I was obliged to take a Tanzanian driver/guide. I say trepidation simply because it was a situation where conflict could arise from two so-called experts each trying to outdo the other. In my case, I would never take that attitude, being very much aware that I was a part-time amateur, but I worried that the Tanzanian would feel irritated that I was treading on his toes.

From the start, I explained to Msafiri, my fellow guide, that I had no intention of stealing his thunder, that he was the professional and that I would bow, in most circumstances, to his expertise. After the first few days of rather tense suspicion, the ice melted and I think we benefitted from each other's knowledge. Without doubt, his eyesight was superlative; and whereas I nicknamed him 'Hawkeye', he irreverently called me 'The Blind White'.

The safari made a modest start with four days in Tarangire, where the most frequently encountered wildlife was the tsetse fly. At that time of year (February) the grass was high and lush, and the tsetses, voracious. I always react for the first twenty-four hours with a big lump around the bite followed by furious itching, but by the second day, I am 'salted' and the only problem is the momentary burn when the insect bites. All the same, tsetses are unpleasant and for that reason alone we were glad to leave for our next destination having not seen a single lion, a fact which was remarked upon rather pointedly by our visitors. I hoped that Lake Manyara, our next stop, would put an end to that particular complaint.

It did. Manyara is famous for its tree-climbing lions; and some of these were in full view close to the road, so the pressure was off.

Ngorongoro was the next stop. We intended to spend a day there, but this was foreshortened when the temperature gauge started climbing into the red and we discovered a hole in the radiator. We limped across the ten-mile-wide floor of the crater, topping up the radiator between more prides of lions, and made the 1,500-foot climb to the rim just before the engine seemed about to explode. In the way of Africa, a man appeared from a hut with a ramshackle tool-box, drove the vehicle onto a makeshift, oil-soaked inspection pit and proceeded to remove and expertly repair the radiator. The whole operation was completed in less than an hour; I shuddered to think what it would have taken in the way of time and money back in the U.K.

The next day, as we crossed the boundary between the Ngorongoro Conservation Area and Serengeti National Park, we saw more lions. Msafiri and I were beginning to enjoy ourselves, as we frequently reminded the guests that they did say that lions were what they wanted.

Our camp was situated on a bluff overlooking Lake Lagaja, at the far end of which could be seen Ndutu Lodge where I had often stayed before. Wildebeeste were every-

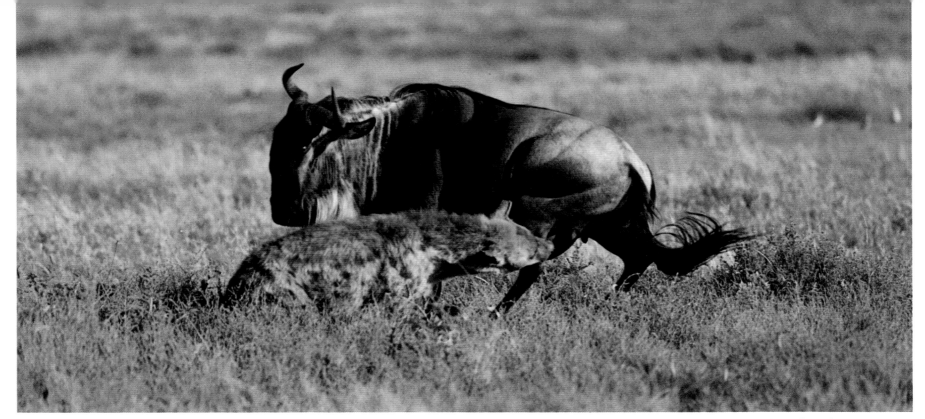

Hyenas, despite their disgusting, sinister appearance, are efficient and tenacious hunters. Possessing immense endurance, they will often chase lions from a kill.

where; the annual calving had started, so activity was frenzied. The Serengeti wildebeeste herds are estimated at about 1.75 million, and all the females drop their calves in a period of three weeks or so towards the end of February. This is a time when the cows are constantly calling their calves and vice versa, and the herd bulls are vocally and physically attempting to keep their harems together, at the same time warning off would-be usurpers. In short, everyone has more than the average to say, with the result that the air is filled with the hum of thousands of voices.

Nature is clever. All those babies being born in such a short period of time means that the many predators which are in attendance at that time can gorge themselves only to a certain limit before reaching saturation point.

The weather was teasing the wildebeeste, which were so numerous that they had to keep moving all the time to find new grazing. Around us were the short-grass plains which provide the sweetest and most nourishing graz-ing when watered by rain, but the showers and storms were very local so the herds shifted constantly to try and catch the best growth. One day we might have been surrounded by tens of thousands of restless, ever-moving animals; the next, they would have disappeared, the hum of many voices replaced by an eerie silence.

Lions roared near the camp in the night, and the next morning revealed a wildebeeste kill with two lionesses in attendance less than a mile away. We started taking bets on what the final lion tally would be.

• • •

The next three days were spent tracking the great herds and watching the many dramas enacted in and around this awesome congregation of wildlife. We watched calves being born and marvelled at how soon they could stand and run. Many did not make it, tragically falling prey to the predators—the lions and hyenas and their cohorts, the jackals and vultures. Hyenas, in par-

ticular, have a loathsome appearance and hunt with such a callous ruthlessness that the most indifferent heart will soon detest them.

One morning, we found a big male lion and his mate lying satiated near a wildebeeste carcass. As we watched and listened to the occupants of the rear seat suggest that we had perhaps seen enough lions, I noticed unusual movement in a dense herd of wildebeeste close by. Looking through the glasses, I could see one animal being hotly pursued by a single hyena. I had watched similar incidents before; somehow, the hyena singles out a particular wildebeeste, probably because it senses a weakness, and sets off in single-minded pursuit with relentless determination. Other wildebeeste will hardly move out of the way, sensing that today, it is not their turn.

I started the engine and moved to a position which I hoped would be where the wildebeeste was caught; sure enough, it happened only about thirty yards from the car. The hyena sank its teeth into a hind leg and bowled the wildebeeste over. The hyena fell underneath but still grimly hung on.

Then I noticed five more lions over to our right, sitting up alertly and obviously contemplating a take-over bid. In another direction, the flurry of activity had aroused a large pack of hyenas which were also showing extreme interest in the proceedings. I glanced across at Msafiri, who nodded his head and raised his eyebrows gleefully. He and I had each witnessed a vio-

lent confrontation between these sworn enemies in the past, and we both knew that this had all the makings of a classic. Anyone who has seen lions being faced up to by a pack of excited hyenas can never forget the ferocity of the cats, the teamwork of the bristling, slavering hyenas and, most of all, the cacophony of howls and screams and snarls.

But this was not to be. The hatred of hyenas became too much for one of our lady guests. Rising to her feet and sticking her head out of the roof hatch, she let fly a stream of the foulest insults I have heard in a long while. We sat there stunned. The hyena was even more shocked; it let go the wildebeeste's leg and shuffled away—but the most surprised participant was the wildebeeste, which had obviously resigned itself to an awful death starting with emasculation, then evisceration—both the hyena's grisly trademarks. It struggled to its feet and cantered away with, I am sure, a look of astonishment on its stupid face and a good story to tell its grandchildren.

At dusk, as I drove slowly along the edge of a stream bed which flowed into Lake Lagaja, I saw a cheetah and three tiny cubs still with long manes of silver hair on their backs. A little further on, a lioness led her three cubs down to the stream to drink. They played and scragged each other only a few yards from our vehicle.

Migrating wildebeeste at Soit Lemotonyi on the northern edge of the Serengeti.

It reminded me of a tragic incident which will be forever indelibly imprinted on my mind. It was early morning in Kenya's Masai Mara Game Reserve; across a dew-covered, grassy plain limped a lioness with one leg badly injured, unable to touch it to the ground. Behind her, struggling to keep up, were four very small cubs. Behind them were three hyenas. There was an awful inevitability to the scene, and it is at times like this that one is sorely tempted to intervene despite the edict which insists that nature should be allowed to take its course.

I often contemplate how we tend to group animals into the 'good guys' and the 'bad guys'; then we condition ourselves to accept that one lot are expendable but will cry blue murder when the others are threatened. It is therefore quite refreshing to meet the occasional person on safari who loves hyenas, vultures, crocodiles and warthogs.

• • •

Our lion count had now reached sixty with much speculation as to whether we could hit one hundred, so Msafiri and I decided to explore a remote area to the south—a place called Mawe ya Simba ('Lion Rocks'). Neither of us had been there before but both knew generally where it was. This is what appeals to me so much about the Serengeti: the chance to drive towards the distant horizon across the plains, not following any tracks, and using distant mountains and kopjes

as navigation aids, not knowing what excitement awaits beyond the next ridge. I wonder how long it will be before off-road driving is disallowed. I suppose, ecologically, it would be a good thing but I would sorely miss the freedom to roam at will. The plains fell away into lower, broken country with large kopjes scattered amongst the valleys. The nearest was probably Mawe ya Simba, so we stopped there for a picnic. This was truly wild Africa: not another vehicle or human being in sight.

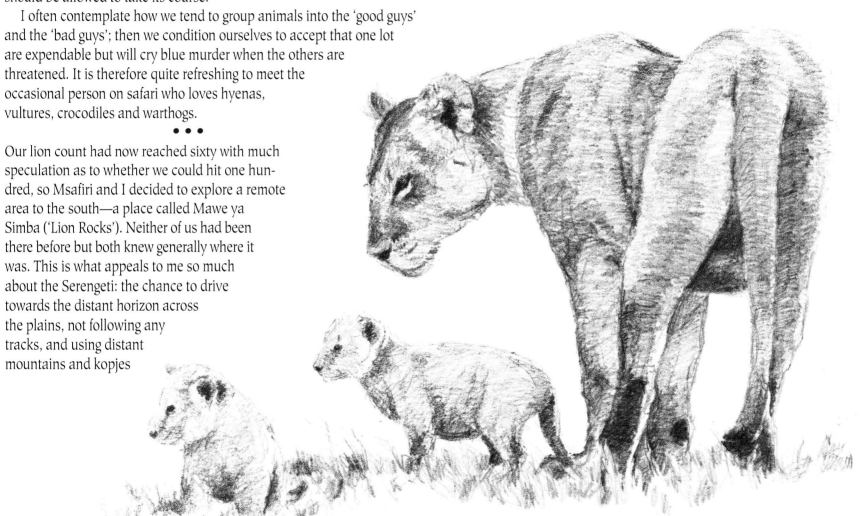

As we drove off, there appeared to be a herd of animals moving in file across the plains ahead. We moved fast to cut them off and soon realized that these were lions returning from a hunting foray—nineteen of them, our largest pride yet. They looked lean and hungry and, being in an area where few vehicles ventured, were wary and fled for cover when we approached.

Later, back in wildebeeste territory, we came upon a large male lion asleep under a small bush. He woke at our approach, growling and snarling ferociously which was unusual because normally they pay scant attention to cars. We stopped and watched as he settled back down, muttering and grumbling. Then I whispered urgently for everyone to stay quiet because walking towards us, and particularly to where the lion was lying, came a solitary

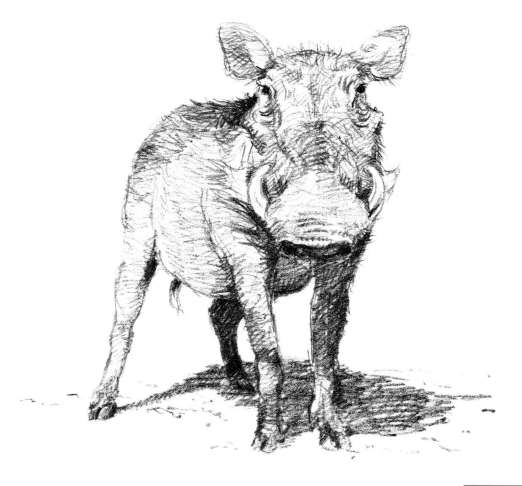

zebra apparently quite unaware of what lay ahead. When it was only yards away and we were all holding our breaths, the lion let out a fearsome roar, scaring the living daylights out of the zebra, which turned and fled. The lion lurched to his feet, using some wicked lion language, his eyes wide and blazing and his tail flicking furiously from side to side. Then I noticed that his belly was so full that it almost touched the ground. Here we had a glutton, a crusty old gentleman who had eaten to excess, was suffering the discomforts of indigestion and was livid at being disturbed by gawking tourists and a stupid zebra.

• • •

We took the main road north-west from Naabi Hill to Seronera and saw seven more lions along the way. This was getting laughable. The hundred seemed ever more probable.

A shadow glided through the grass near Simba ('Lion') kopjes. Too small for a lion; maybe a cheetah. Investigation revealed a serval cat, which was unusual at this time of day since they are mainly nocturnal and are seen mostly in the early morning or late evening. It was very shy and ran away on its long legs. Such a beautiful, spotted coat, and huge ears to detect the tiny rustles of the birds and rodents which form its main diet; another example of a species which has evolved certain characteristics to suit its special niche in the grand scheme of things.

And so to our last camp at Turners Springs, to the east of Seronera. It is named after Miles Turner, who was a warden in the Serengeti and was responsible in many ways for its continued success as a unique sanctuary for wildlife. We were only three or four hours' journey from our previous location, but the habitat was very different. The wildebeeste would reach here later in the year and eat this tall, lush grass flat; but now, the inhabitants were impala, buffalo, eland, topi and—yes—lions.

I woke in the night to find the watchman asleep in my vehicle when he should have been patrolling the camp. He swore that he had seen a leopard, so locked himself in the car for safety—a likely story. The headman would sort him out in the morning.

This was a tough area for game spotting. So much undergrowth and tall grass was intimidating for plains animals, which fear such conditions for the

cover it affords predators. A herd of impalas stood rigidly alert, all staring fixedly towards a small stream bed. We could hear their snorts of alarm, a sure sign that something dangerous was lurking there. We kept our distance and carefully scanned the area of their attention until a tiny movement betrayed the position of a leopard. As soon as we tried to get closer, it vanished.

This beautiful, stealthy, efficient hunter was in stark contrast to the rabble we found later: eight young lions covered with mud, looking as if they had just come off a rugby field. They were trying to dig a warthog out of a

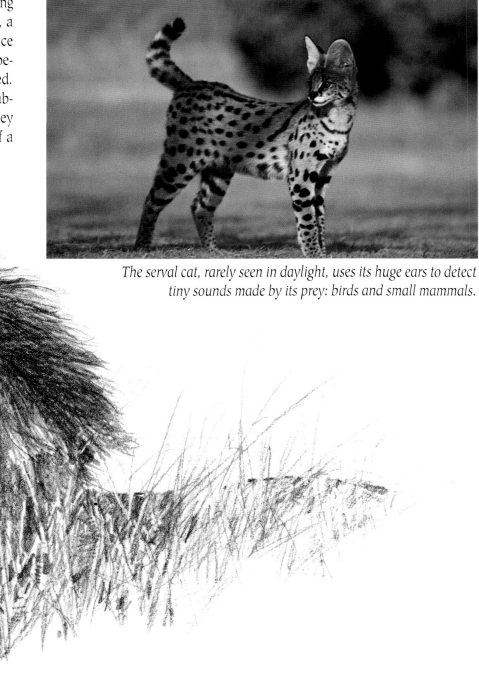

The serval cat, rarely seen in daylight, uses its huge ears to detect tiny sounds made by its prey: birds and small mammals.

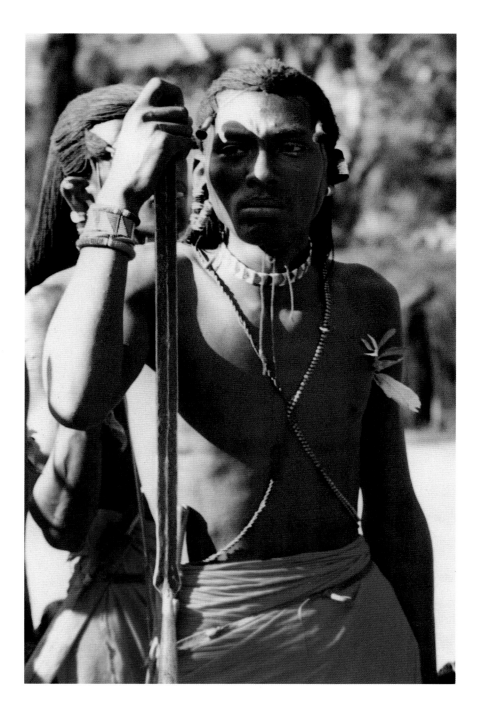

hole and had trampled the grass flat in a wide area all around it. Obviously, the warthog was temptingly close; the lions were making strenuous and excited efforts to reach it. They appeared very lean and hungry, a far cry from their bloated and satiated cousins forty miles to the south. Here, there was little to eat at this time of year, so it was not surprising to find them resorting to these desperate measures.

There was room for only one or two lions down the hole and periodically these two would start arguing. A fight would break out with much spitting and growling, which sometimes spread to the watchers above; positions would shift, and someone else would start digging. Suddenly, there was a frenzy of activity, roars and growls, and out came the hapless warthog, squealing briefly before it was ripped to pieces. These lions were ravenously hungry. With so little to eat and so many mouths to feed, the competition was brutal and it was surprising that more were not injured.

It was all over in minutes. A few lucky lions sidled away with a small piece of booty, but the majority returned hopefully to the hole. Just as we were driving away, there was another uproar, this time over a piglet.

● ● ●

This safari ended with a tally of 120 lions—probably more than I have ever seen on one trip before. Ironically, a year later, the lion population of the Serengeti was drastically reduced through an outbreak of canine distemper which had been passed on from dogs kept by the Masai people who inhabit the fringes of the park. Estimates went as high as a 60 percent mortality, but those that survived hopefully would have built an immunity against the disease, and lions will multiply rapidly to return to their original numbers. Meanwhile, a rigorous campaign has been going on to inoculate all the dogs against distemper, although it may have been too late to save the already-endangered wild dog from dying out in this particular part of Africa.

● ● ●

The lions on the kopje at Moru formed the basis of the largest painting in the Great Cat collection, the centerpiece of the entire project. It was the backdrop of that massive rock which inspired this particular piece and, indeed, when I had finished the rock itself, I could let my imagination run riot describing to people what I had cunningly concealed in its multicoloured,

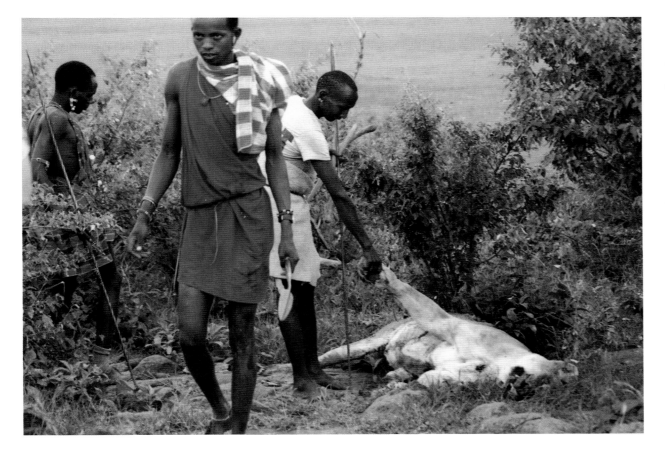

Opposite page: Warriors (moran) of the Masai tribe. Left: Masai villagers exacted revenge after a pride of lions killed two of their penned sheep. It took them several hours of mental preparation and a hallucinogenic drink to get prepared. This lioness was speared but mauled two Masai before she died. We arrived minutes later and offered hydrogen peroxide, the only first aid available.

complex markings. All lies, of course. The markings were actually as I saw them, but it was possible to picture the profiles of lions, Masai warriors and voluptuous maidens. The lions were draped, semi-comatose, over the rocks, highlighted by the sun against the shadowed rock; a cub in the foreground gazed idly at an agama lizard. It was titled *Lion About*.

I still wanted to produce a lion painting as part of the set of nine. In the early stages of planning, we had toyed with the idea of treating the lion and lioness as separate subjects because they are so different; but that idea was rejected, so I painted a male and two females on the one canvas and called it *Pride*.

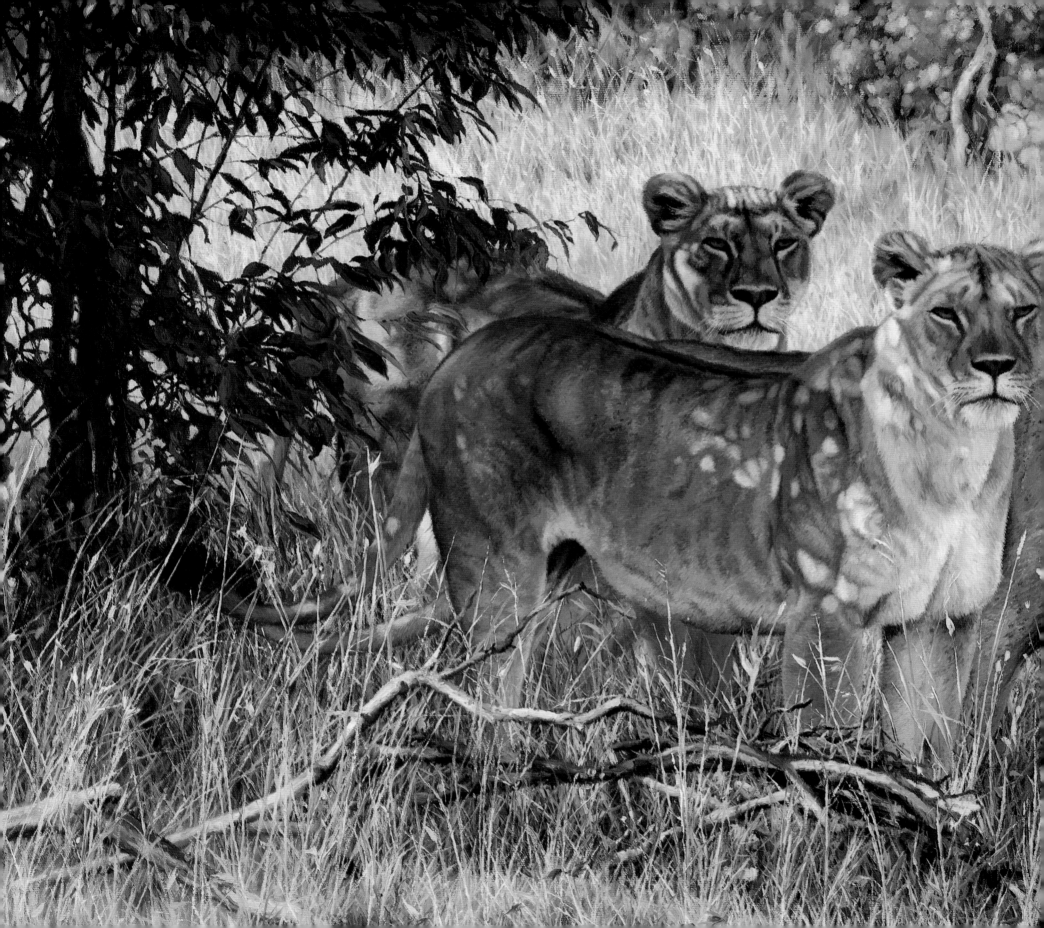

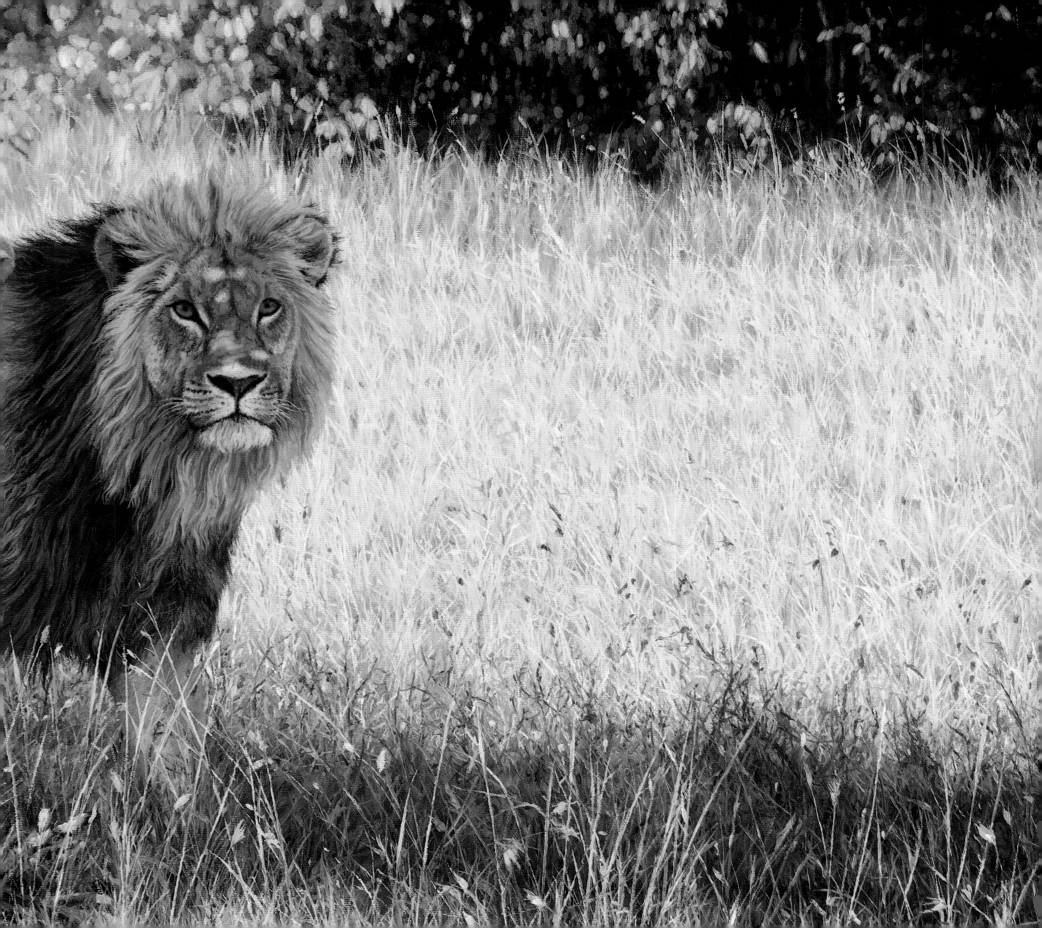

CHEETAH

ACINONYX JUBATUS

Cheetahs have always intrigued me, perhaps more than any of the other cats. They have rightly been described as enigmatic; it's a bit like meeting frequently with someone who has poise, elegance, class and fleeting moments of warmth, and yet is tantalizingly aloof. Getting to know that person and what goes on behind the enviable façade can become obsessive.

Physically, in many ways, the cheetah is unlike the other cats; the small head, deep chest, tiny waist, long legs and dog-like claws, which do not retract, all proclaim an athlete built for speed. But there are less obvious differences. My first cheetah acquaintances were tame animals whose best feature to a small boy was their wonderful, deep purr. You haven't lived until you've heard a cheetah purr. And the eyes—those large, rich, warm, amber eyes which have evolved as the cheetah's most precious asset—enable it to see long distances across the plains and select prey by analyzing the slightest sign of weakness.

Painting cheetahs can be both a joy and a challenge. I am a fervent advocate of simplicity, particularly in the use of colour. Too many different colours detract from the main subject, especially in wildlife painting where the animals I portray have evolved over millions of years to blend into their environment—none more so than the cheetah, whose spotted pelt merges so perfectly with the ochres, yellows, rusts and golds of the dry African plains. So I use a very limited palette and certainly use the same colours surrounding the cheetah as I do for the animal itself.

The challenge to painting these cats is twofold. Firstly, anatomical: the cheetah's chest is so pronounced in comparison, say, to its head that in certain positions the animal looks positively grotesque; so, although your chosen pose might be physically correct, aesthetically it might appear deformed. Secondly, I am challenged to depict the cat's mood— back we go to the 'enigmatic' cheetah. What is this mysterious cat thinking behind that mask of haughty disdain? Does this animal ever relax and have fun? Always so serious, so intent, so reserved.

• • •

This is about a safari which spanned both Kenya and Tanzania and which, against current trends, produced many cheetahs.

We camped just outside Kenya's Masai Mara Game Reserve on the edge of

DESCRIPTION AND BEHAVIOUR: Cheetahs, called *duma* or *msongo* in Kiswahili, are pale yellow with white underbellies, covered all over with small round black spots. They are readily distinguished from their other spotted relatives by their 'tear lines': heavy black lines extending from the inner corner of each eye to the outer corner of the mouth. Average adult weight is 43kg (95lbs) for males and 38kg (84lbs) for females. The cheetah is built for speed with a deep chest, wasp waist and proportionately longer limbs than the other big cats. It also has enlarged bronchi, lungs, heart and adrenals. A captive cheetah was accurately clocked at 112kph (69mph) over a short distance; cheetahs' sprints rarely last longer than 200–300m (219–328yds). Flexion of the elongated spine has been measured as increasing the cheetah's stride length by 11 percent at speeds of 56kph (35mph). Its claws remain exposed, lacking the skin sheaths found in most other felids, and thus provide additional traction, like a sprinter's cleats. Its long tail helps the cheetah's balance as it swerves during a chase. In East Africa, the cheetah's main prey is the Thomson's gazelle on the plains and impala in the woodlands. Cheetahs are predominantly diurnal, probably because competing predators are nocturnal. Even so, cheetahs often lose their kills to lions and hyenas.

LONGEVITY: Average 12–14 years.

HABITAT AND DISTRIBUTION: Cheetahs are distributed primarily throughout the drier parts of sub-Saharan Africa, though small populations are still found in North Africa and south-west Asia, where their range has diminished greatly. In the past, in Asia and Europe, captive cheetahs were kept by the nobility and trained to hunt, a practice dating back about 5,000 years to the Sumerians.

POPULATION STATUS: During the past 20 years, the total number of cheetahs in sub-Saharan Africa has been variously estimated at 15,000; 25,000; and 9,000–12,000.

PRINCIPAL THREATS: Genetic research has demonstrated that both captive and free-ranging cheetahs exhibit a very high level of homogeneity in coding DNA, on a par with inbred strains of laboratory mice. The cheetah appears to have suffered a series of severe population bottlenecks in its history, with the first and most significant occurring possibly during the late Pleistocene extinctions, around 10,000 years ago. The factors which would have led to these ancient population bottlenecks are not clear, but both their causes and their consequences could be of significance to cheetah conservation today. Zoos have had great difficulty in breeding cheetahs; however, there is no evidence that reproduction is compromised in the wild. The survival of the cheetah outside protected areas is primarily affected by conflicts with people over predation on livestock.

a small stream called Olare Orok. This was December. Three months previously, more than a million wildebeeste had migrated here from the Serengeti plains to the south and had spent six weeks eating this area flat. Then they moved into the whistling thorn and *leleshwa* scrub in the broken country to the east of the Mara River before turning south again in their endless quest for grazing. Now, after a few inches of rain, the countryside was carpeted in fresh, green grass, and many of the ungulates were dropping their young to take advantage of such rich nourishment.

Such conditions are ideal for cheetahs.

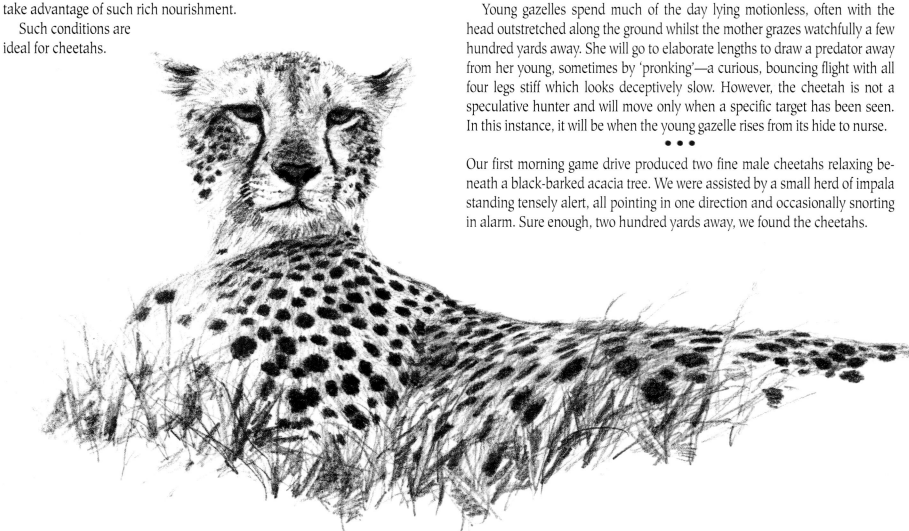

Although the grass may not yet be long enough to provide good stalking cover, this is more than made up for by the numbers of young and vulnerable gazelles, impala, reedbuck and even topi.

The cheetah needs only to sit and watch, using its superb eyesight to spot the slightest sign of a young antelope moving from its hide. In one lithe movement, it will rise to its feet, eyes locked onto the prey as it trots forward to make the kill.

Young gazelles spend much of the day lying motionless, often with the head outstretched along the ground whilst the mother grazes watchfully a few hundred yards away. She will go to elaborate lengths to draw a predator away from her young, sometimes by 'pronking'—a curious, bouncing flight with all four legs stiff which looks deceptively slow. However, the cheetah is not a speculative hunter and will move only when a specific target has been seen. In this instance, it will be when the young gazelle rises from its hide to nurse.

● ● ●

Our first morning game drive produced two fine male cheetahs relaxing beneath a black-barked acacia tree. We were assisted by a small herd of impala standing tensely alert, all pointing in one direction and occasionally snorting in alarm. Sure enough, two hundred yards away, we found the cheetahs.

The zookeeper at the Marine World Safari Park in Vallejo, California, posed me for this photo like a character from a Hemingway novel, with their favourite cat, a male cheetah, seated in patient attendance.

The guests were happy to wait in case anything happened, so we withdrew a discreet distance and enjoyed the many and constant interactions of animals and birds which can be spotted in the African wilderness by the patient observer. But, as so often happens, our stationary vehicle was seen by others, and before long the peace was shattered by a convoy of noisy minivans. We tried to con them by staring intently in the opposite direction but 'our' cheetahs were seen, and as the clattery pack closed in, they trotted away to a rocky ridge where vehicles could not follow. Tick cheetahs off the list and roar away to the next stop. Peace again, but the cheetahs had gone. I felt like apologising for attracting such an insensitive rabble.

As these beautiful cats decline in numbers or become more shy of tourist vehicles, so the demand to see them becomes more frenetic. I have witnessed scenes of pandemonium with thirty or more vehicles of all descriptions desperately trying to get close to a single cheetah: engines revving, wheels spinning, chassis getting hung up on rocks, people shouting, horns hooting, vehicles being towed off or out of obstructions—and all breaking the rules of the park by not staying on the road. Small wonder that the cheetahs often run when they see a vehicle approach. However, it is interesting to note that the cats themselves seem able to differentiate between those safari operators who pay scant attention to ethics and the sensitivity of animals and other vehicles, and those who are more discerning and less inclined to hassle the animal by getting too close. They can make this

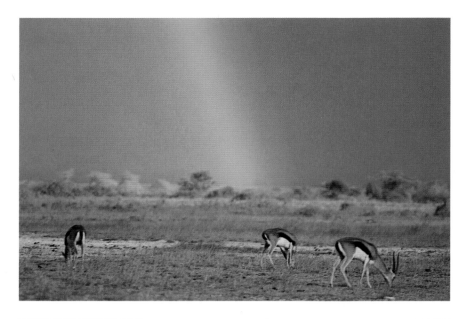

Thomson's gazelles grazing in the Serengeti with a rainbow backdrop.
Below: A herd of impalas in Tarangire National Park freeze to attention
at the approach of a predator.

judgment, I think, by recognizing the type of vehicle and can then exercise willful discrimination. Some would say they have become snobs.

However, the cheetah's future can be seriously affected by too much tourist pressure, especially when the cat is trying to hunt. Unless it is 100 percent certain of success, it will abort its hunt—which often happens when an over-zealous driver approaches too close or alerts the prey. Worse still is when a litter of cubs is discovered; then the pressure by drivers to show their clients the cubs is relentless. The mother, under such duress, will attempt to move them, which often means dangerously exposing them to lions, hyenas and eagles. Having painted such a gloomy picture, I am pleased to say that I saw compromise on both sides whilst on safari recently. The drivers, in general, seemed much more responsible, and the cheetahs in the Masai Mara had even learnt to use the vehicles as cover for a stalk. Also, they tended to have changed the traditional times of early morning and late evening to hunt. This is when tourist buses are thickest on the ground, so the cheetahs now wait until most have rushed back for breakfast or sundowners before venturing out for the chase.

• • •

In the evening we returned to the vicinity and, after careful scrutiny from high ground, detected agitation amongst the plains animals about a mile from where we had seen the cheetahs that morning. We made our way carefully down to a small plain where groups of Thomson's gazelles were standing rigidly alert, heads held high, ears pricked forward, occasionally stamping a front foot and snorting at the same two cheetahs which had now killed a young Tommy. Already it was half-devoured—not much of a meal for two large predators. Maybe they would hunt again. We decided to quarter the area and look for other game, checking back from time to time in case any action seemed forthcoming.

We drove away downwind and, half a mile from the cheetahs, came upon two spotted hyenas moving in their direction with their ugly, shambling gait, stopping occasionally to raise their muzzles and sniff the air. Everything about these scavengers—their slavering jaws, distended bellies, the sly way they move, the filth that

usually covers their hides—all underlines their sinister, loathsome association with death. But they do keep the place clean and ensure that the fittest survive by culling out the weak and aged. Despite this, I couldn't arouse any charitable thoughts for them, especially when they galloped towards the two cheetahs, forcing them to flee and abandon the remains of their meal. At least there was hardly any left.

The African people, generally speaking, regard the hyena as an animal of ridicule. Maybe it harks back to ancient tradition when many tribes would leave their elders, whose lives were nearly at an end, outside the corral at night for the hyenas to take care of. This, therefore, was the animal which would ruthlessly settle your ultimate destiny, so any chance to mock it would be welcome. One tale which always amused me concerned the way the hyena can knock itself senseless by running into a tree. Resting in the heat of the day, it will gaze up at the skies, studying the vultures as they circle ceaselessly in their search for carrion. Once a kill has been spotted, the birds will change to a dead-straight, fast glide, and any others seeing them will quickly follow suit. If the hyena sees this, he, too, will set off at a fast lope in a straight line, staring up at the sky as he follows the direction of the birds. If a tree is in the way, he will bump right into it.

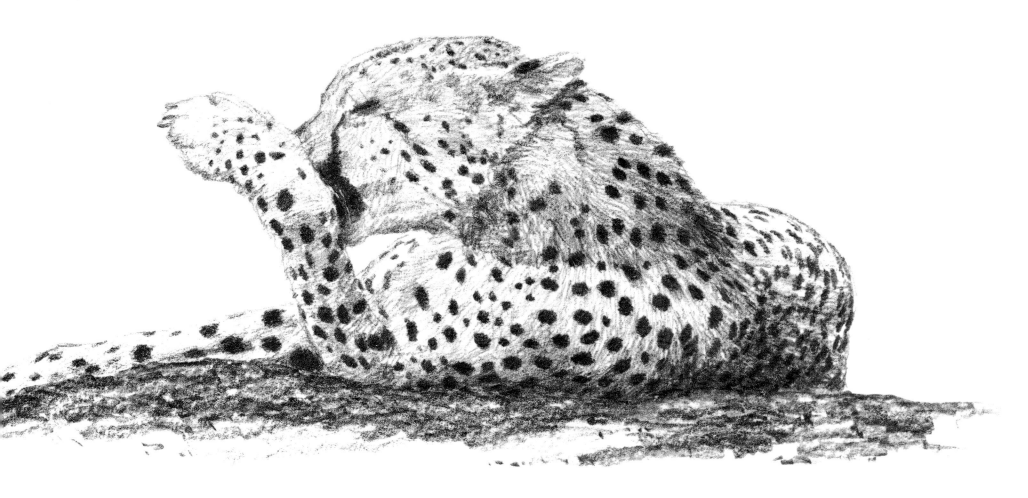

The following day, we saw the pair of cheetahs again, resting in the shade with full bellies; unlikely that they would hunt again for a while. They were probably brothers and would split up only through competition for a female, when brotherly love would be replaced by fierce aggression. The germ of an idea for the cheetah painting was beginning to form in my mind. At one point, as these two animals were relaxing in long grass, a flicker of movement must have caught their ever-watchful eyes; both sat up, staring fixedly in one particular direction. Then, whilst one still lay and stared, the other rose in one fluid movement and took several cautious steps. The idea appealed to have the two (or even three) cats in progressive positions of intent.

I would have to do something about the green grass. This is a small quirk, but I do prefer to portray the animals of the plains in a dry-season environment when the grass has the colours of gold and yellow and ochre, all of which blend so well with the coats of the cats themselves.

• • •

We moved south into Tanzania, spending time at Lake Manyara and Ngorongoro Crater before descending from its 9,000-foot-high rim to the heat and dryness of Olduvai Gorge, where the Leakey family made world-renowned discoveries of our ancestors' fossil remains. Our camp was established five miles from the famous site, further down the gorge where the river runs into what used to be a vast lake. With a bit of imagination and knowledge of the chain of stupendous geological events which shook this area, one might picture man, in the early stages of his evolution, foraging and hunting in this vast wilderness. The various layers of sediment are vividly exposed on the sides of the gorge by centuries of erosion, each layer representing a further cataclysmic eruption and blanketing of ash from the volcanoes to the east.

Pieces of fossilised bone litter the sides and floor of the gorge. What strange and exotic animals did these belong to so many millions of years ago? Olduvai is a place of fierce and unpredictable winds, but we were lucky. Recent rain had given the landscape a light brushing of green and,

uncannily, the wildebeeste herds had already arrived to nibble off the succulent new shoots of grass.

The first morning brought us another cheetah sighting. A subtly different tone to the constant roar of thousands of wildebeeste grunting and bleating told us that something was afoot. Sure enough, on rounding a clump of magnificent acacia trees, we saw a pair of cheetahs trotting through the wildebeeste formations, gathering, like the Pied Piper, a following of curious, snorting, bucking, cavorting animals. These were all male wildebeeste—bachelor herds which tend to graze the outer extremes of the area where the great mass of these animals congregate. They had no calves to protect and nothing to fear from the cheetahs, so were content to gently harass them and 'see them off the premises'.

Two days later, we moved north-west, past the Barafu kopjes to the edge of the acacia woodland which stretches north to the Kenya border. Whilst the camp was moved, we spent a night at Ndutu Lodge overlooking Lake Lagaja in the south-east corner of the park. Here, the wildebeeste were thick on the ground, and the air reverberated with their constant, monotonous lowing and the thunder of their hooves. New-born calves were everywhere, providing easy food for the many attendant predators but, at the same time, confusing them with their abundance.

The calves are easy prey for cheetahs, which can outrun them with little extra exertion. Their tactic is to sprint after a herd of females with calves afoot and cause such confusion that some calves become separated from their mothers and are then easy to isolate and pull down. However, cheetahs are reluctant to do this here due to the profusion of hyenas and lions which will immediately chase a cheetah off its kill.

The herds thinned out as we moved north from Ndutu. Passing Naabi Hill, where we paid our dues to the park authorities, we soon came to the Gol kopjes, a name reminiscent of something from a Rider Haggard novel. These remarkable rock outcrops, standing like rugged islands in a boundless, undulating sea, draw me like a magnet. Their multifaceted rock faces, large ficus and acacia trees, nooks and crannies are all in wonderful contrast to the surrounding plains and always hold promise of some excitement—a lion's look-out? A leopard's lair? An eagle's roost?

That day confirmed that this was truly the 'cheetah safari'. North of Naabi, thousands of Thomson's and Grant's gazelles covered the plains, and

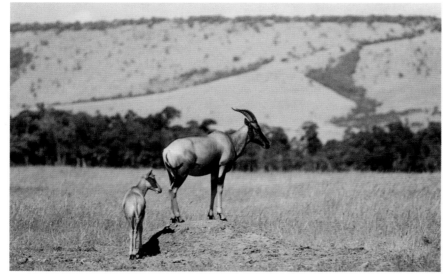

In Kenya's Masai Mara game reserve, a pack of young wild dogs captures an immature wildebeeste and prolongs the agony of both prey and viewers with its amateur performance. Below: A topi antelope and her calf in the Masai Mara. She adopts a classic pose, standing sentinel on a termite mound. Her outstanding eyesight will spot any threatening movement in the long grass.

in the space of six hours, we saw no less than eleven cheetahs. One large male had killed a zebra foal and was having a difficult time defending it from a circle of ravenous vultures. Zebra stallions are formidable and brave protectors of their mares and foals, as we were to witness the following day, so it was unusual to see a foal falling to a single cheetah.

• • •

Near Naabi Hill, a pack of nine African hunting dogs had established a den in an old antbear hole, where they were raising a litter of seven pups. We passed the spot on the way to our new camp and watched these rare and fearsome hunters relaxing in the midday heat. The men in our party wanted to see the dogs hunt; the ladies, fearing a spectacle in keeping with the dogs' bloodthirsty reputation, declined. The pack would hunt only in the early morning or late evening, so we planned to try and follow them early the next day.

Our camp was twenty miles to the north, with no formal tracks connecting the two locations. In order to be at the den at dawn, we would have to leave camp at about 4 A.M. and travel without lights across country. That can prove to be an interesting but sometimes uncomfortable experience because antbear and warthog holes are everywhere and are difficult to see by starlight.

In fact, the stars that night were as bright as I have ever seen, and the Southern Cross was clearly visible. We used this to navigate and, as the first red tinge lit the eastern horizon, we arrived almost exactly on target at the dogs' den, feeling very proud of ourselves.

As the sun peeped over the mountain range near Ngorongoro, the dogs suddenly came alive, rushing about excitedly, yipping and chirping almost like birds, wagging their tails, greeting each other and playing boisterously with the pups. After several minutes of this, as if on a signal, the adults became serious and purposeful and set off at a steady trot towards the Gol kopjes.

For an hour, nothing happened by way of a hunt, although other animals in the way of the oncoming pack fled in instant panic, a reaction very different to that caused by other predators. Lions or cheetahs would be carefully watched from a safe distance, their intentions being shrewdly analyzed, but not the dogs—with them, it was wise to assume the worst.

The pace quickened. A small herd of zebras, which included a young foal, was the target. Soon the zebras were at full stretch with the pack strung

out behind and the lead dog closing on the foal, but the stallion galloped between them, lashing out with his hooves and putting himself at the mercy of the dogs. This fascinating duel continued for a mile or so until, to my surprise, the dogs gave up and regrouped before moving on.

Their next mini-drama happened at a small waterhole where they stopped to drink. Close by, I noticed some hyenas raising their ugly heads above the small, scrubby bushes where they had chosen to lie up for the day. Evidently, the close presence of the dogs was too much for the three hyenas, which leapt to their feet and ran out onto the open plains. The dogs set off in pursuit, soon catching one of the hyenas and biting its backside and hind legs. The hyena attempted the impossible: tried to put its tail so far between its legs that it touched its chin, tried to look back at its pursuers, tried to sprint at top speed to elude them and accompanied all this with a series of blood-curdling screams. Having given the hyena a severe hiding, the pack left it to go on its painful way.

One of Africa's most ruthless and efficient raptors, the martial eagle "mantles" over the baby gazelle which it has just killed. Too heavy to lift from the ground, the gazelle is shielded from other predators by the eagle's outspread wings.

I wondered why they did that. Certainly, there was no territorial conflict. Maybe, like me, they have little love for hyenas and just felt like indulging in some bully-boy tactics.

By mid-morning, we were wondering if we would ever see these dogs make a kill. The pack had pulled up and lain down to rest as the day became hotter. Another vehicle joined us—a TV film crew from England who explained that they were making a documentary on hunting dogs. The crew asked that, in the event of any excitement, could we try to keep out of camera view. A large camera was mounted on a tripod on the roof of their vehicle.

As we chatted, someone noticed a lone wildebeeste approaching over the skyline, heading straight for us and the dogs. They saw it in the same instant and, as one, came silently to their feet, moving quickly to meet the unfortunate, unwary animal. There is an attitude of ruthless, relentless inevitability when a pack of hunting dogs moves towards a prey animal with heads low,

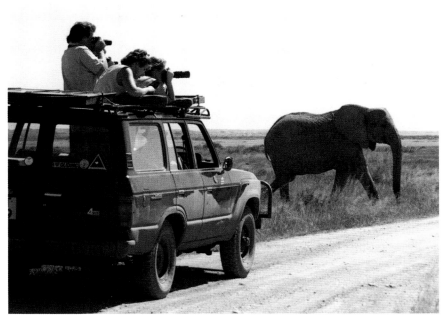

Elephants always have right of way!

ears laid back and eyes focussed in total concentration. Too late, the wilde-beeste realized its fatal dilemma. You could almost hear it say 'Oh, shit!' as it saw certain death staring from nine pairs of burning eyes. In total despera-tion, it sought refuge with man, in this case the lesser of two evils. Frantically, it galloped straight to the film crew's vehicle, pressing itself tight against the side with a ring of panting dogs waiting somewhat perplexed about ten yards away.

Confusion reigned in that car. The cameraman was yelling for the driver to move away because he could not depress his camera low enough to shoot the wildebeeste. The producer was urging the driver not to go, knowing full well that to do so would mean the wildebeeste's instant demise. It had taken on a new and embarrassing significance since demonstrating such pathetic and desperate trust in their protection. Human emotions were getting seri-ously screwed up as we watched with interest their battle to come to a deci-sion. But how long can you hang around with a doomed wildebeeste leaning against your bumper? No matter what happened, this one was going to die, and eventually they drove off fast, leaving it to its fate.

But this wildebeeste was not finished yet. As its fickle guardians left, it spied us and threw itself on our mercy, thus triggering the same debate in our car; but we hardened our hearts and drove away, leaving it to the inevitable.

It was not a pretty sight. The unfortunate beast was almost disembow-elled before it fell to the ground. The carnage seemed to go on for an age, but in minutes there was little left. My macho male guests were somewhat sub-dued as we drove back to camp.

I often wonder about such incidents. Why did that single wildebeeste canter across the empty plains away from the direction of the herds, directly into the jaws of those dogs? It was as if all the players in the drama were carefully following a script.

This was meant to be about cheetahs, but in Africa it is easy to have the attention diverted. Cheetahs are just one bright part of the great kaleidoscope.

• • •

A few years after the incident with the dogs, I was showing off Africa to my cousin from Chile. North of the Masai Mara Game Reserve, we left the track to investigate a vehicle which had been stationary in an acacia thicket for a long time. This goes against the grain, but sometimes curiosity overrules principle. The occupant of the vehicle was a very famous wildlife photographer whose books are internationally known. He was watching a cheetah with two half-grown cubs as they played with an impala fawn. The female cheetah had caught it for her offspring and was keeping a maternal eye on proceedings as they took their first lessons in hunting. They were very inept, and it was not an experience for the faint-hearted. At last, the fawn crawled under the photographer's car, followed by all three cheetahs. With camera in hand, he was hanging from the window, upside-down, trying to shoot the sad finale of this particular drama. The mother cheetah decided that the game was over and mercifully dispatched the impala, which they dragged into the open and devoured.

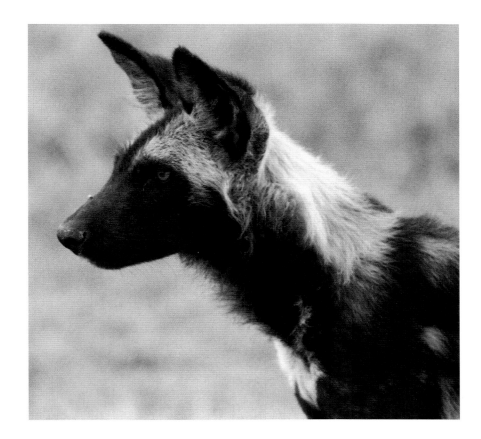

The next day, we thought we would be witness to a similar tragedy. At dawn, a big male cheetah, with belly distended, lay on a termite mound, panting as he tried to digest his latest large meal. Wildebeeste with small calves were everywhere, so he had probably spent a profitable night amongst those. He took no notice of us as we clicked cameras from close range. Then I saw another vehicle approaching, and my heart sank as I realized that it was being followed by a zebra foal which could not have been more than a day old. Somehow, in the confusion of the night, it must have become separated from its mother and now, as dawn broke, it pathetically galloped towards the nearest large, moving object, not being able to differentiate between mother zebra and safari vehicle. Now it was galloping straight towards almost-certain death; the cheetah saw it coming and in- stinctively raised itself, head lowered, ready to run and pounce. Then it must have remembered its large belly; all the fire disappeared as it flopped tiredly back down. The baby zebra was spared but, sadly, not for long. We never waited to find out, but a lost youngster like that would be unlikely to last the day without the protection of its mother. Nature is sometimes cruel.

• • •

My initial plan to include two cheetahs in the painting changed to three, and I tried to illustrate that quintessential moment when animals which have been in a state of complete relaxation are suddenly galvanised into action by the promise of food or threat of danger. I mentioned that cheetahs always seem to me to be such serious animals, so I titled this one *Serious Intent*.

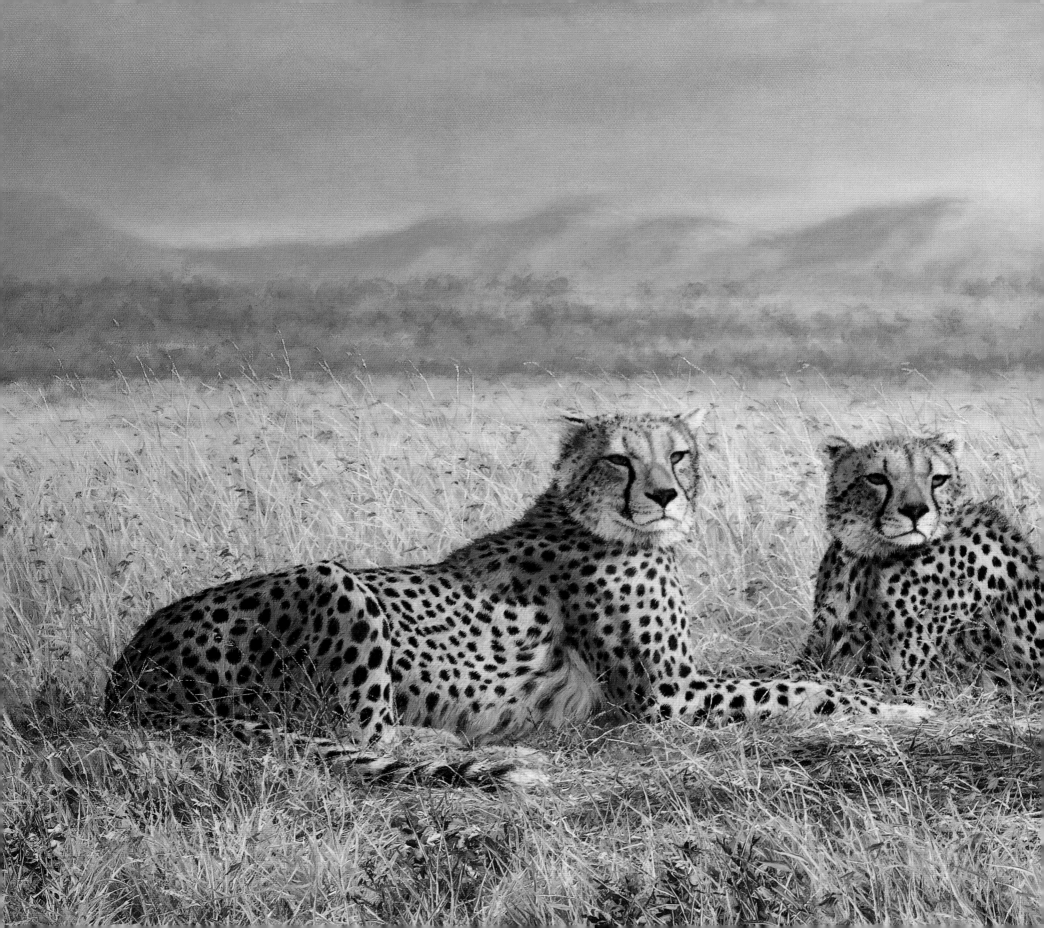

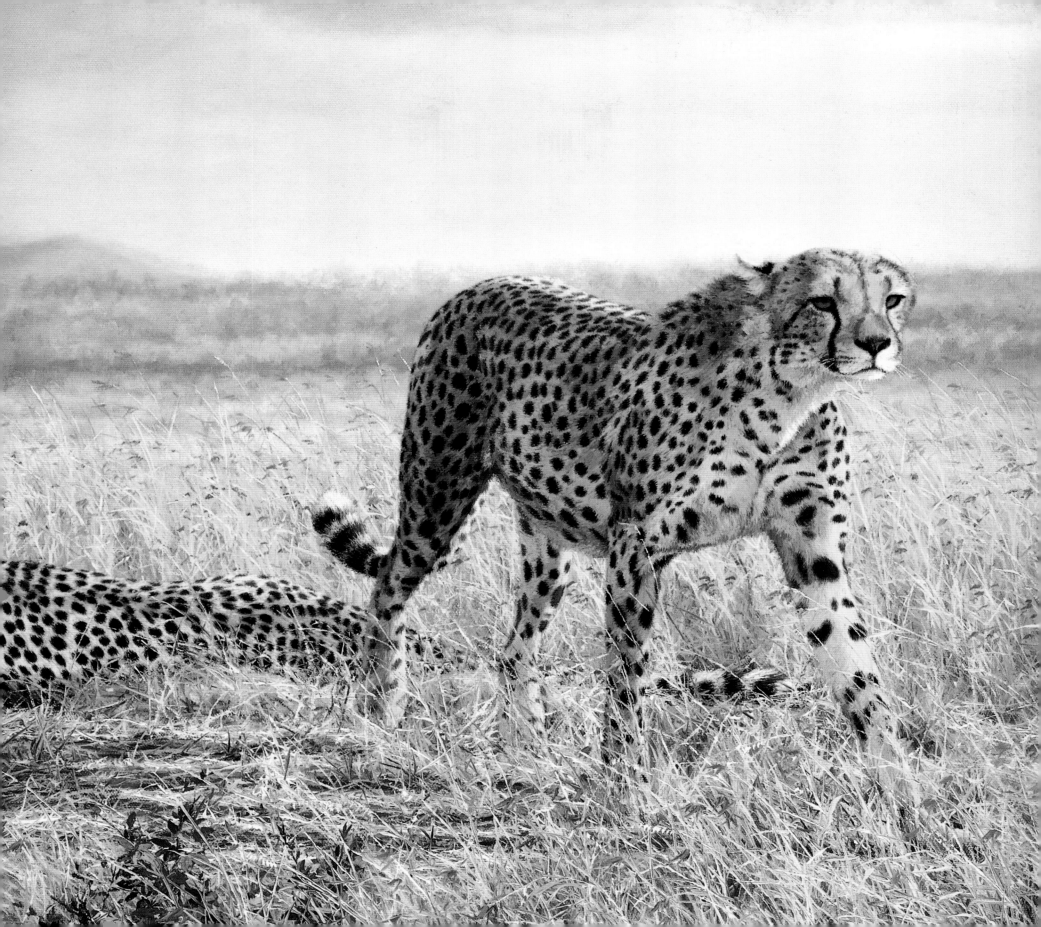

AFRICAN LEOPARD

PANTHERA PARDUS

Sport fishermen will know that feeling: when the line snaps free from the outrigger and the reel starts to scream; moments later, the rod in your hands is bent into a tight curve with what feels like an elephant dragging along at the other end. All the waiting is over, all the searching for long, boring hours wondering whether it's really worth it. But now, almost certainly, it is. This is the prize—the big one.

So it is with a safari guide who, after days, even weeks, of searching for the elusive leopard, suddenly spies a flash of gold, maybe a tail dangling like a bell-pull from the branches of a tree. There is a sudden thrill of recognition, then a warm sense of achievement, satisfaction and excitement as he whispers dramatically to his guests, 'Leopard!'.

Years ago, in all probability the animal would have been shot, the triumphant hunter carrying the hide back to his house, but no longer. With equal triumph, today's hunter instead shows off his photographic trophies to his friends, and those who are lucky enough to see the leopard do indeed have a trophy. Many return from their safaris without ever having ticked it off their lists.

During five memorable days in the Serengeti, Tanzania, a group I was with saw six different leopards. They were in the area of Seronera toward the western edge of the Serengeti Plains. Here, the countryside is more undulating and broken, intersected by a network of watercourses. Scattered here and there are some spectacular kopjes, fringed with ficus, acacia and euphorbia trees. Along the watercourses, some of which are little more than four-foot-deep ditches, grow more acacias and the grey-barked, broad-leafed 'sausage' trees, so-called for the eighteen-inch-long, sausage-like seed pods which hang from their branches. At ground level, ample cover is provided by dense scrub and tall grass. This is the leopard's favorite domain, and this is where we established our enviable record.

DESCRIPTION AND BEHAVIOUR: The leopard, *chui* in Kiswahili, has the widest distribution of the wild cats and shows great variation in appearance and behaviour. In general, the coat colour varies from pale yellow to deep gold or tawny, and is patterned with black rosettes. The head, lower limbs and belly are spotted with solid black. Black leopards (the so-called 'black panthers') are merely a colour variation, not a sub-species. The leopard is well known for its versatility as a generalist predator and shows a number of morphological adaptations to this end, including its variable size. Exceptionally large males weighing over 91kg (201lbs) have been reported; average adult weights are otherwise 58kg (128lbs) for males and 37.5kg (83lbs) for females. Much smaller males of 31–41kg (68–90lbs) have been reported.

Leopards are generally most active between sunset and sunrise. The known prey of the leopard ranges from dung beetles to adult male eland, which can reach 900kg (1,984lbs), and at least 92 prey species have been documented in the leopard's diet in sub-Saharan Africa. Leopards often cache large kills in trees. Great strength is required: there have been several observations of leopards hauling carcasses of young giraffe, estimated to weigh up to 125kg (276lbs)— 2–3 times the weight of the leopard— up to 5.7m (18.7ft) into trees.

LONGEVITY: Probably 10–15 years, perhaps up to 20.

HABITAT AND DISTRIBUTION: Leopards occur in most of sub-Saharan Africa, and their range extends into North Africa and south-west Asia. They are found in all habitats with annual rainfall above 50mm (2.2in) and can penetrate more arid areas along river courses. Of all the African cats, only the leopard occupies both rain forest and arid desert habitats. Leopards range exceptionally up to 5,700m (18,700ft), as evidenced by the 1926 discovery of a carcass on the rim of Mount Kilimanjaro's Kibo Crater.

POPULATION STATUS: In 1988, the sub-Saharan leopard population was estimated to number 714,000. The cat's status has been a matter of controversy since 1973, when it was first listed as being threatened with extinction; however, it is generally agreed that the leopard is not currently endangered but is subject to local depletion through exploitation and loss of habitat.

PRINCIPAL THREATS: The leopard is now largely protected across its range, although killing of 'problem animals', either by landowners or government authorities is generally permitted. Rural people are at present the force responsible for the continuing decline of the leopard in the region, through degradation of habitat where their livestock graze, and persecution of the leopard as a threat to these animals. A system has been in place since 1983 which permits selected countries to export an annual quota of legitimate sport-hunting trophies.

Our idyllic safari camp in Kenya, shaded by graceful, yellow acacia trees. These were named 'fever trees' by early explorers because the trees and malaria seemed synonymous.

The leopard's favourite prey are Thomson's gazelle and impala, but they will hunt anything smaller, including birds. The prey animals are well aware of the danger lurking in dense cover in the stream beds and will venture there only to cross with fearful trepidation and best speed, or when the grazing on the ridges between streams has become scarce.

That is no problem for the leopard. He will spend his day draped in the branches of a preferred tree, avoiding the worst of the ground-level insects, catching a welcome, cooling breeze and, through lazy, half-closed eyes, mentally logging the movements and locations of possible prey which he can spy from his treetop lookout. At dusk he will descend, patrol at leisure up or down his watercourse highway and emerge at a point where his instincts direct him to hunt.

Out on the plains, the impalas and gazelles will take comfort from their own numbers and from the lack of cover behind which a potential predator can hide. But they seldom reckon with the supreme hunting skills of the leopard which, using his spotted hide, blends into the background and moves like a wraith with infinite patience and concentration.

Because the leopard is a nocturnal hunter, records of his stalking success rate are largely speculative, but I suspect that he comes near the top in the big-cat-league table. He hunts by stealth, moving to within pouncing distance rather than relying on a last-minute sprint like the lion.

Once he has killed, his problems really start. Hyenas and lions will rob him of his kill (and his own life) given half a chance, so he must drag the carcass to cover as quickly as possible. Ultimately, and for total protection, he will carry the kill—which often far exceeds his own body weight—high into a tree, where he will wedge it firmly in a fork and, barring serious interruption, feed on it for the next few days. One of the best ways to look for leopards is to watch out for these kill remains in the tops of trees.

• • •

Our group comprised two guides—myself and Alan Binks—and five 'clients'. Actually, they were more friends than clients. Bill and Debbie were both lawyers and came in for a lot of ribald teasing because of that; Kimberly was a student from Boulder, Colorado; Rod was a fellow wildlife painter with an encyclopaedic knowledge of birds and a mischievous sense

of humour; finally, there was the ubiquitous Terry Begg, the wildlife-art-gallery owner who accompanied me on all my Great Cat travels. By the time we reached Seronera, we had been on safari for two weeks and had seen large numbers of animals and birds of every size and description. The lists were long and impressive, and we felt happy to devote our remaining time to the one that still eluded us: the leopard. A week remained. With our current track record and luck, we felt confident.

The camp at Seronera nestled between two kopjes separated by a distance of some twenty yards. We were here by default; the Serengeti National Park authorities give specific permission to groups such as ours to camp only in specially designated sites. When we drove from our previous base at the eastern end of the plains to our allocated camp at Soit Lemotonyi, the clouds had been building up since midday—great towering thunderheads with rainbow colours, visible through binoculars, tens of thousands of feet up where the sun was reflecting on ice crystals. By mid-afternoon, there was an almost-constant rumbling of thunder right across the horizon, and forked lightning frequently split the gloom. Ahead of the storms came violent winds blowing up brown dust clouds and urging the herds of wildebeeste, gazelles and zebras to stampede aimlessly. Occasionally the sun would break through and light the dust, creating a dramatic contrast to the inky, blue-black clouds behind and the silhouettes of galloping animals in the fore-ground. Scenes for an artist to salivate over.

We took a direct route to Soit Lemotonyi, driving straight across country from Ndutu, hoping to find our camp already set up, but nothing was there. After a council of war, whilst the heavens continued their grumbling display, we guessed that our truck carrying tents, food, fuel, water, drinks and every-thing else bar the kitchen sink, not to mention our nine-man camp crew, would have taken the longer but safer main road to Seronera and tried to ap-proach Soit from that direction. It turned out that our guess was right; an hour later, we reached the point where the truck driver had used his discre-tion at the edge of a flooded stream and turned back.

After another twenty miles of plunging through rivers and lakes resulting from the storm, we reached the Seronera area as dusk was falling and set about visiting the several official campsites to find out which one was occu-

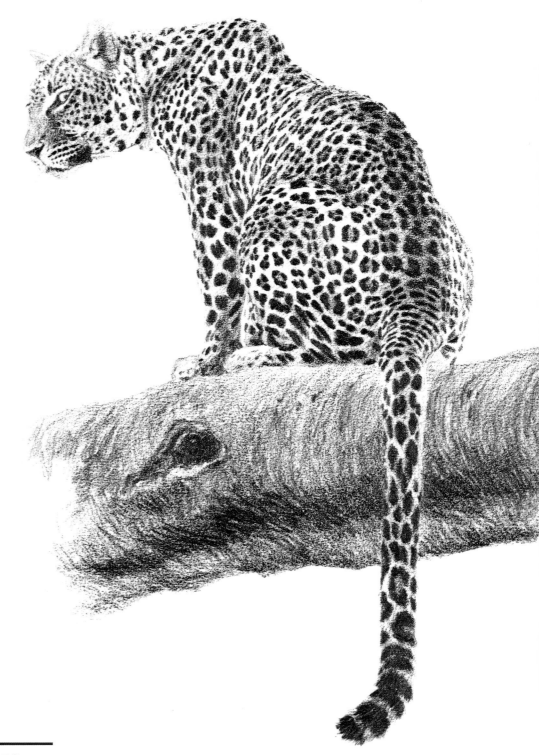

pied by our crew. Luckily, we found them at the first attempt. These cheerful, enthusiastic, friendly people never ceased to amaze our guests and even myself at the speed and efficiency with which they could set up a camp: tents erected, beds made, hot water boiled in a forty-four-gallon oil drum for showers, bread baking in an oven made from an old ammunition box, and an evening meal of roast chicken and vegetables on its way to completion; a large, welcoming camp-fire surrounded by canvas camp chairs, a table full of drinks to one side and ice and cold beers available from a portable deep-freeze. This is what 'roughing it' should always be like.

Later that evening, while sitting around the camp-fire, watching Africa's own special light show as lightning from distant storms flickered continuously along the western skyline, and listening to the faint rumble of thunder, the whoop of hyena, the roaring of lions and the sad-sounding trill of a nightjar sitting atop the towering boulder at our backs, we discussed the next day's plan of action. There was no question as to our quarry and little choice as to where we would seek him. It had to be a patient trawl along all the stream beds. We decided to set off at dawn and return to camp for brunch. It had been a long day, and everyone slept well that night despite Africa's nocturnal chorus.

• • •

The search began at dawn the next day. With two vehicles, we could cover much more ground and, sparing no expense, each was fitted with a two-way radio so that Alan and I could communicate should either of us find anything of interest.

For me, this was a mixed blessing. On the one hand, I could benefit from his ultra-sharp eyesight and uncanny instinct to know where to look for animals, but on the other, he and his passengers would derive huge enjoyment from my discomfort if, for instance, they were ahead and spotted a lion: they would wait with bated breath to see if I would call up and say, 'Hey, did you see this lion?'—but if I missed it, the jeers and mockery and hoots of deri-

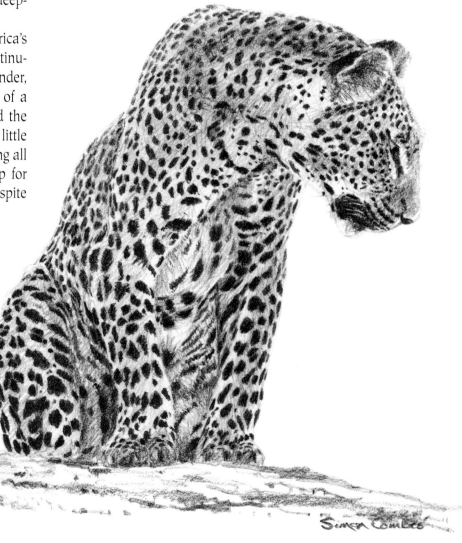

sion would be endless. Of course, once in a blue moon it worked the other way, when I could crow about something I saw and he missed. We have worked together for many years but the light-hearted competitiveness never stops. Alan is head and shoulders above me where spotting is concerned, and so he should be: it's his profession. It is an art. The eye should not look for specifics but, instead, should scan and register anything which slightly breaks nature's pattern. The trick is to recognize that pattern.

The morning wore on with sightings of giraffes, impalas, Thomson's gazelles, warthogs, hyrax and the usual multitude of birds. Birds it was that led us to our first leopard. Helmeted guinea-fowl are very active and vociferous in the early morning when they fly down from their roosts to scratch and forage for seeds and insects. Leopards are very partial to a guinea-fowl snack, so whenever one is sighted, these large, hen-like birds will fly up to the safety of a branch and set up a furious cacophony of metallic-sounding noises. This was what Alan heard, and soon we found a number of the birds craning their necks to peer into a patch of long grass by the track-side.

Leopards are very wary when on the ground, and this one was no exception. A group of guinea fowl was still on the ground, standing on tiptoe in the grass, clicking nervously, trying to locate the danger that their tree-bourne comrades were yelling about. After about five minutes, there was an excited hiss from one of Alan's passengers, who could see the leopard stalking close by, moving with immaculate stealth through the long grass and using the vehicle as cover to screen it from the guineas.

This time, the hunt was unsuccessful; the birds suddenly took fright and burst from the ground with a noisy cackle to join the rest of the flock in the trees. The leopard, by now accepting and studiously ignoring our two vehicles, relaxed, sat down and started washing itself, licking its large paws and rubbing them across its face just like any old house cat. Inside my car, there were big grins all round as we headed back to camp for brunch.

• • •

We were just leaving camp for our evening game drive when I stopped the car to let a large, black cobra slither across the track. My passengers on this occasion were the Terrible Twins, Rod and Terry. The latter went uncharacteristically silent when I drew to a halt and touched the snake with a stick as

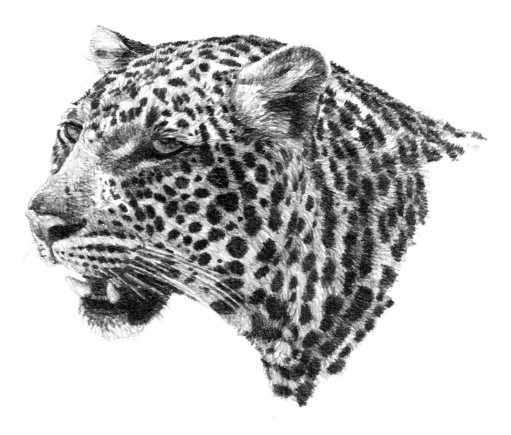

it disappeared down a hole at the base of a tree. I have no love for these reptiles, having had a bad experience with one in my teens, but Terry was paranoid. Later he related how his older brother had locked him in the trunk of a car with a garter snake when he was a small boy. No wonder.

Most people fear snakes, and almost all our visitors will voice concern about seeing them during their safaris. In actual fact, snakes are rarely seen and will normally take every effort to get away from man.

As evening approached, Alan found two more leopards—a female and her almost-mature offspring. They had killed a reedbuck and hauled it forty feet up into a yellow-barked acacia tree. As we sat quietly below, the two animals started arguing over the carcass. The big female sat on top, snarling and spitting at her son, who adopted a subservient attitude while at the same time trying to edge closer to the meal. Looking up, I saw the female's rear end parked on top of the reedbuck's head. In keeping with the tone of

Storm clouds descend over acacia trees on the Serengeti Plains of Tanzania in eastern Africa. Below: Impala rams in a bachelor herd.

the afternoon, I turned to Rod and pointed out 'a fine example of a leopard giving birth to a reedbuck'. Without pause, he declared my observation wrong. What I was seeing was 'a perfect example of a reedbuck wearing a Davy Crockett hat'. This was the tone of the safari.

• • •

A pride of lions moved through the camp that night. There was a bright moon, and early in the morning I could see them clearly and hear their soft, moaning calls. Only a piece of canvas and two yards separated me from the nearest, and I hoped they had been seen by the others in our party. The lions were insatiably curious, cautiously investigating the furniture round the camp-fire, the ropes holding up the tents and especially the canvas bags in which the tents had been packed.

In the morning, I found that no-one else had seen the lions, but at least I could point out the pug marks in the soft sand around our tents.

After a dawn snack, we headed back to the leopard tree and found the pair still in the vicinity, but now on the ground. They were surprisingly accustomed to our vehicles and paid us scant attention.

As the sun rose higher and dawn's coolness disappeared, the big female leopard moved back to the kill tree and, after delicately sniffing the ground around its base and the tree's bark, launched herself upwards, pausing halfway to scan the surrounding area. Another staccato burst of camera shutters before she effortlessly climbed the last twenty feet to her kill.

A week previously, war had been declared in the Persian Gulf. Operation Desert Storm was well underway, and due to the very prominent build-up to that event, large numbers of potential visitors to East Africa had cancelled their tours. Consequently, we had the place almost to ourselves.

At one stage that morning, though, a mini-van with diplomatic number plates pulled up next to us under the tree. The occupants stared at us, then stared all around, craning their necks to discover what we were watching. I glanced at the others in my car and could read mischief all over their faces. (Please don't let them embarrass me.) Then Terry started to laugh and surreptitiously pointed to the rear of the mini-van where an obviously bored youth was sitting with a vacant look on his face, a finger idly exploring the depths of one nostril. We had to leave; my car was about to erupt.

That afternoon, the air became still and heavy with humidity. Rain clouds began building up in the west, and the plains to the east shimmered with mirage. Animals and birds seemed held in suspended animation. Only the vultures moved, soaring high on thermals in their constant quest for death. Tiny Masai flies appeared and clung to the skin with sticky, tickly feet. I folded a bandanna into a strip and tied it around my forehead where the skin is so sensitive.

That was the cue for more tomfoolery from Rod and Terry, who launched into a series of imitations of Bruce Lee and the Ninja. Terry found a piece of material to wrap round his head. Rod resorted to the roll of toilet paper which I always carried for emergencies. Never being one to do anything by halves, he used the entire roll, ending up with a head which looked like an Egyptian mummy with holes for his eyes and mouth. At that moment, I recognized the vehicle approaching as that of the Park Warden. Too late, I tried to warn my

Vervet monkeys will spot a leopard before any other animal, or person. Their raucous alarm often led us to the elusive, spotted cat.

back-seat maniacs, but they were already leaping to the windows with hands raised to deliver karate chops. I had a fleeting glimpse of several open-mouthed, astonished black faces, and then they were gone—as, probably, was my reputation.

We headed for camp still behaving like a bunch of children. A tree had fallen across the trail where it crossed a small stream bed, and a rough detour meant that the vehicle had to be driven past the obstacle very slowly. They hatched a plan: why not hide the car behind the tree and ambush the others with wild kung-fu yells and flailing karate chops as they slowed to cross the stream? As Rod opened the door to take up his ambush position, still with twenty yards of toilet paper wrapped round his head, I hissed at him urgently to stop right there. No more than ten yards away lay a very large male lion, glaring at us in wide-eyed astonishment. Rod stumbled back into the car, and we drove sedately back to camp, feeling rather foolish.

Our penultimate morning was one of special memories. Mist shrouded the area around Seronera as we drove out to the east; as the sun's rays slowly penetrated, a wonderland of light, shapes and shadows was revealed. Giraffes and zebras moved like ghosts through a silver sea. Heavy dew hung on each grass stem and these, in turn, seemed to be linked by endless, dew-laden cobwebs. The sun shining through the mist created an incredible, surreal effect which I knew I would find almost impossible to paint.

Later that day, we saw two more separate leopards and a further one on our final day. A feast of leopards and much good material for my main leopard painting. Somehow, I had to reproduce that beautiful, rich gold of the leopard's coat. Already, my thoughts were to position the cat in an old, yellow acacia tree whose bark varied in colour from a greenish lemon-yellow to a warm orange. These old trees have a dark outer bark which cracks and peels off in strips and chunks, leaving the smooth, yellow colour beneath.

The contrast of dark brown and yellow reminded me of the leopard's pelt and how good they could look together.

Back in the studio, I found a shot I had taken some years back of a wonderful, old, yellow acacia with a leopard almost hidden behind a mass of foliage and vines. This became my background. From another source, I superimposed a typical acacia (fever tree) branch for my leopard to lie along. The yellow under-bark was stuck with curling slabs of the old outer bark, giving great texture to paint and a perfect base for the elegantly draped, golden cat, silhouetted against the darkness of the old tree. The title had to be *Golden Silhouette*.

A Masai giraffe and its calf in the Serengeti. One giraffe female will often serve as 'baby-sitter' for several youngsters of similar age.

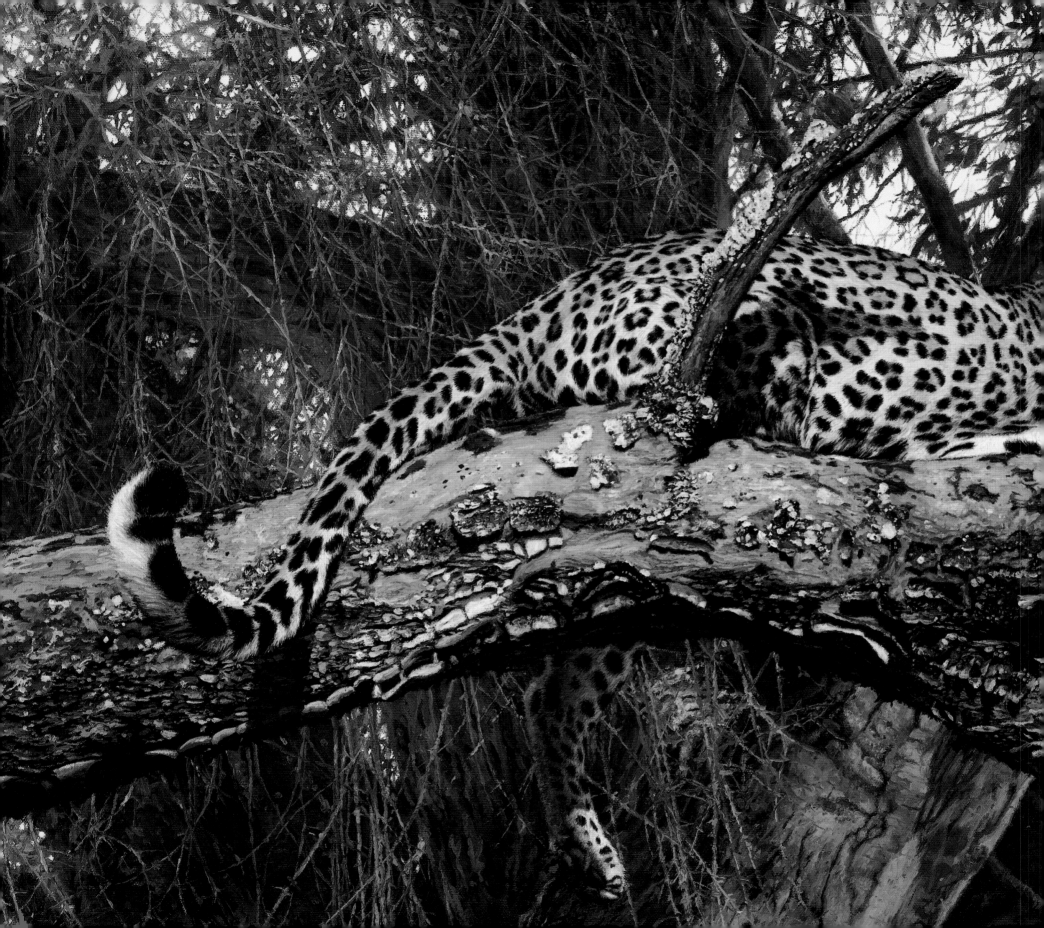

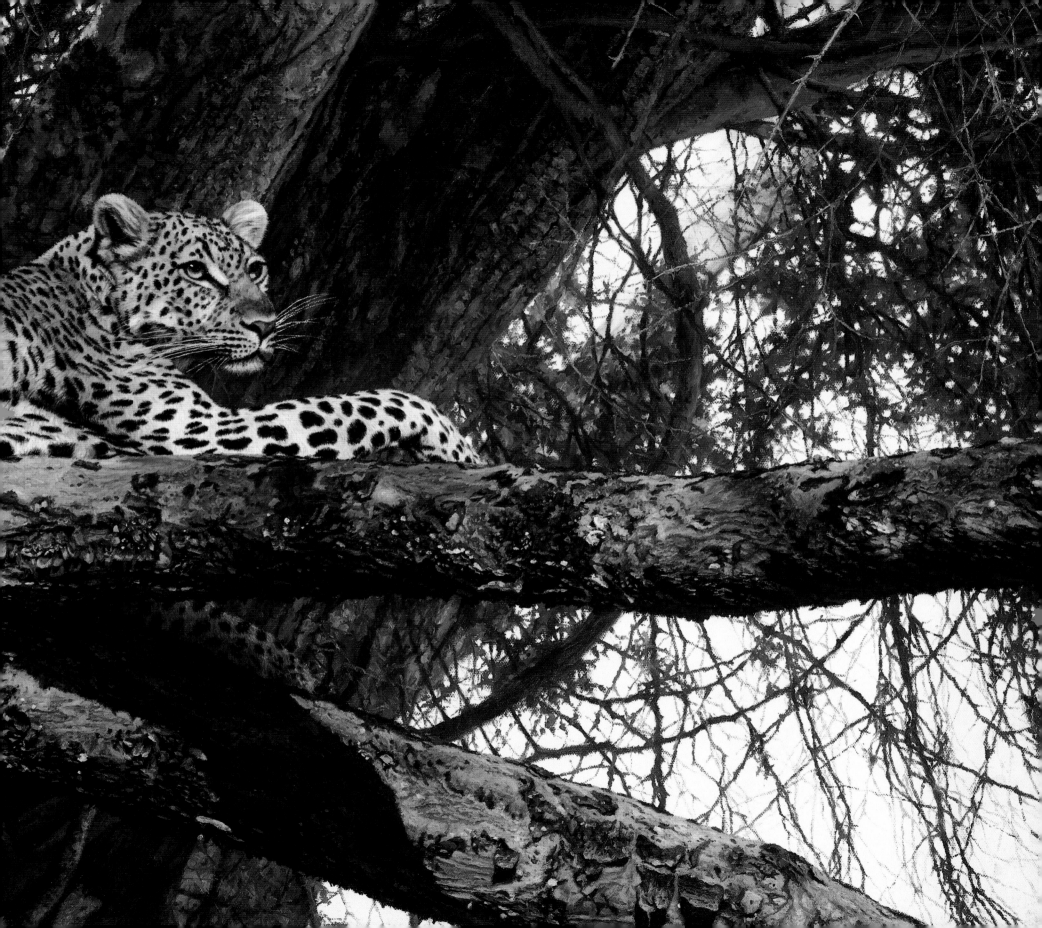

CATS O

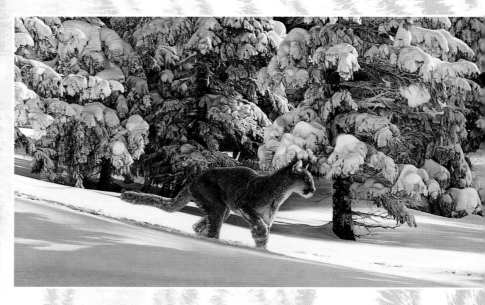

F THE SNOW

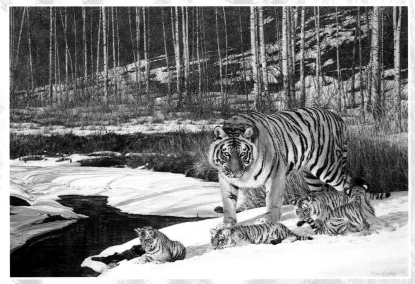

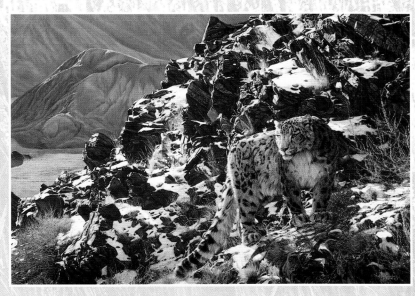

COUGAR • SIBERIAN TIGER • SNOW LEOPARD

COUGAR

PUMA CONCOLOR

In the United States, I find this animal mostly referred to as the mountain lion; I think the name "cougar" is perhaps more familiar in the Southwest. It also has many other names, which is not too surprising given its enormous range in both the North and South American continents and its ability to exist from scorching hot desert country to the freezing temperatures of the Rocky Mountains—probably the widest-ranging big cat in the world. Without doubt, this cat is a survivor. Despite being hunted extensively throughout its range, mainly for reasons of livestock protection, there are still thousands in existence even though it is on the endangered list.

This rather optimistic statement does not mean that I would find one easily. No animal can survive such depredations without having considerable cunning, and I was well aware that even if I should be lucky enough to see one, it would probably be little more than a fleeting glimpse.

I was pinning my hopes on Dr Maurice Hornocker, a big-cat expert, firstly by visiting his Wildlife Institute, a research location in northern Idaho and secondly by accompanying him in winter, using snowmobiles, to track cougars which he had previously fitted with radio collars. This would be in Yellowstone and Glacier National Parks.

Telemetry is a method of tracking an animal by using a collar to which is fitted a radio transmitter. Several times, in my travels to find the cats, I was assisted by field researchers who were using this method. Normally the cat is trapped in a snare, which sounds cruel but is designed to cause minimum trauma. The trap is activated by foot pressure on a pad that is concealed along a regular trail or close to a bait. The aim is to catch the animal round a leg, and the noose will flip up only a limited distance. I was assured that, once caught, the cat will struggle only to a minimal extent—no frantic, hysterical foot-chewing.

The traps are checked daily and if a cat has been caught, it will be sedated or tranquillised, either manually by using a syringe on the end of a jab-stick or, in the case of the larger cats, by using a dart fired at distance from a gun.

Normally, the animal will be under the drug for forty to forty-five minutes. During that time, it will be weighed and measured. Samples may be taken of its hair and blood, and it will be fitted with the radio collar and sometimes an ear tag. The collar with its tiny transmitter will last about two years and, although unsightly, will not hamper the cat in its daily life.

The signal from the transmitter travels by line of sight and can reach up to ten miles in

DESCRIPTION AND BEHAVIOUR: The cougar—also called mountain lion, catamount, panther and puma—has large feet and proportionally the longest hind legs of the cat family. The plain coat can vary in colour from silvery-grey to tawny to reddish, even between siblings. Faint horizontal stripes may occur on the upper forelegs. While it cannot roar, it is capable of a variety of vocalizations, and both sexes have a distinctive call, likened to a woman's scream, which is probably associated with courtship. Average adult weights range from 53–72kg (117–159lbs) for males and 34–48kg (75–106lbs) for females. The cougar is an exceptionally successful generalist predator, and its adaptability probably helped it survive the late Pleistocene extinctions of the other large North American felids. Known prey ranges from insects, birds and mice up to porcupine, capybara, pronghorn, wapiti, bighorn sheep and moose. Large kills are often covered with vegetation and dirt, and cougars often remain in the vicinity, returning frequently to feed. However, they rarely feed from carcasses of animals which they have not themselves killed.

LONGEVITY: Probably 8–10 but up to 12–13 years. A female cougar on Canada's Vancouver Island was killed by hunters when she was at least 18 years old.

HABITAT AND DISTRIBUTION: Cougars have a broad latitudinal range encompassing a diverse array of habitats, from arid desert to tropical rain forest to cold coniferous forest, from sea level up to 5,800m (19,029ft) in the Andes. While several studies have shown that dense understory vegetation is preferred, cougars usually live in very open habitats.

POPULATION STATUS: The cougar is endangered in North America. In Canada, the main population is now found only in south-western British Columbia and is estimated at 3,500–5,000. As in Canada, the cougar was essentially eliminated from most of the eastern U.S. within 200 years following European colonization; the only eastern state where it is unequivocally known to persist is Florida. It has fared much better in the less-populated western U.S., and the population is estimated at over 10,000.

PRINCIPAL THREATS: Across the Americas, ranchers are likely to continue to view cougars as a threat to their livestock and to attempt to eliminate them. Cougars are vulnerable because they return to their kills, which can be poisoned, and because they take to trees when hunted with dogs.

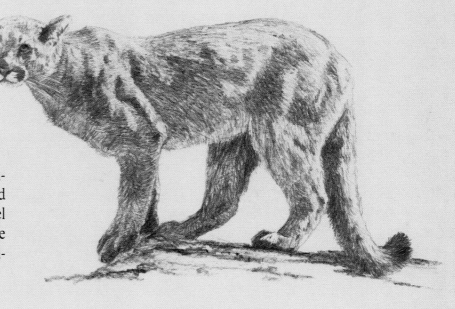

good conditions. Each transmitter emits a different, distinct signal so that scientists can differentiate between their various study subjects. The frequency of the received signal bleeps can indicate whether the animal is static, walking or running.

Thus, the researcher can obtain invaluable information on the cat's range and habits, all of which will help ultimately to preserve the species.

It was the end of summer. I was heading for Running Creek Ranch in northern Idaho where Maurice has his cougar research station. It's a long haul from London and all went well until I reached Chicago, where, waiting in the departure area for our connection to Boise, my fellow passengers and I were deafened by a small child whose 220-pound mother seemed incapable of stifling its screams. I whispered all the usual prayers—'Please don't let them sit next to me'—but this time, to no avail. Four hours of serious seat overlap and pungent diaper odour made a very strong drink an absolute priority on my arrival. Terry Begg was there to meet me and did not disappoint. However, I was staying at his house and, from the smell, seemed to be sleeping in the same bed as his two dogs. I hesitate to mention this because he is most sensitive about his two schnauzers.

• • •

Hailey, Idaho: early morning in late August and already there was frost on the ground, which was not surprising at an altitude of 6,000 feet. Terry and I met Maurice at the town's airfield and he introduced us to Mike, who was to fly us to the research area. I noted with interest Maurice's purchase of a fishing license for each of us before take-off. Our one-hour flight in a twin-engined, six-seater aircraft took us over country with names that were truly reminiscent of the Wild West: a place called

Boulders, then White Clouds and across a wide valley to the Sawtooth Range, over the headwaters of the Salmon River, down Middle Fork, across the River-of-no-Return Wilderness and the Salmon River itself until we touched down on a grass strip between stands of pine trees and taxied toward a cabin nestling close to the river. This was Running Creek Ranch, no longer a ranch since it was bequeathed to Maurice's organization and was accessible only by air or on foot or horseback.

• • •

A TV documentary titled *Ghost of the Rockies* was made here about a female cougar. Maurice built a very large enclosure where this captive-raised animal would produce her young. The plan was to release all of them into the wild, which is indeed what happened but not without tragedy. One of the cubs, when almost mature, leaped the fence and was set upon and killed by a resident wild cougar. After the successful departure of the others, an even greater blow was the loss of the mother. By then, she was completely unconfined and free to roam the area at will; but a stranger hiked in, set up camp and, glancing up from his breakfast one morning, saw the cougar nearby watching him. Instinctively, he reached for his rifle and shot her. Sadly, the cougar had little fear of humans, and the man had no knowledge of her tame upbringing.

• • •

Here, in this wilderness of mountains, forests and clear streams, wildlife roams basically unhindered as it must have a couple of centuries ago. There are no roads or power lines, nor the subliminal noise of machines. I climbed 2,500 feet through aspens, Ponderosa and lodge-pole pines, Douglas firs and spruce, searching the ground for tracks and the undergrowth for signs of life. I saw deer and a pair of coyotes. Sitting motionless, I

made the high-pitched yip of a jackal, and they slunk closer to investigate this strange being, bolting when they realized that I was just another human.

Cougars were there, but I did not see any—not even a track. Maurice said they must have followed the elk herds high into the mountain meadows. It was disappointing but not unexpected. Already I had made plans with Maurice to return in the winter, so maybe then my luck would change. I pondered the strength of this cat. They can bring down and kill a one-thousand-pound elk, and yet they themselves weigh from 100 to 120 pounds. I was told that they initially hit the elk so hard and with such speed that it bowls that big animal clean over.

• • •

I was standing on a rock in the middle of Running Creek, trout rod at the high port in my left hand, landing net in my right and my expensive Minolta camera in a holster on my hip. A steelhead trout was fighting at the other end of the line. As I struggled to control the situation, I slid from the rock into shallow water, my boots filled up, the camera slipped into the river and the trout escaped. I think, in America, this is termed a SNAFU. The camera was a write-off and probably, if I had looked through the view finder, I would have seen that trout laughing at me.

Later, with shorts and sneakers replacing the other sodden clothes, I caught up with Maurice, who was expertly thrashing the waters upstream. As I stood in the shallows admiring his skill, a sixth sense made me glance down to my right and there, on a rock in the water, not eighteen inches from my bare leg, was a two-and-a-half-foot-long rattlesnake with head drawn back in the strike position. Gently, I eased away, thinking how unfair it was not to have given me warning with its rattle. In fact, I prodded the snake with my fishing rod, but only after a vigorous poke did it offer a feeble rattle.

• • •

Our last evening at Running Creek developed into one of those fishing stories-tall stories-squalid jokes-'one-for-the-road' affairs which caused some painful regrets the following morning when 'Crazy' Mike, the pilot, flew in to lift us out. He chose that morning to take us back via the scenic route—which, in his language, meant flying close to and between the mountain peaks, banking steeply to give us even better views and roller-coastering

In winter at Yellowstone National Park, bull elks come down from mountain meadows to feed at lower elevations. At left, Dr Maurice Hornocker and I fished for steelheads in Running Creek, Idaho.

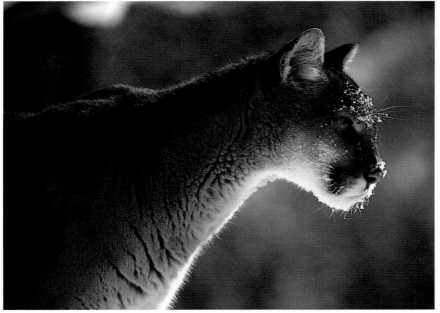

through gut-wrenching turbulence. Another of Terry's many hang-ups came to light: he is a lousy flier even when not dreadfully hungover.

• • •

Four months later and I was back, just a few days before Christmas. Susie, my wife, was with me, and we planned to spend Christmas itself in the lodge in Yellowstone before joining Maurice and his collared cougars. Terry had set up everything, including two days in Boise to recover from the long journey, but the party season had started, so it was hardly a rest cure.

On Christmas Eve, we left at 5.30 A.M. and at midday reached West Yellowstone on the national park boundary. Here we met up with fellow wildlife artist Rod Frederick, plus his wife and two children. Snow was blowing horizontally through the streets, stinging the face and making me wonder for a moment what a man of Africa was doing in this terrible -25°C climate.

We traveled in a snow bus for the last leg to our lodge. I was disappointed. Firstly, I did not expect to see more than half a dozen people here, but the place was crawling with tourists. Secondly, I expected to stay in the big lodge next to the famous geyser, Old Faithful; no such luck—we were in dormitory-like cabins. Apparently, the famous lodge is too large to heat in the winter. For that matter, *anything* would be hard to heat in this place.

The snow bus was very noisy and uncomfortable, so it was a relief to reach our destination. The cabins were, in fact, warm and comfortable. Disregarding the discomfort of our transport, we did see lots of wildlife: bison, elk, coyote, trumpeter swans, bald eagles and various waterfowl. And snow—more than I had ever seen. We were told that even for this place, the snowfalls had been exceptional.

Terry had decided to give everyone a uniform for evening wear—long, tartan-flannel night-shirts, so we tramped around that evening wearing these and snow boots, singing carols to our bemused neighbors.

• • •

I am accustomed to spending Christmas on the equator, wearing shorts and sweating over the traditional fare in the noon heat. This was certainly different, and we started by circuiting Old Faithful on cross-country skis—for Susie and me, a first—most of the time, helpless with laughter. Then, onto West Thumb Thermal Basin in that infernal snow bus—but what an extraor-

dinary place. Steam jets shot from the ground, covering nearby trees with a fine mist which promptly froze, giving a spectacular effect. A lake was covered with a thick layer of ice, but fifty yards out we discerned movement: a family of otters cavorting in their peculiar caterpillar-like gait. They were in and out of a hole in the ice and evidently had been bringing out fish; near us, on the shore, a crafty coyote watched intently for a chance to dash out and steal one. I marvelled at any living thing which could survive the temperature of that water.

Everywhere I looked, the scenery was breathtaking and I shot roll after roll of film, wondering if and hoping that I had the right filter on my lens and was following the correct procedure. I am pathetically hopeless with anything technical, which includes instructions in a camera handbook. It was easy to forget that I was here on a mission—to find the elusive cougar—but I was not going to be short of background material in which to paint him.

On the way back, I noticed a sign saying that we were at an elevation of 8,000 feet, an altitude similar to the Kenya highlands, so I felt acclimatised.

● ● ●

The day after Christmas was a nightmare. If I thought that the number of people was high when we arrived, that was nothing. The park filled with day-trippers on public holiday, and at West Yellowstone, even if you are barely twelve years old, it is possible to rent a snowmobile; so the access road was a solid convoy of these machines and the noise was tenfold that of a dirt-bike scramble. A mile from the lodge, a herd of bison plodded sedately across the road. One old cow stopped to chew cud and, I am sure, to frustrate the hundreds of snowmobilers backed up on both sides. Who said animals don't have a sense of humour? The bison's ponderous gait is misleading: we were warned that several people who failed to recognize them as wild animals had been killed.

The bison were almost buried by the snow as they dug deep to find fodder. These dark-coloured animals are a real challenge to photograph against the snow, and I was sure my shots would show the animals as pitch-black silhouettes, fears which eventually proved completely founded.

Terry and I rented a snowmobile and found an offshoot track which had been ignored by the hordes. Still no sign of the big pug marks of a cougar,

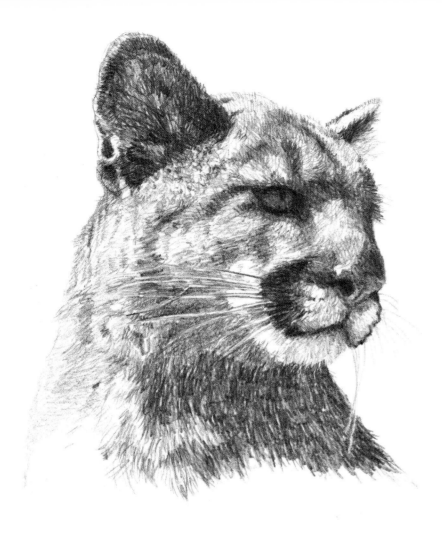

we arrived and no-one seemed to know how to handle it there. Power lines were down, and the motel where we stayed was without light or heat.

The next day, we found the wildlife refuge and, despite some reluctance, were allowed in. They were not normally open at this time of year but made an exception when we mentioned Maurice's name. The animals were in small cages which were covered with about a foot of snow. This made photography impossible in the gloomy light, so we volunteered to help clear it off. The animals got a new lease of life—anything to alter their boring daily routine, and so much snow was evidently a rarity. At last, we could concentrate on sketching and photography, and I felt a bit happier that I had some reasonable material even if the wild cougars were not seen. There were other cats there, too: Siberian tigers and jaguars, the latter looking distinctly miserable in the cold weather.

• • •

After a long and hazardous return drive to Boise, we learned that, due to the unrelenting snow, both Yellowstone and Glacier National Parks were closed. So much for the great plan to find a wild cougar. I was very disappointed and now would have to compose my cougar painting using animals which I have seen only in captivity. Maurice kindly lent me some excellent slides of wild cougars which he had taken over the years to use as reference.

• • •

This became the main challenge for the cougar painting. My reference material from captive animals was rather unimpressive—bland-looking cats standing or sitting in boring poses behind bars. What should this animal be doing in my painting? How could I introduce movement and an air of expectancy? These are questions I ask at the start of every painting, and the answers are governed by any number of factors, the most common being the availability of photographic material or sketches of the animal reacting to a certain situation in the wild. I lacked that advantage, but my eventual composition was inspired by one of those memorable snow scenes from Yellowstone.

Piecing together a collage of shots of snow-laden pine trees, I was drawn to the foreground where a strip of sunlit snow crossed the entire scene slightly downhill from left to right. It was like a spotlight on a stage, and it cried out to be filled with an interesting subject—like a cougar? Could I not

but on this machine, at least, I was getting practice for our later safari with Maurice to track the ones he had fitted with collars.

We left Yellowstone the next day and looked forward to our imminent return—in a week's time—when we would rent snowmobiles and track Maurice's cougars, both there and farther north in Glacier National Park. Meanwhile, leaving Susie in Boise, we drove westwards to the Olympic Peninsula in Washington State—specifically, to a wildlife refuge at Sequim where many animals, including big cats and wolves, are taken care of after a life in movies, TV or as pets. Maurice had recommended this place just in case we failed to find a cougar in the wild. Snow was falling heavily when

portray it running through that sunlit snow, following the spoor of a deer?

Gradually, using the meagre reference material at my disposal, I put together a master drawing of a running cougar. Then I made a model from plasticine, with the objective of ensuring that the sunlight hitting this cat would correspond exactly to the angle at which it was shining on the pine trees. By using a strong light on the model in the studio, I could adjust it as required.

At last, I was satisfied with my master drawing and all the other elements, so the canvas was stretched and I started to paint. Instantly, a new challenge: snow. Yes, that stuff which had already caused so many problems. Never had I really tackled a snow scene, yet here I was with acres of it. It became an interesting experience requiring some new additions to my Africa palette, especially the blues. It was fascinating to me that almost none of the snow in my painting was completely white. Trees, leaves, rocks and the cougar itself all seemed to reflect their individual colours, in the subtlest of tones, back onto the snow. In turn, the snow's lightness reflected up onto the undersides of objects in rather the same way as a mirror. Just the construction of a hoofprint was a challenging undertaking, working out the light source and how that would create the blue and mauve shadows in the disturbed surface of the snow.

Painting the coat of this cougar was quite different from any other cat that I had previously portrayed, namely the cats of Africa, all of which have short, sleek hair which mostly lies flat to the skin. As such, it is relatively simple to paint by making the brush strokes conform to the direction in which the hair is lying. However, the cougar, especially with its thick winter coat, has a dense covering of hair which lies almost at right angles to the animal's skin—and, furthermore, the colour of each hair varies from the root to the tip. Hence, it is necessary to paint it with a kind of stipple effect until you come to a part where the underlying skin bends in a concave curve—for instance, on the neck where the fur is particularly dense, and as the animal turns its head, the coat on the opposite side to the direction the cougar is facing will open up a series of jagged canyons and crevasses, revealing a completely different colour to that which you see on the surface. In short, it seemed to take a whole lot longer to paint than a cat with a fine coat.

The completed canvas, measuring twenty-four by forty-eight inches and titled *Snow Tracker*, was duly consigned to The Greenwich Workshop, and I heaved a sigh of relief, hoping that the remaining paintings would not be so demanding. Imagine my frustration, fury and despair when they called me very apologetically to say that, with great respect, they did not think the cat itself was up to scratch. It looked wooden. Could I do something?

With dark mutterings and vile, whispered threats, I set about scraping off the whole cat with a knife, knowing in my heart of hearts that they were right and feeling almost guilty that I had been caught trying to pass off something which was not up to my normal standard. The original drawing, the model and all other sketches went out the window. I kept the background intact but started completely afresh with a new cat. This one was much better, although the head—yet again—was not quite right and had to be replaced. Poor old cougar. He had a rough passage, but I was well pleased with the final result.

A tiny cougar cub, born in captivity in rural Kansas.

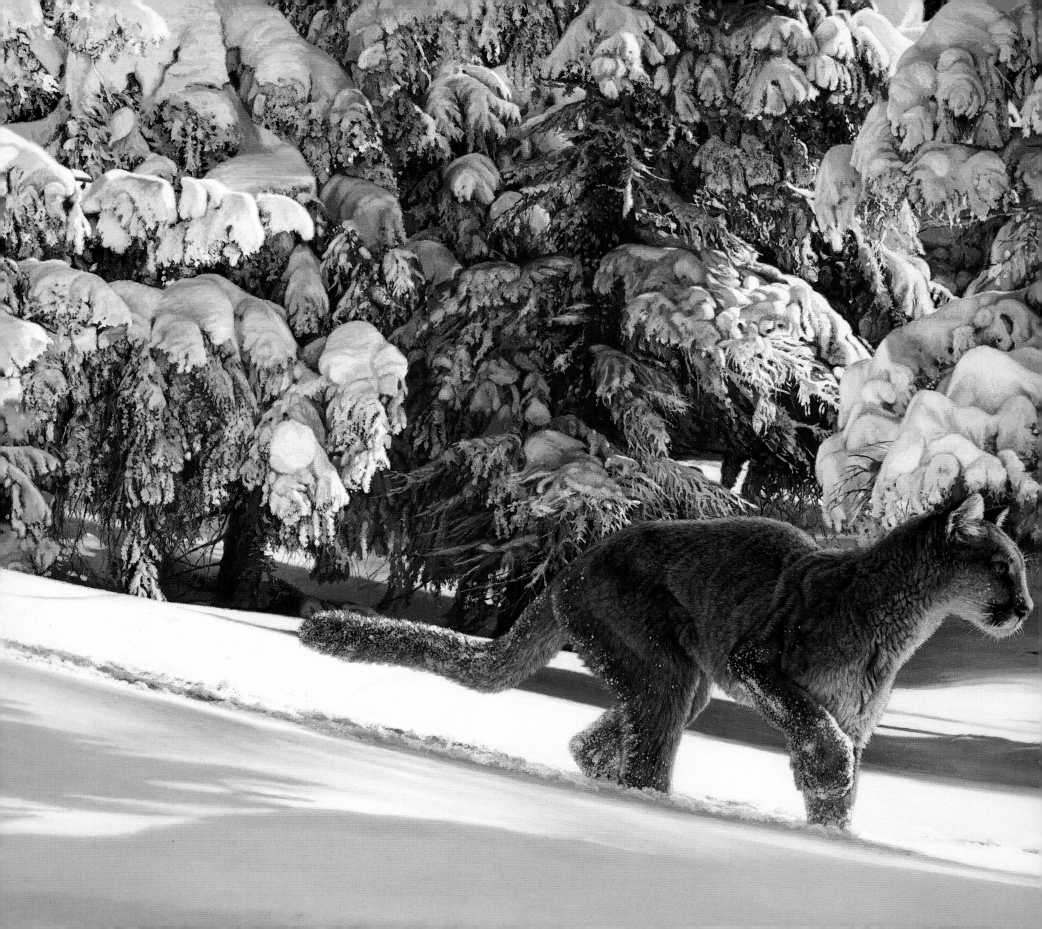

SIBERIAN TIGER

PANTHERA TIGRIS ALTAICA

Russian bureaucracy dominated the start of this trip. Before leaving for the winter safari season in Kenya in January, I set the wheels in motion to obtain a visa to join Maurice Hornocker in Siberia in March. He had provided the necessary letter of invitation from a prominent scientist on the Siberian tiger project, and I assumed all would go smoothly. The project was a joint co-operation between the Hornocker Research Institute and Russian wildlife scientists to capture Siberian tigers, fit them with radio collars and conduct extended research into their movements and habits. This would provide precious information in the fight to save the last of these, the world's largest felines.

But my luck was out. The Russian authorities rejected the letter, so I was back to square one with only a few days to go to my departure date. Frantically, I called Maurice and Terry Begg in the States, and they set about trying to obtain the right authority from the Russian Consulate in San Francisco. Still no word, and the days crept by until they themselves had to leave. Their route would take them westwards to Siberia whilst I was to travel east across the continent of Asia to meet them there.

Now I was on my own, trying in vain to be philosophical. As my flight date drew ever nearer, I started calling anyone I knew who might have the slightest idea as to what I could do. The Russians in San Francisco rejected my application. Then I was told about Steppes East, an outfit which organises adventure tours in the wilder parts of Asia. They told me I would never get a visa unless the person issuing the invitation had a KGB number—did Maurice's scientist, who had written my letter of invitations, have one? I had no idea. They were aghast at my plan to fly to Moscow, change airports to connect with another flight to St. Petersburg and thence across the continent to Khabarovsk in Siberia. Did I have any idea how long it takes to change airports in Moscow? Was someone meeting me there and in St. Petersburg? In the end, I asked them to re-arrange

DESCRIPTION AND BEHAVIOUR: The winter and summer furs of the Siberian tiger (as well as the extinct tigers of Turkestan and the Caucasus) differ sharply. The hairs in winter grow dense and long, giving some animals a plush or even shaggy appearance. The winter coat is generally paler, or more ochraceous, than in summer.

HABITAT AND DISTRIBUTION: *P. t. altaica*, the Siberian tiger, is found in the Amur River region of Russia and China, and in North Korea. Tigers require adequate prey, cover and water, and their ranges vary in accordance with prey densities. While females need ranges suitable for raising cubs, males seek access to females and have larger ranges. In the Russian Far East, where prey is unevenly distributed and moves seasonally, ranges are as large as 100–400km² (39–154sq mi) for females and 800–1,000km² (309–386sq mi) for males.

Tigers are not reluctant to enter water; some have reportedly swum 8km (almost 5mi) across the Amu-Darya and Amur Rivers in the Caspian area and the Russian Far East, respectively.

POPULATION STATUS: Tigers in Russia in 1994 numbered only 150–200, most located in Primorye territory, with a smaller population in Khabarovsk. The Russian tiger population fell as low as 20–30 animals in the 1930s but recovered under protection from hunting extended in 1947. Only about 20 percent of Russia's tiger population is found in protected areas. Outside these areas, commercial logging and hunting of ungulates are on the increase. Tiger density in the Sikhote-Alin mountains of eastern Russia has been estimated at 1.3–8.6 (including young) per 1,000km² (386sq mi); high-quality tropical habitats can support 7–12 tigers (includ-

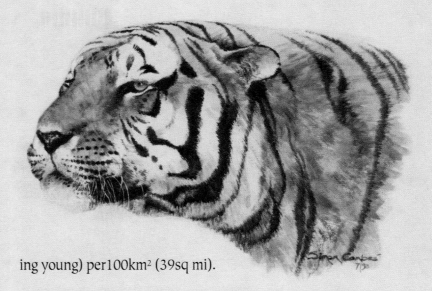

ing young) per100km² (39sq mi).

PRINCIPAL THREATS: The Russian tigers have come under increased poaching pressure in recent years as political and economic change has swept over the region. Tiger bone and other body parts are used in traditional Chinese and Korean medicines. Today, the changed conditions in the former Soviet Union, and what appears to be a combination of increased demand among Asian consumers coupled with a decreased supply of wild tigers, have made poaching for bone the pre-eminent threat to the Siberian tiger.

SUBSPECIES	WEIGHT		TOTAL LENGTH		SKULL LENGTH	
	M	F	M	F	M	F
tigris	180–258kg	100–160kg	2.7–3.1m	2.4–2.65m	329–378mm	275–311mm
	(397–569lbs)	(220–353lbs)	(8.9–10.2ft)	(7.9–8.7ft)	(13–14.9in)	(10.8–12.2in)
altaica	180–306kg	100–167kg	2.7–3.3m	2.4–2.75m	341–383mm	279–318mm
	(397–675lbs)	(220–368lbs)	(8.9–10.8ft)	(7.9–9ft)	(13.4–15.1in)	(11–12.5in)

Peasant farmers north of Vladivostok, Siberia, must guard their cattle, horses and dogs from the tigers. Our hosts in Siberia led us through the wilderness at right, pointing out fresh tracks and trees where the tigers had left scent marks.

everything, and with just three days to go, they worked miracles. Meanwhile, Terry Begg called from Khabarovsk with tantalising tales of the adventures he was having and the characters he was meeting.

At the eleventh hour, the visa was arranged. As if in a scene from a Le Carre novel, I was to meet a courier wearing black leather and carrying a brown envelope at the foot of the escalator in Heathrow Airport's Terminal One. I never saw his face (hidden under a motorcycle crash helmet) but the envelope exchanged hands, with barely a word. Now I knew I was really on my way—or did I? The monitor in the departure area stated that the British Airways flight to Moscow was cancelled. I was stunned. Moscow airport was snowed in. Would I ever get there? The next flight departed twenty-four hours later. Too late—I had to catch a flight out of St. Petersburg at that time. Panic. I had to get there that day or early the next.

The best advice I was given was to try reaching St. Petersburg via Helsinki, but nobody was prepared to commit due to the weather. What the hell—I would chance it, so I bought a ticket and sprinted to catch the flight just before the doors closed. From Helsinki, I called Steppes East and told them my new plan. My connection was to leave in ten minutes for the relatively short hop to St. Petersburg, and I prayed that they would manage to contact the person who would otherwise have been meeting me much later that day from Moscow.

This was my first experience with Aeroflot, and I was pleasantly surprised. Champagne and candies were served, and we soon landed at St. Petersburg. Snow everywhere. The temperature was -8°C. The airport building looked like something from ancient Rome—columns and painted ceilings, but very dirty and neglected.

I handed my Kenya passport to a flinty-eyed, two-star, female immigration officer who lengthily studied the many stamps and entries. Suspicion was written all over her face as she stared at me icily, evidently striving to reconcile a much-travelled white face with a passport from a black African country. At last, she banged down the stamp and nodded me through.

A slim, dark-haired, bespectacled girl approached me. 'Meestair Kombess?' I nodded with relief. In careful English she said, 'I am Tanya. Welcome to Russia.'

Outside, we took a taxi to the Pulkovskaya Hotel, a huge, ugly, gray monolith where I was given a clean, sparsely furnished, cell-like room for 120 dollars. Apparently, this was the best in town but almost empty. Tanya departed, promising to meet me the next day for a tour of the city. I broke open my duty-free bottle of Scotch for a well-earned drink at the end of an action-packed first day in Russia.

● ● ●

An interesting evening in the downstairs bar of the Hotel Pulkovskaya: a rare smattering of well-to-do Russians mixed with a contingent of noisy Finns who fly in for the weekend specifically to pick up one of the many beautiful Russian prostitutes; according to my Finnish informant, they were an incredibly good value at one hundred dollars.

I was sitting at the bar quietly sipping a beer, indulging in people-watching and sketching their faces in my little book. After a while, I became aware that the room had gone strangely silent with many of its occupants glancing furtively in my direction. Then it dawned on me: these people, so recently under the intimidating yoke of communism, must view with great suspicion and caution anyone seen making apparent notes in a little book. I gave the room a weak, reassuring smile and left, feeling somewhat humbled and stupid.

● ● ●

In stark contrast to the atmosphere the previous night in the hotel bar, the streets of St. Petersburg were gray, dirty and almost deserted on this cold March morning. There was an air of poverty, neglect and sadness despite the splendor of the Winter Palace, the imposing statues and monuments, the baroque architecture and the exotic Russian churches in this wonderful city built by Peter the Great on a series of islands

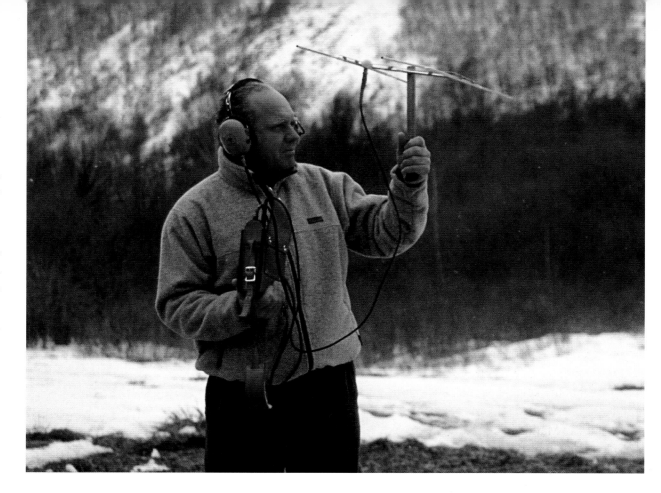

Signals were coming loud and clear from a radio-collared Siberian tiger just a few hundred yards away, but the deep snow and dense undergrowth prevented our getting a glimpse of him. We were following the tiger, whose plate-sized footprints were freshly evident in the snow trail. What if I suddenly came face to face with such a huge predator? Nowhere to hide, no trees to climb. Whose nerve would crack first?

at the mouth of the Nova River. After breakfast, Tanya arrived at the hotel in a Mercedes driven by Alyek, and they gave me a guided tour.

At one point, when we were on foot in the middle of a vast square dominated at one end by a huge arch topped by a line of horsemen, a gang of some ten or so children appeared as if from nowhere. They were in rags, and Tanya warned me to get back to the car as soon as possible. She ran ahead, but I was soon surrounded by small beggars aggressively holding out their hands and tugging at my clothes. I gripped my camera with added determination, extracted two dollar bills from my pocket and, whilst they fought over those like a pack of rabid dogs, sprinted for the car, making it just in time.

Tanya and her husband were both professors at the university but had not been paid for almost a year. He was writing a book whilst she tried to keep him and their eleven-year-old son by working as a guide. It really is tough for these people.

• • •

St. Petersburg Airport again. In the early afternoon, after bidding farewell to Tanya and Alyek, I checked in for my long Aeroflot flight and joined a throng of people in the departure lounge. Buses pulled up at the doorway, and my fellow passengers boarded—we must all have been on the same flight because the number was flashing on the board, but every time I reached the gate, a uniform sent me back with much arm-waving. Soon I was alone and feeling very much so as the buses disappeared into the distance. My distrust of officialdom began to surface again, but when I was on the point of panic, the uniform jerked his head in the direction of the door and I was off, still

alone but moving at last. Thoughts were going through my head that I might be the only person on the flight, but that was unlikely because I had been told that it was full. Later, I learned that the first buses were for Russians and the last one for foreigners—all one of us, in this case.

Then I was climbing the steps of an enormous Ilyushin and going through the door to a situation ten times as rowdy as the bar the previous night and with many times more people. They were drinking, shouting, singing and smoking; many were in military uniform, and not a single seat seemed available. I handed my boarding pass to the cabin attendant who looked at once alarmed and amused, gazed helplessly around the overcrowded cabin and then started shouting at three people sitting in a nearby row of three seats. They did a bit of shouting back but then, with reluctant resignation, lifted the arm rests and shuffled up tight to make room for me. Three seat belts for four people was a cosy prospect, but ultimately it didn't matter because nobody seemed to bother with them.

My neighbour explained in halting English that they were marine biologists heading for the Institute of Marine Biology at Vladivostok. We spent much time discussing fish, particularly the game fish of the Indian Ocean, which I amplified with sketches. These were good people, but in the row in front was a very sinister situation: two Russian Army officers—one devastatingly smooth and good-looking, the other totally evil, with a weak, thick-lipped mouth; red-rimmed, piggy eyes; a pathetic pencil mustache; greasy hair and a tortured, hacking cough which made me want to hold my breath all the way to Siberia. From time to time, they both got up and locked themselves in the toilet together. I was sure they were KGB and prayed that I would never have them as interrogators.

At 3 A.M., we landed for refueling at Krasnayarsk in Siberia. Everyone had to get off and file into the airport building, tramping through deep snow, escorted by men in heavy greatcoats. It was bitterly cold but inside there was a bar, and I offered to buy my new-found friends a beer. There was a near riot when I offered to pay with one-dollar bills. More of the communist hangover—my friends quickly tried to smother sight of my money and pay the bill with roubles, but several men close by had seen my money and started shouting loudly at me. Did they want to do a deal, or were they officials telling me I was either breaking the law or a filthy capitalist trying to corrupt the poor people of Russia?

I was hustled out by the marine biologists and set off to find the restrooms, which were situated down a long, dark corridor in the basement.

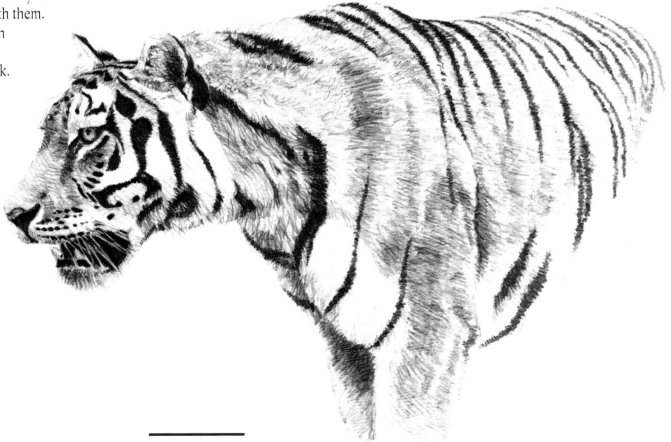

Peter Jackson of I.U.C.N's Special Cat Unit found these home-made wooden skis in a forest ranger's cabin in Siberia.

Half-way through, in the dim light, I discerned an old lady wrapped up in layers of shawls, sitting behind an upturned box. It transpired that she was selling single sheets of toilet paper—a rouble a sheet. They were marginally larger than a rouble note, and mentally I questioned the point of such a transaction. The rouble note might even have been softer.

I did not like this place, Krasnayarsk. It had a nasty atmosphere, and the name rhymed neatly with a conveniently crude, three-word, Anglo-Saxon phrase. It became 'Kissmayarse'.

• • •

Khabarovsk Airport has the reputation of being the worst and slowest in all of Russia—even worse than Kissmayarse. It was dirty and untidy, and my much-travelled, battered, canvas suitcase, held together with double leather cross-straps, took an eternity to appear. Every other bag on the conveyor was heavily swathed and sewn up in sack cloth—precautions against un-controlled pilfering and theft. As I finally reached to lift my bag, a very large Russian whisked it from under my nose, gave me a huge grin and said, 'No

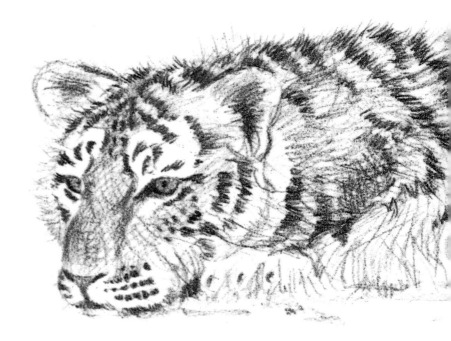

problem!'. This was Yuri Orlov, boyfriend to Lena, the interpreter for Maurice's team. Outside, we crammed into a small, much-dented car with Lena and Terry Begg, who already seemed to have established himself as the resident comedian.

Yuri was a safari operator, Siberia-style. He ran hunting and fishing trips but, judging from the contents of his house—the largest audio system I had ever seen, speakers the size of a cabin trunk, the very latest in TV and VCR, stacks of microwave ovens and other electrical appliances—there must have been a nice little sideline. Lena had spent time at school in the United States, so she spoke good English but was struggling to understand some of Terry's jokes and innuendoes.

Our hotel was yet another typical, grey, concrete block. The Spartan room was dominated by a twenty-four-inch TV and a huge refrigerator which did not work. After checking in, we visited Khabarovsk market. In contrast to the gloom and despondency of St. Petersburg, this place was positively humming. Certainly, there was evidence of poverty everywhere but also a hustle-and-bustle atmosphere of enthusiasm and excitement.

The market filled a vast, high-ceilinged hall which had a second-floor balcony round the inside. Rows and rows of stalls lined the main floor where throngs of people bought and sold an astonishing variety of commodities—meat and fish of every kind, fruit and vegetables which one would hardly associate with a frozen Siberian winter, bananas, pineapples, citrus, even fresh roses (we bought a bunch for Lena), chickens roasting in a rotisserie, pastries, building materials, clothing (including jeans), spices, drinks. At vast expense, we purchased a can of Coke each and, as we toured the stalls, gathered, like Pied Pipers, an increasing following of ragged children. Maybe it was the rarity of seeing strangers—but no: as soon as we threw an empty Coke can into a trash bin, there was a frenzied stampede and scrum to grab and carry away such a precious trophy.

Outside, twenty-foot icicles hung from the building's roof, and more stalls lined a large, open space from which the snow had been pushed to lie at the edges in great drifts. These stands were dominated by the fur sellers. Astrakhan hats, coats of every length, gloves and boots, all in a variety of fur—sable, silver fox, mink and many more. The sellers themselves were hard-looking men from a variety of ethnic backgrounds: Chinese, Mongolian, Caucasian—one particularly evil specimen, with slant eyes and a long, drooping mustache, spoke enough English to tell me that he was born in Mozambique. Alongside them

were Gypsy women selling garments intricately woven in Angora wool, and old ladies bundled up against the cold in layers of shawls offered bric-a-brac, small odds and ends, even single cigarettes and boxes of matches.

• • •

Yuri took us to dinner at a hotel/restaurant in which he had a share. A bouncer at the door barred everyone who was deemed unsuitable, but with the big man as our escort, we were whisked through to a clean, richly furnished room where an excellent meal was washed down with quantities of beer and vodka. That is the way here; with money, one can live a good life. In fact, the meal cost us seven dollars each, which was outrageously expensive for this country.

Terry noisily proclaimed me to be an accomplished joke teller so, despite my protestations and serious jet lag, I was persuaded. 'Tell us the one about the antique dealer,' he yelled. This joke required props, including two round objects to represent Nebuchadnezzar's testicles; imagine my astonishment when, in the kitchen, I discovered a pair of kiwi fruit—in Siberia? The joke dragged on, suffering a serious continuity problem as each sentence was faithfully translated by Lena for the benefit of Yuri and his cronies, who laughed uproariously even though the funny part had not been reached. The punch line, accompanied by the appearance of the kiwi fruit, caused even more hilarity, and I wished I always had such an appreciative audience. I

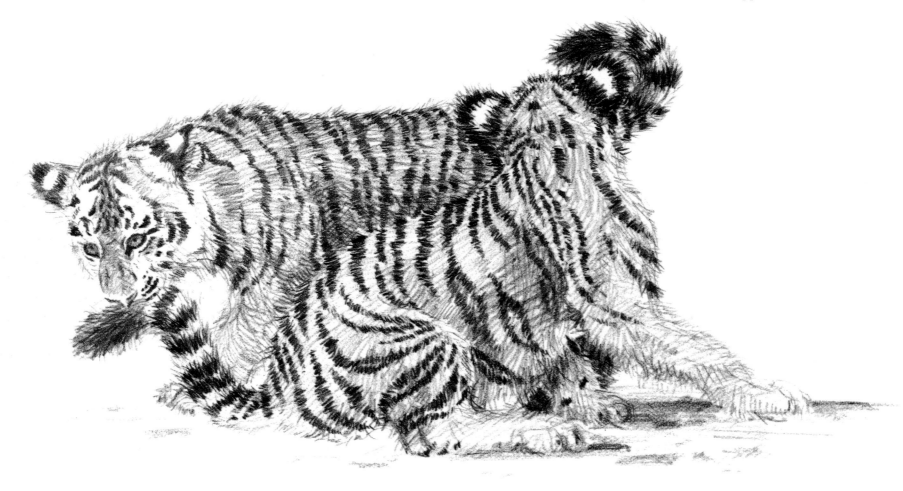

doubt very much if any of our Russian friends understood anything about the story, but Yuri was insistent that I repeat the whole performance the next day in front of his video camera.

By then, I was exhausted and longing for my bed. Back at the hotel, I trudged up the central stairwell to the third floor. On each landing was a desk manned round the clock by a 'matron' strategically positioned so that she could view the long corridors on either side. I tiptoed past the third-floor dragon, giving her a nod and a weak smile, and feeling like a naughty schoolboy who has been caught climbing up the drainpipe. There was no acknowledgment—just a stare—and I imagined her making an entry in her log for the commissar: 'Watch the foreigner in 322'.

Room 322 boasted a large TV set which did not work, a telephone which rang at intervals all night with an angry-sounding, unintelligible Russian at the other end of the line, a bed with a lumpy mattress and a window which would not close. Outside, the temperature was -20°C, so I donned another two layers of clothing and spent a very wakeful, uncomfortable first night in Siberia.

● ● ●

The team assembled at Khabarovsk Airport for the next leg of this marathon journey to Ternay. There had been a Siberian tiger symposium in Khabarovsk over the preceding few days so, in addition to Maurice, Terry and myself, there were several other visitors. After the inevitable, long-drawn-out bureaucracy, we finally boarded our twelve-seater Antonov 28 STOL which had been rented from Aeroflot and headed south for Ternay, a small town on the coast of the Sea of Japan, where the scientists had their research base. The pilot demonstrated the maximum short-take-off capabilities of this aircraft, leaving the ground after only fifty yards, pointing it at the sky at an angle of 45° and ignoring our loud complaints as items of loose baggage slid rapidly to the rear of the cabin.

After an hour-and-a-half flight over unspectacular, snow-covered mountains, we landed on Ternay's dirt strip and taxied to a dilapidated airport building where the only sign of life was a pig rooting in the front yard. Eventually, some jeeps arrived and took us to the headquarters of the tiger reserve, where we were introduced to the director, Dr Anatoly Asafiev, a very serious man with strangely penetrating eyes.

Terry and I were greeted by the only sign of life at the airport in Ternay, Siberia.

Ternay, population 4,000, resembled a frontier town of the last century: wooden houses and shacks built round a river estuary; pot-holed, muddy roads; livestock in the small, fenced yards of most of the houses; and piles of snow everywhere. Our ultimate destination was five miles out of town, a cabin in the woods close to the beach at a place called Blogadatna. There, we were welcomed by the housekeeper, Emma; assigned our sleeping quarters and treated to the ubiquitous borscht, a greasy, grey soup with swimming chunks of unchewable beef (?) and the occasional strip of pallid cabbage. In one brew, I swear I saw a cow's eye wallowing unblinkingly on the surface. In pleasant contrast, the dessert was berries and wild honey.

That afternoon, I walked the half mile to the coast of the Sea of Japan. A bleak, pebbly beach stretched far in either direction; the sea itself was a deep indigo blue, and the air, crisp and bitingly cold. To the south, separated from the sea by a narrow peninsula of sand, was a small, frozen, inland lake where two Russians fished through an ice hole. Back from the beach were birch woods and open glades of tall, tufty grass which was a

nightmare to walk on, and all around were snow-covered mountains. There were many signs of elk, and in the distance I glimpsed some wild boar. Altogether, a stark but beautiful setting.

Our cabin had five rooms all built round a large, iron stove which threw out tremendous heat and effectively warmed the whole building. There was no running water—just a basin attached to the wall and a jug on the floor. Fifty yards away in the woods was the *bania* (sauna)—a small, divided wooden hut, one half in which to strip off, the other containing a small stove which produced fierce heat. We sweated out several days' worth of grime and then, as instructed by our Russian hosts, rushed outside and rolled naked in a snow-drift. No gorgeous blonde to thrash me with birch twigs, but it was certainly invigorating.

In the evening, we were joined by Anatoly Asafiev, Sergei Smirnoff (a local tiger tracker) and a lady called Luba, a schoolmistress from Ternay who was to be our interpreter. The inevitable vodka session developed. I

The research team posed before taking off to monitor radio-collared tigers.

presented a copy of my book *An African Experience* to Anatoly, who was visibly moved, and the others received handouts of duty-free cigarettes. Sergei proceeded to do justice to his illustrious name.

I have slept on some seriously uncomfortable beds during my travels, but this one beat them all. The springs sagged low under the frame, and the mattress, if you could call it that, must have been filled with individual, knotted lumps of stuffing rather reminiscent of the porridge I was expected to eat as a small boy at boarding school. In desperation, I tried moving it onto the floor but, in the end, abandoned even that and slept on the floor itself.

• • •

The Antonov 2 is a rugged biplane designed to carry about eight passengers—or the equivalent freight—and fly in tight terrain. We hired one from Aeroflot the next day (Aeroflot seemed to own all aircraft in the country at that time) with the aim of locating from the air those tigers which had already been fitted with radio collars. The two Russian pilots, dressed casually in khaki coveralls, were obviously relishing the chance to do something different, and whilst Begg viewed the prospect of his next few hours with pale, tight-lipped fortitude, Sergei took frequent boosts from his ubiquitous bottle-in-the-bag. Having fitted the small receiving aerial to one of the wings, we took off and started quartering the vast, snow-covered, mountainous, 1,400-square-mile Sikhote-Alin reserve, flying in tight circles about 200 feet from the ground and banking steeply to avoid the mountain slopes all around us.

The aircraft's cabin was very basic—just folding canvas seats against the fuselage, and certainly no heating or toilet. I noted with interest a familiar cable running along the roof to the door, onto which paratroopers could clip their static lines. Terry, whose face was now a delicate shade of grey-green, started making frequent lurching treks to the rear of the cabin to heave his breakfast into a large, crumpled tarpaulin.

By noon, we had located and pinpointed on the map four different tigers. Each was circled several times at about 100 feet from the ground but despite straining my eyes, I could not catch even the slightest glimpse. It astonished me that such a large, primarily yellow cat could conceal itself so effectively in a completely white, snow-covered landscape.

The next phase was interesting. We were to try and walk up on the four tigers we had found from the air. The first location was deep in the pine forests and a long drive from Ternay. The snow got deeper and deeper as the afternoon wore on until, eventually, the jeeps could go no further, and we continued on foot down a faint track, over a rickety bridge spanning an ice-covered stream. This place was called Nachet.

Up the far bank was a two-roomed log cabin, the base for two forest guards—Vasiliy and Sergei—who doubled as tiger watchers. On that particular afternoon, they both seemed incapable of guarding anything. They stood on the porch dressed in grubby, unlaundered clothes, their eyes half closed, gazing vacantly at this strange invasion of their squalid patch of *taiga* (forest). I was reminded of the movie *Deliverance*. Outside the cabin—tied, thankfully, to a post—were two vicious-looking, wolf-like dogs surrounded by a random scattering of rusty tin cans, empty bottles, dog dung and other assorted garbage. (One of our guides remarked that if you are a long-haired dog in Siberia, it is necessary to be fierce to avoid being made into a hat.) Inside, as I skirted cautiously past the two sinister inhabitants to explore the room where we were to sleep that night on the floor, the stench of stale liquor reached intoxicating levels. The reason soon became apparent: on a shelf were four 5-gallon milk churns full to the brim with fermenting birch sap.

As the light was fading, we set out for a nearby ridge where one of the tigers had been located from the air. My feelings were mixed when we discovered that the animal had moved away, probably a substantial distance, since that morning. The decision was made to move back to Blogadatna that night. Much as I would have loved to see one of these magnificent rare cats, the prospect of sleeping on the floor in this cabin with the leery moonshine-makers was not one I relished.

• • •

The next few days were spent fruitlessly searching for the remaining three tigers. It was very disappointing but not unexpected. These animals have been heavily persecuted in the past so are unlikely to hang around for a bunch of noisy scientists. At one point, the signal from one tiger's collar was very strong, indicating that it was no more than two hundred yards away,

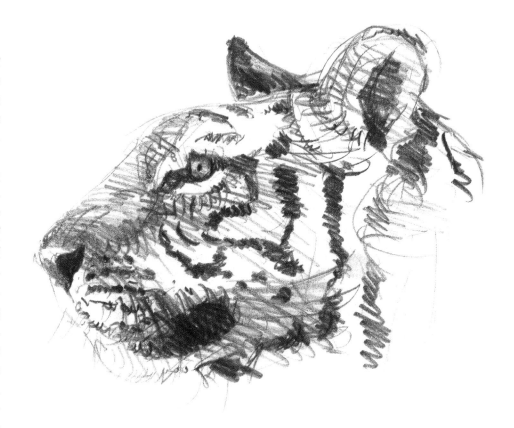

but the deep snow and dense undergrowth prevented any closer investigation. It was exciting, the prospect of actually seeing the world's largest cat in the wild, and my hopes were high as I glanced apprehensively at huge, dinner-plate-sized pug marks in the snow and the yellow-stained trees beside the trail, where the tiger had sprayed urine to mark his territory. But, sadly, our luck was out.

Nonetheless, the whole experience was invaluable to me. The animal's habitat is just as important in a painting, and I took many photographs and wrote notes on and sketched notes of pristine snow; rocky cliffs; crystal-clear, dark-watered streams; silver birch, oak, larch and pine trees; and tall, corn-like grass.

The previous summer, the scientists had trapped and collared their first tiger, a female which they named Leana. For the rest of that year, Leana's signal came through loud and clear, giving them precious insight into her

movements and habits. Carefully, from time to time, they would physically check her territory, noting her tracks and whether she had moved significantly from her previous location. Around Christmas-time, they were overjoyed to discover that she had produced a litter of four cubs.

One day in January, Leana's signal took on a tone of alarming constancy. The team drove out to investigate and discovered, to their great concern, the collar lying beside the road. Subsequent investigation revealed that, in the night, she had been picked up in the headlamps of a passing truck; the driver had reached for his rifle and shot her, cut off the collar and driven on with her body thrown in the back. With one bullet, he had probably earned, through the sale of her hide and bones, the equivalent of a whole year's wages.

Immediately a search was mounted for the cubs, and after a couple of days, all four were found, cold and hungry but fiercely defiant. Sadly, two subsequently died, but the survivors, a male and female, became celebrities who ultimately travelled to the U.S.A. to become a priceless part of a captive breeding program and a rare example at that time of successful American/Russian co-operation.

This tragic story was related to me as we trudged through the snow in what was formerly Leana's territory. What a drama. I pondered the senselessness of her killing, the pathetic waste, the feelings of futility and frustration it must have brought to those dedicated naturalists. An idea began to form in my mind, and before it had fully developed and the consequences were wholly explored, I blurted out that I would consider it a privilege to paint a posthumous picture of Leana and her four offspring. Everyone applauded. I renewed my efforts to record as much of the local environment as possible and welcomed their promises to provide photographic material of the tigress and cubs at a later date.

Only as I thought out my pledge more thoroughly did I begin to appreciate the complexities of the task I had taken on. We still had not seen any of the big, shaggy-haired Siberian tigers. My experience of painting snow was limited, and I had never seen a live tiger cub. On top of all that, I felt a great responsibility to these people who had dedicated so much to saving these animals and who had welcomed me so warmly to their very special project. This one had to be absolutely right.

A post-mortem on the two tiger cubs which died showed that their deaths were caused by a genetic defect of the diaphragm rather than the expected trauma of having to survive without their mother for a few days in Siberia's harsh climate. This significantly underlines the problem faced by a species whose gene pool has been reduced so much that genetic defects start to occur. Theories vary on the minimum size of the community needed to keep the species in existence, but the figure I have heard most is 500.

In the case of the Siberian tigers, the problem is compounded by the destruction of their habitat, primarily

for lumber. Since the end of communism, local and foreign lumber companies have cut down vast acreages of forest, leaving widely dispersed pockets of cover for the tigers with large, hostile distances in between. Hence the already-small numbers are further restricted from successfully spreading the gene pool.

Estimates put the numbers of Siberian tigers in the wild at 200–300. In captivity, there are supposed to be about 800 worldwide but, since there has not been a proper international register, the parentage of most of these is little known, and some could have been interbred with other tiger subspecies. I was told that there has been no fresh genetic input to the captive Siberian tiger community for about fifty years, so the significance of the introduction of Leana's two cubs into the captive breeding programme is immense. They could greatly assist the survival of the species.

Luba, the interpreter, was also the English teacher at the Ternay school. Before we returned to Khabarovsk, she asked if I would talk to her pupils about Africa and painting. I told her I had some slides, and she assured me that she could find a projector. From the freezing cold of a Siberian winter, we went through the school doors into a furnace. I was nervous enough as it was, but the temperature in the class-room and my winter 'long johns' soon had me sweating like the proverbial pig.

The room was draped with American and Russian flags (despite the fact that I was neither), and Luba made a long speech of welcome to about thirty teenagers. A photographer from the local press flashed his vintage camera from beneath a black cape, and the children applauded politely. The slide projector was even more dated than the photographer's camera. It was one of those which took just one slide at a time, placed in a window at the rear and then pushed across the face of the light. Panic welled up as I contemplated struggling through the 120 slides in my box.

The machine was placed precariously on a pile of books, pointing at an angle of 45° to the only small area of wall just below the ceiling which was

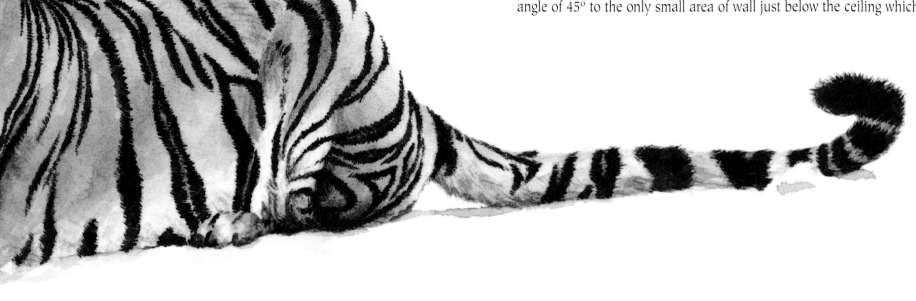

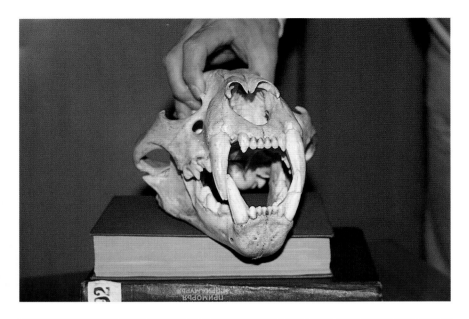

In the offices of the tiger conservationists in Khabarovsk, I had the opportunity to study Siberian tiger skulls and skins. This kind of research is invaluable when painting an endangered animal. Below: Stretching my legs in the Siberian wilderness.

not covered with flags. Laboriously, with Terry's help, I started through the slides. To my amazement, all the children spoke English, which solved one of my problems—but then, disaster struck: I fumbled one slide, bent to retrieve it and knocked the projector off its books. It crashed to the floor and broke the only projector bulb in Ternay, probably in all Siberia. At Luba's suggestion, I continued my presentation with a verbal description of my subject and then asked for questions.

Hands shot upwards, and the first question was: 'What is your favorite pastime?'

My mind went blank. 'Fishing,' I muttered.

'Who is you favorite film star?'

(I thought I was talking about wildlife and painting…)

The mind went blanker. 'Meryl Streep.'

There were many more searching questions, and I ended up much humbled by finding, in the depths of Siberia, a classroom full of impeccably mannered teenagers who spoke good English and showed a remarkable knowledge of the rest of the world.

• • •

The pilot of the Antonov 28 landed us back in Khabarovsk, again determined to demonstrate the aircraft's STOL capabilities to the full. We screeched to a halt less than a hundred yards from our touch-down point and all the flotsam and jetsam, plus our own bags which had flown to the rear of the cabin a week ago on take-off, now whizzed for'ard past our ears.

'Big' Yuri and Lena were not there to meet us so, with some trepidation, we caught a tram into the city center. It soon became evident that a tram fare could not be paid with cash; one needed a voucher which, of course, none of us had. The occupants of the tram peered at us with polite curiosity as the pantomime continued, with me delving into my phrase book and the conductor waving his arms and jabbering away in Russian. At last, an old man rose from his seat and handed the conductor sufficient of his vouchers to cover our fare. By the look of his clothes, he could ill afford it but graciously refused my efforts to recompense him in cash. Another humbling experience.

Later that night, we witnessed another display of 'Big' Yuri's impressive influence. We were taken to his favourite Japanese restaurant that evening

for a meal which, for six people, cost the equivalent of a month's wages. On the way there, his driver, Andrei, was stopped by the police and accused of driving too fast and under the influence of drink. Yuri was summoned and, after much animated discussion, the police backed off. Earlier in the day, he had dutifully taken us to the bank to change dollars into roubles but suggested that he could get us a much better rate. Of course, he did, and produced bundles of mint-condition currency still with the bank seals intact.

We were regaled with his stories of hunting trips before the communist regime ended. His clients were mostly Japanese who came to hunt bear, elk and moose. He referred to them (the Japanese and, indeed, any people of Oriental appearance) contemptuously as 'maankees'. The KGB insisted that he always take one of their agents, who would report back to his bosses on everything that happened. Yuri solved this problem by feeding the man copious quantities of vodka, thereby ensuring that he never breathed a sober, if conscious, breath during the entire trip.

In one story, President Gorbachev was to visit Khabarovsk, and local officials decided to give him a banquet of locally hunted game befitting that wild part of Siberia. Yuri was deputed to hunt a suitable elk so, a few days before the visit, he arranged to meet his driver at the top of the street at dawn. Whilst he was waiting on the corner with his rifle and telescopic sight, a Red Army truck braked to a halt, and several uniforms jumped on Yuri and bundled him into the back before driving rapidly away. For three days, he was rigorously interrogated. His captors were convinced that he intended to assassinate the president. Yuri never did get to shoot an elk for the feast.

As we walked down the icy street back to our hotel, an old Russian soldier, very much the worse for drink, with his medals pinned to his threadbare jacket, cheerfully staggered along beside us, shouting, 'Winston Churchill!' and throwing an exaggerated salute. Then, 'Roosevelt!'—another salute and cackles of laughter.

• • •

My last day in Khabarovsk was spent shopping, visiting Yuri's apartment and the local wildlife institute, where the conservationists displayed trophy heads and hides on the wall. Despite this, I was impressed by their efforts against all odds to preserve the tiger. One of them, in broken English, explained to Terry that he liked to hunt sable with his dog. Sometimes, 'dog meet tiger and tiger keel dog. If dog die, I am sad this much.' (He held his hands a foot apart.) 'But if all tiger die, I am sad this much.' (His hands were stretched to the limit.) I spent time sketching huge tiger skulls and marvelling at the size of these cats. An interesting but hopeless postscript to this visit was learning that the fine for poaching a tiger was 500 roubles. (The exchange rate at that time was 750 roubles to one dollar.)

In Yuri's apartment, Terry and I were invited to wait in the sitting room whilst he fixed some drinks. He warned us not to move because it might provoke Dick. Dick was his hunting dog, a smallish, deep-chested character with fierce, bright eyes; torn, lopsided ears; and worn-down teeth. He lay in the middle of the room and fixed us with an unblinking stare as we sat side

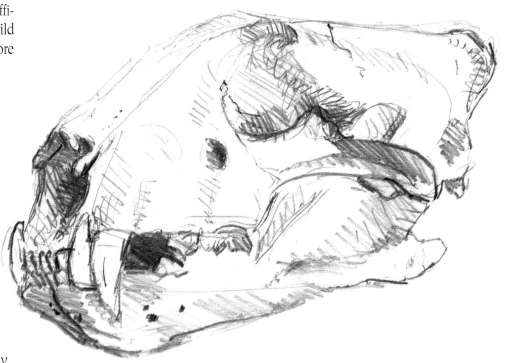

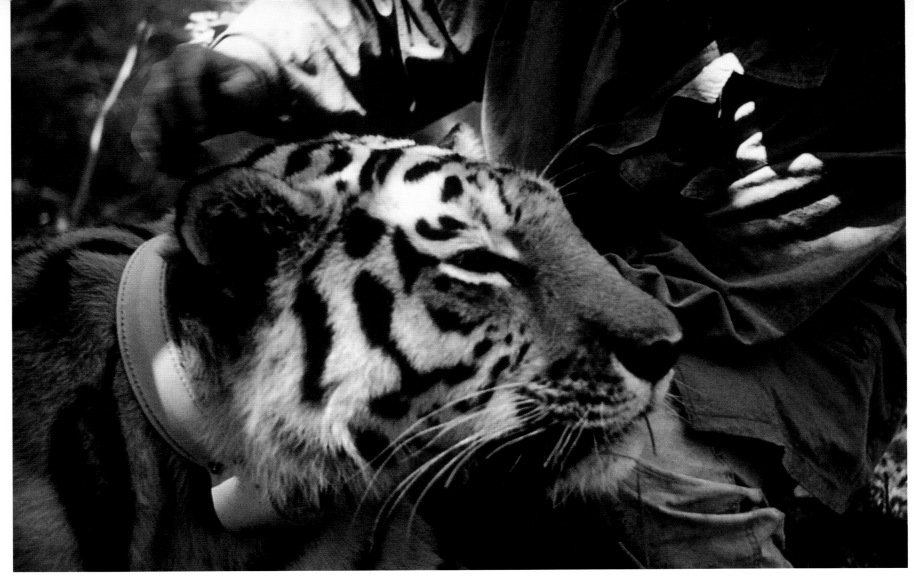

Leana, the Siberian tigress, was captured the summer before our visit. Scientists attached the radio collar while she was tranquillised.

by side on a settee like a couple of lemons. The slightest movement made Dick raise his head and growl. I started talking to Dick in dog language, a very high-pitched whine made by blowing through my teeth. Few humans can hear it, but Dick could and he leapt to his feet, rushed across the room and placed his wet nose firmly between Terry's thighs. Begg was now demanding in a stage whisper from the side of his mouth what the effing hell I did that for and what the eff he should do now. I suggested that he keep very, very effing still. Just then, Yuri returned and was impressed to see that Terry had made such good friends with Dick.

My impressions of this city, which was founded in the 1870s, were best summed up in brief in my diary: ice and snow melting everywhere; sidewalks buckled and cracked with frost; many new buildings under construc-

tion, but no work being done; many different ethnic faces, many lined with suffering; surprisingly few really poor-looking people; most business done behind closed doors—no window displays; surreptitious deals done on streets; many invitations to sell my dollars; most people very clean and well-dressed. Fur predominates, as do gold and silver teeth; drinking is a problem; police are corrupt; everything has its price—huge black-market economy; beautiful women, many with striking green eyes and proud bearing; decrepit cars, trucks and buses; hustle and bustle; back streets filthy with garbage; stray cats and dogs—heaven knows what it will smell like in summer.

We left Khabarovsk's 'worst-airport-in-the-world' the next day, laden with amber, Angora wool, astrakhan hats and sets of different-sized, hollow Russian dolls, all of which fit into one large one. Yuri and Lena bade us a fond and tearful farewell, urging us to return for a real Siberian safari.

The airport at Seoul, although run by Yuri's so-called 'maankees', was as great a contrast to the chaos of Khabarovsk as one could ever imagine. We waited there in a spotlessly clean, highly efficient airport for several hours before transferring to another flight and another adventure.

● ● ●

The Siberian tiger painting proved as difficult as expected. During my all-too-brief stay in its snow-bound habitat, we never had good sunshine, so my background shots were uninspiringly grey and dull. However, I hoped to overcome this by including a subject to contrast well with the snow: a dark-watered stream.

The portrait of Leana herself was based on a zoo animal which I was able to study. All tigers have different stripe patterns, like fingerprints, and I was fortunate to have useful photos of Leana from when she was captured and fitted with the collar, so I could transfer her distinctive markings to my study animal. There were the usual problems of changing a bland, captive cat into a lean, mean, wild-looking tiger—a task which had become depressingly repetitive.

Maurice Hornocker sent me black-and-white photos of the cubs from when they were captured and during their next few weeks in captivity. This was my biggest headache, since I was unable to find any captive Siberian tiger cubs to work from. In the end, I did what might sound like the unthinkable: I used some of the many shots I have of lion cubs, chose those which

Yuri Orlov's infamous hunting dog, Dick.

had appropriate poses to suit my composition, rebuilt them (particularly the heads) into tiger-cub shapes and, finally, put on the stripes. Did I paint stripes on lion cubs? Certainly not! But the lion poses did help; after all, a cat is a cat.

There is a postscript to this story. Four years later, I was relating my Great Cat travels to an audience at the Indianapolis Zoo. When I described the two surviving cubs' coming to America, the zoo director shouted out, 'One of them is here!' The next day, he took me on a tour of the zoo and especially to the big cat section, where I gazed in fascination at a beautiful, mature tigress named Leana, after her wild mother. She crouched and stared at me with wide, unblinking eyes, and my host inquired if we had met before. I think his imagination was getting a little out of hand, but it was fun to speculate whether this rare animal could sense somehow that she and I had both once trod the snowy wastes of her native Siberia.

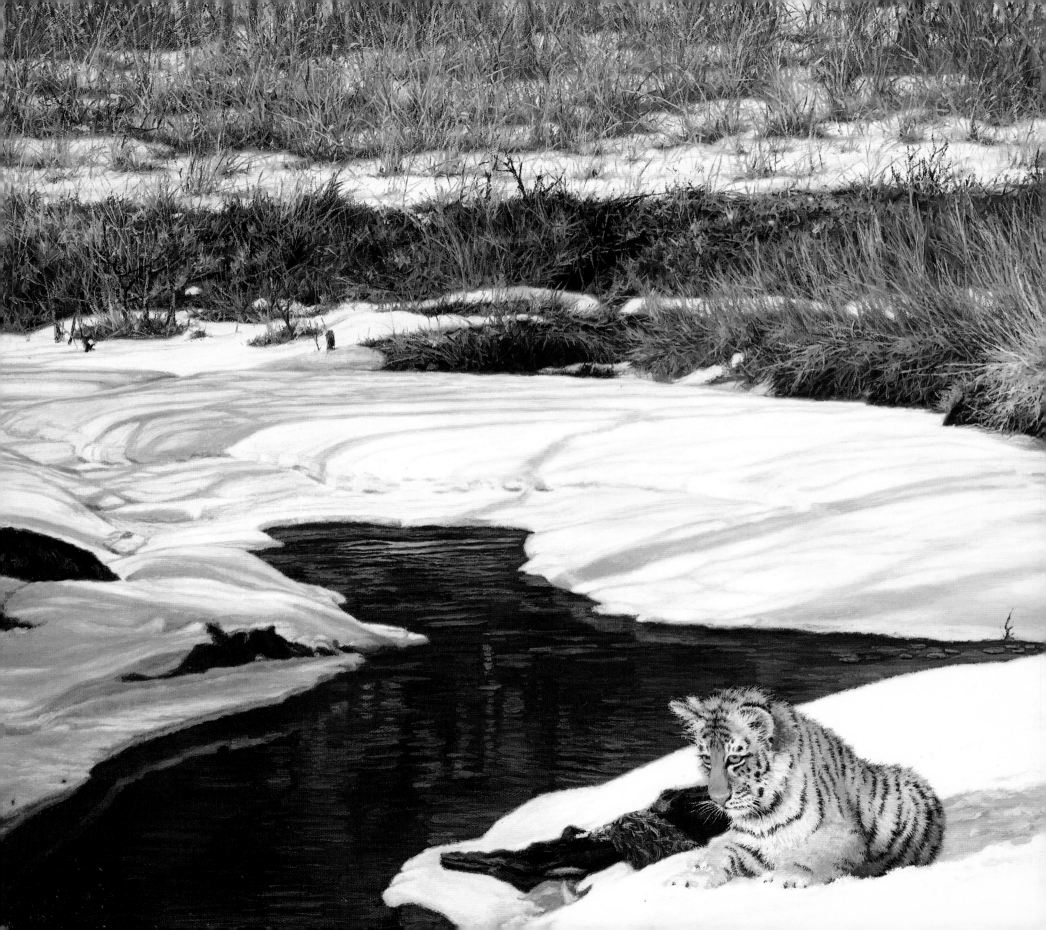

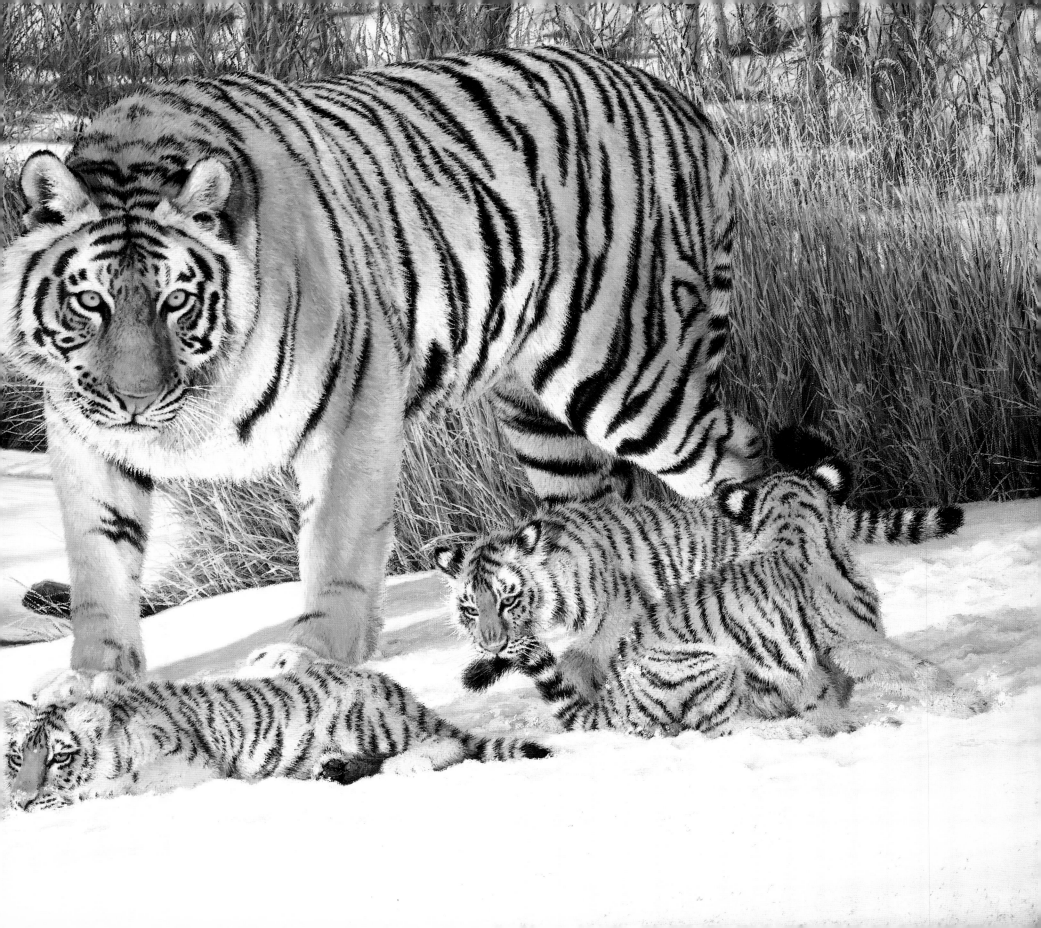

SNOW LEOPARD

UNCIA UNCIA

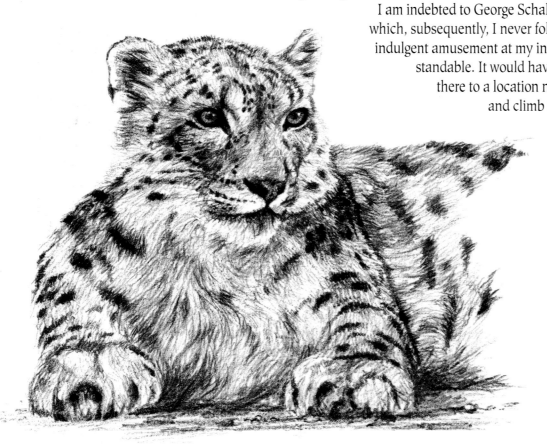

The snow leopard, fabled cat of the world's highest mountain ranges, conjures up images almost as spectral as its mysterious cohabitant, the *yeti* (abominable snowman). Initially, my plan had been to visit Nepal after the Bengal tiger safari in India so as to catch the last of the winter snow. However, my research showed that any hopes of sticking to a strict time schedule at that time of year (April) would have been the height of optimism. Bad weather could close roads and airfields for weeks.

I am indebted to George Schaller, Al Rabinowitz and Rodney Jackson for their invaluable advice which, subsequently, I never followed. George had carried out years of research in Nepal, and his indulgent amusement at my intention to find a snow leopard in Nepal in winter was quite understandable. It would have involved much preparation in Katmandu, an internal flight from there to a location near Annapurna, hiring of guides and porters, and then a long hike and climb to altitudes of between 12,000 and 15,000 feet and a bitterly cold, windswept moonscape where the chances of seeing this elusive cat were almost nil. The weather was seriously unpredictable and could have meant being stranded at any of these places for long periods. So I shelved that plan and fell back on the usual Combes alternative: hoping that something would turn up. It did. Terry Begg heard from Jack Whitman, who had been part of Maurice Hornocker's research team in Siberia and had gone on to study the rare Amur leopard on the frontier between Siberia and China. He had heard of an American field researcher from Alaska, Tom McCarthy, who was conducting a successful snow leopard project in Mongolia. During one of Tom's rare visits to his home, Terry made contact and we were

DESCRIPTION AND BEHAVIOUR: The snow leopard, or ounce, exhibits superb camouflage for its mountain environment of bare rocks and snow, being whitish-grey (tinged with yellow) in colour and patterned with dark grey rosettes and spots. Further adaptations for high-altitude life include an enlarged nasal cavity, shortened limbs, well-developed chest muscles (for climbing), long hair with dense, wooly underfur (belly fur grows as long as 12cm (4.7in), and a tail up to one meter (3.3ft) long, 75–90 percent of head-body length. Snow leopards molt twice a year, but the summer coat differs little from the winter in density and length. The long tail is thought to aid balance, and snow leopards will wrap their tails around themselves when lying or sitting for added warmth. Weights average 45–55kg (99–121lbs) for males and 35–40kg (77–88lbs) for females. The most common prey consists of wild sheep and goats (including blue sheep, Asian ibex, markhor and argali), but also includes pikas, hares and gamebirds. Predation on livestock can be significant, with stock losses on the Tibetan Plateau averaging about 2 percent per village.

LONGEVITY: Up to 21 years.

HABITAT AND DISTRIBUTION: The snow leopard has an extremely patchy and fragmented distribution, consisting of a mix of long narrow mountain systems and islands of montane habitat scattered throughout a vast region surrounding the Central Asian deserts and plateaux. Through most of their range, they are associated with arid and semi-arid shrubland, grassland or steppe. Snow leopards are generally found at elevations of 3,000–4,5000m (9842–14,763ft). Steep terrain broken by cliffs, ridges, gullies and rocky outcrops is preferred, although in Mongolia and on the Tibetan Plateau they can be found in relatively flat country, especially if ridges offer suitable travel routes, and shrub and rock outcrops provide sufficient cover.

POPULATION STATUS: China is home to the largest number of animals (mainly in the Tibetan region), and Kyrgyzstan and Mongolia hold the next largest populations. The total estimated population is 4,510–7,350.

PRINCIPAL THREATS: Reduction in prey: large ungulates have been hunted out of many areas of the high Central Asian mountains, and large-scale pika and marmot poisoning programmes have also been conducted on the Tibetan Plateau. Livestock depredation tends to be greater in areas where wild sheep and goat populations have been depleted. Snow leopard bones are sometimes substituted for tiger bone in Chinese medicine trade, and coats made of the cat's fur—though no longer traded internationally—can still be found for sale throughout China, including Taiwan.

The early morning sun accentuates the ripples on a frost-covered sand dune in Mongolia, where our jeep broke down the night before.

told we would be welcome to visit his research base at any time. We also heard that the chances of seeing a snow leopard in Mongolia were twice as good as in Nepal, but since the latter was a million-to-one chance, it did not give cause for too much optimism. However, it seemed a good prospect and—what is so important in planning these trips—we had a contact and potential host in situ.

Almost a year went by; all the other Great Cat quests were completed, and still we had nothing more than a vague welcome from Tom. I was giving Terry a hard time, urging him to obtain some kind of firm commitment. Then, at last, it came through; Tom paid another visit home to Alaska, and definite plans were made.

Tom sent copious notes on how to find him in Mongolia. They included such classics as, 'If you arrive at Ulaan Baatar and no-one is there to meet you, stand in the road outside the airport with your thumb out; everyone will stop to give you a ride, but don't pay more than five dollars'. Our old enemy, time, was still a limiting factor, so I decided to forego Tom's happy-go-lucky advice and instead elicit the help of Steppes East, who had bailed me out of my problems in getting to Siberia and who had a good contact in Mongolia.

A few weeks before our departure, Steppes East asked whether we would mind a BBC film crew (five strong) accompanying us on part of the trip. They were to film part of a series on tourism and wanted footage on the more adventurous aspect of the subject. Later, we learned that a group of actual tourists would be travelling with us but going their own way once we arrived.

It would have been much easier from many points of view to research my snow leopard in summer but, for obvious reasons, I wanted to paint the animal in a snow setting, which is why the trip was planned for November/December.

The ever-faithful Begg would be there, as would Dave Usher, a Great Cat adventure veteran after our trip to Venezuela. We debated whether to travel westward through the U.S. and China or eastward through London, Europe and Russia, and chose the latter for no other reason than the comments we recalled from 'Big' Yuri in Siberia: aircraft of China Airlines all take off at the same time every morning and head for their various destinations without any real plan about who should land first. The best way to fly with China Airlines is to drink a very great deal of vodka. So we chose the other way, but would we regret it?

• • •

On a Sunday morning, we met at London Heathrow's Terminal One to catch our British Airways flight to Moscow. Hopefully, this would not be a repeat of the last time I tried to reach that particular destination. The BBC crew were there with their twenty-four pieces of luggage, as were the tourists—a disparate, cosmopolitan group of eccentrics with one common denominator: an aversion to stepping in anyone else's footsteps.

On the way to Moscow, the BBC cameras recorded us eating lunch and me taking a nap with head back and mouth wide open.

Moscow's Sheremetyevo Airport was as slow, dreary and bureaucratic as I had been led to expect, although we were assisted through the whole process by the local Steppes East representative. I was beginning to wonder if agreeing to the BBC coming was such a good idea after all. Anything to do with TV brings officials out of the woodwork like bees to a honeypot.

We had a lot of time to kill here and started by buying a round of Foster's lagers—four for 19,000 roubles. The exchange rate had changed considerably since my stay in Russia two years back. The dollar then was worth 700 roubles; now it was 3,000.

Our next flight was on MIAT (Mongolian Airlines), which was scheduled to take off in the early hours of the morning. We were given one ticket for the whole group (fourteen people) and for some strange reason, I was elected group leader—which simply meant that I had to do most of the donkey work. Thanks to the BBC, our total baggage weight was 155 kilos, for which the MIAT check-in official wanted to charge five dollars per kilo despite a letter from the Mongolian Embassy in London instructing everyone to let these people through without let or hindrance. The official had some problems deciphering this—not surprising, since he was trying to read it upside-down. After a lot of arm-waving, shoulder-shrugging and smarmy smiling, the boss man threw up his hands in mock despair and waved the whole lot of it through without charge. At other check-in counters, I noticed with a twinge of concern, similar arguments were taking place over more mountains of overweight baggage.

MIAT took an even more casual attitude to safety than Aeroflot. The security check was a joke: it bleeped when I walked through but they just waved me on. Nobody had a seat assigned. We waited long hours in an Irish bar (staffed by real Irish!) in the departure area until the early hours of the morning, when our flight was called. Then, down an unlit staircase to a small, airless room with only one exit which was firmly closed. Judging from

Coming down from the mountains to the Gobi Desert in search of food, we found this nomad tending his flocks. He directed us to a family who sold us a sheep to replenish our food stocks.

the antics of our Mongolian fellow passengers, the drill seemed to be to push as hard as possible toward the door until there was such a scrum of tightly packed bodies that breathing became a bit of a problem. At the point when my rapidly growing claustrophobia was about to cause complete loss of control, the door was opened and a tidal wave of humanity sprinted across the tarmac to the nearby MIAT Boeing 727.

Terry, Dave and I were close to the front, so we managed to grab a row to ourselves but too late did we realize, as we leant backwards to relax, that some of the seats' ratchets were faulty and swung back onto the passenger behind. Most of the passengers were Mongolians who had imbibed more than enough, so they were all happy and very noisy. One of the last to board was a very haughty, fat, red-haired Russian woman who stamped up and down the aisle demanding a seat, but no Mongolian wanted her sitting next to him; they spread themselves out whenever she approached and indicated that a friend was soon coming. She lost her temper and they loved it. It seemed that these people had little time for Russians.

The aircraft, hopelessly overloaded, rolled on and on, just managing to lift off with about two runway lights left before the end. A Mongolian sitting next to Mary Dickinson, the producer of the BBC series, started to sing and kept it up all night. He had an incredible voice ranging through several octaves, which is another Mongolian tradition, but poor Mary didn't get a wink of sleep, nor did most others.

Drinks were served, as if any more were needed for most of these people, and the trolley worked its way forward the length of the cabin, disappeared through the door to the cockpit and was never seen again.

• • •

At Ulaan Baatar Airport, we were met by Sean Hinton and a team of assistants, all wearing 'Nomad' T-shirts. Sean, who was fluent in the Mongolian language, ran safaris there and had been subcontracted by Steppes East to look after the BBC and the tourists. We had to tag along because they had organised a hotel and a tour of places of interest—the last thing I wanted to do after a sleepless night on MIAT listening to a manic rendition of every Mongolian song in the book. But we were stuck with it, so after checking into the Bayan Gol Hotel, our first stop was the Khan Palace, now a museum.

The typical dwelling of Mongolian nomads is a *ger* (a circular tent, nor-

mally made from camel-hair felt and slats of wood—in other countries, known as a *yurt*). Inside the palace, we were shown a ger which had belonged to a high-ranking nobleman; it was lined with 115 leopard skins—which was excessive, to say the least.

Ulaan Baatar, Mongolia's capital city, was a dirty, untidy place with cattle and sheep wandering the pot-holed roads, and ugly buildings—mostly Russian-built—badly in need of repair and a coat of paint. Decrepit cars, trucks and buses slalomed their way between the potholes with many broken down and abandoned along the sidewalks. Over the city hung a cloud of pollution, mostly from the power station. I would be happy to leave this place.

Our guide and interpreter was a Mr Badomachi, scrupulously polite and very intelligent. Under his guidance, we shopped at the department store and bought the classic Mongolian hats (*genging malagai*), coats (*dehl*) and cashmere sweaters, all for just sixty-two dollars.

• • •

Tom McCarthy was conducting his research in the Altai Mountains, near the country's western border and on the northern edge of the Great Gobi Desert. He had arranged to meet us at the town of Altai and drive us in his jeep the 250 miles to his base camp. I was wondering what sort of a man he was and whether he would take kindly to an invasion of strangers, some of whom took quite a bit of getting used to.

We left Ulaan Baatar early the next morning in a MIAT aircraft of Russian design flown by a thickset, dashing Mongolian pilot with long, drooping mustaches, a peaked cap worn at a jaunty angle and a very expensive, black-leather jacket. The aircraft was packed, with people even squatting on the floor, most wearing traditional Mongolian costume—genging malagai, dehl buttoned to the neck, wide leather belt and knee-high boots. They looked a tough, cheerful people.

As we headed west, I caught glimpses of rugged mountains through gaps in the thickening clouds. Some were snow-covered; others, stark red and brown. After two hours of flying, the pilot suddenly banked his aircraft sharply and plunged through a rare hole in the cloud cover, heading earthwards at an alarming 45° angle. At the last minute, he pulled out of the dive and landed in horizontally driven snow on a bleak runway which soon was covered with

Mongolian nomads erecting a ger, *known by other nomads further to the west as a* yurt.

people and vehicles. The pilot was the first to descend, walking casually to stand under the aircraft's tail, unzip his pants and pee into the snow.

It was bitterly cold; a strong wind seemed to penetrate through to my skin. We collected our bags and walked through a throng of local people to the terminal to find Tom, happy at last to break free from the BBC and hangers-on.

• • •

The only Caucasian face in a throng of Mongolians had to be Tom McCarthy: about five feet, eight inches; lean, tanned and talking like he had not seen another human for months, which was probably true apart from his interpreter and Mongolian student assistant. We were welcomed with open

arms and set off at once to shop for supplies in the frontier-type town of Altai. There was not much choice: some semi-rotten potatoes and tomatoes, pallid cabbage and meat of dubious origin, but to Tom these were evidently manna from heaven.

The long journey started in Tom's dilapidated, blue, Russian jeep. We reached the crest of a ridge and looked ahead down a long incline to endless miles of virtually uninhabited country—wide, flat valleys flanked by range upon range of high, snow-covered mountains. We stopped at a large pile of stones beside the track, topped by sticks, pieces of coloured cloth and old bones. This was a shrine for travellers, and we each added another stone and solemnly circled the cairn once to bring safety and good fortune to our journey.

Tom brought us up-to-date with his research, and my hopes took a plunge when he explained that, in the two years he had been there, he had captured only three snow leopards, the third coming only a week prior to our arrival. By the law of averages, our chances now looked slim, and hopes of even spotting a leopard using telemetry seemed poor when he explained how difficult they were to see. Would this be a repeat of Siberia, Thailand and Venezuela?

Late afternoon, and suddenly the jeep's instrument panel erupted in a cloud of smoke. We had been motoring for nearly five hours along rutted, corrugated, dirt tracks, occasionally passing groups of nomads mounted on shaggy ponies, tending herds of camels, cattle and sheep, and sometimes a huddle of gers beside the road, from which rosy-faced children in traditional garb rushed out to wave. At one bleak, windswept village, we were able to refuel from a collection of forty-five-gallon oil drums situated on the outskirts in the open and manned by a Mongolian who filled our tank using a portable, hand-operated pump. Cash could not be accepted; the communist regime hangover still persisted, and only coupons could be used. At a similar place some days later, not even coupons would suffice: the man would take only sheep-skins.

So there we were, broken down and miles from anywhere, but Tom seemed quite unconcerned. The jeep would still go but obviously could not do so for much longer. Tom knew the BBC would be stopping for the night near a small town called Bigar, so we headed for that place to await their ar-

High in the Altai Mountains of Mongolia, we met these tough, nomadic people moving their flocks of sheep to a lower altitude to escape the freezing temperatures of the mountains. All of us were anxious to avoid the heavy snow which had blown in during the previous twenty-four hours. It covered the sparse grazing available to their flocks, and we had to reach the airport at Altai for our outward flight.

rival; we hadn't broken free after all. They caught up with us that evening and, having erected their tents and a ger, kindly invited us to share their shelter for the night.

I slept on the ground and woke in the middle of the night with my head covered in frost. The next morning, the small stream beside which we had camped was a sheet of ice. On the far bank, elegantly curved, frost-coated, sienna-coloured sand dunes stretched away into the distance; behind us, on a flat plain covered with dry, yellow grass, herds of horses and shaggy, twin-humped, wild camels grazed before a backdrop of snow-capped mountains bathed in pink from the rising sun. It was breathtaking.

This must have been the winter location for the nomads whose gers dotted the plain and whose herds were starting to move as we left. Riding hard on their tough ponies, they looked as if their lifestyle had remained unchanged for the last thousand years.

The BBC electrician, Pat, helped us repair the jeep so that we were able to make an early start. We toiled up a high pass into and over the Altai Mountains, sometimes struggling to follow the track in the snow, passing through a high-altitude town called Sogt, where the wind was blowing white, powdered snow from the mountainsides against a cloudless blue sky, and down the other side heading south toward the Gobi Desert.

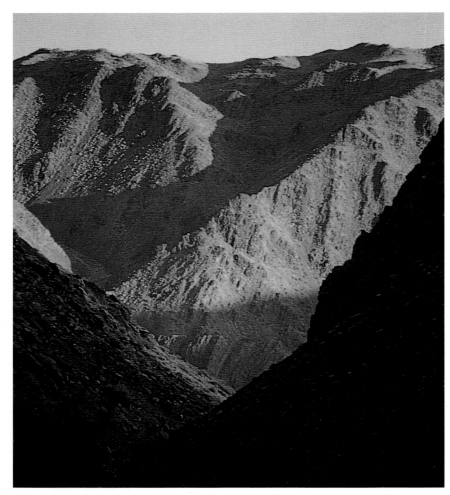

Tom McCarthy's research base was situated in these mountains on the northern edge of the Gobi Desert.

We reached the edge of the desert at noon, and a herd of goiter gazelles fled at our approach. A vague trail meandered through stunted sage-brush; small, leafless shrubs; rock and sand along the flank of the mountains until we reached the Saksai River. Here we swung north, back into the hills, following the river's course for a few miles before emerging into a bowl-like, boulder-strewn valley surrounded by stark, rocky, treeless mountains. In front of us was a single ger with the flag of Alaska flying proudly from a pole near the door: Tom McCarthy's base camp.

• • •

A solitary figure emerged from Tom's ger. This was Idre, a biology student who spoke almost no English. The other Mongolian with Tom was Bhat, the interpreter, who had come to Altai to meet us. Bhat had a great sense of humour and a burning desire to improve his very adequate English. Terry had already given him some lessons, but all the wrong ones. Bhat was intrigued with English swear words and astonished that there should be so many. He had a book titled *Learn Colloquial English,* and one chapter was devoted to English cursing. The various and many words were given star ratings so that 'damn' was a mere * whilst some of those which Terry was explaining were as much as ****. We learned from Bhat that Mongolians rarely swear at each other, and a word equating to 'damn' would probably result in your throat being slit.

Bhat and Idre started an animated conversation which Terry was anxious to have translated. It transpired that Idre had spent most of the two days of Tom's absence quaking in the ger for fear that some wild beast would break in and devour him. Instantly, I could see Begg's mind working and was not surprised to hear him ask Bhat which beast the Mongolians most feared. He whispered the answer in Terry's ear: *almus*—the Mongolian equivalent of the yeti. So every so often, over the next few days, Terry would suddenly rush in with a look of terror on his face, shouting: 'Almus! Almus! Almus!', hoping that poor Idre would wet his pants and lock himself in the jeep. Each time, Bhat collapsed with hysterical laughter.

The Mongolians' diet was a real stomach-turner. Perhaps because they have to survive in such a harsh, cold environment, they consume quantities of fat, but the habits of Tom's partners were a bit over the top. Around the walls of the ger hung slabs of meat from the carcass of a sheep; the freezing temperature was supposedly sufficient to keep it fresh. Whenever they made a brew of tea (which was boiled in a saucepan on the stove—leaves, sugar and milk, all together), Bhat and Idre would then carve off a large chunk of sheep's fat and float it in their mugs.

I was surprised to discover that they preferred very bland food—none of the expected spicy ingredients that we associate with Indian or Chinese cooking. My efforts to jazz up a very ordinary mutton stew with a packet of Madras curry mix were met with comically screwed-up faces and watering eyes.

The ger was about fifteen feet in diameter; the walls were a wooden lattice covered with thick felt made from camel hair. In the center was an iron stove with a chimney stack which stuck through a circular hole in the roof; the rim of the two-foot-diameter hole was a wooden ring into which the end of many roof poles fitted like spokes of a wheel into a hub; the other ends slotted into the top of the lattice wall. A rope was then tied to the central ring and attached to a large rock on the floor, thus pulling everything tight. Over the roof went more felt, and a coarse, white canvas covered that and the walls. Tom's floor was carpeted with throw-outs from the United Nations Development Program building in Ulaan Baatar, and the walls were lined with a bright, flowery material. Boxes of canned food, scientific equipment and Tom's personal possessions lined the walls, and a small painted table and stools completed the furnishings.

In the stove, they burned wood from a gnarled, stunted tree called *saksal* from the Gobi, which quickly generated heat inside the ger. Equally quickly, it became very cold when the fire went out, as we found to our cost in the middle of the night, sleeping in our bags on the floor.

The toilet was anywhere beyond a hundred-yard radius of the ger. A shovel and paper were available on request. The nearest running water was the Saksai River, little more than a freezing stream running past about thirty yards away.

Tom related a true story concerning a visiting colleague who arrived one November straight from the U.S. with a Halloween mask packed in

his bags. After several drinks one evening, it was decided that next day they would give the local shepherd a bit of excitement when he drove his flock past the camp. The visitor would don the mask and, enveloping himself in a large sheepskin cape, hide behind a bush and leap out with a blood-curdling scream at the appropriate moment, pretending to be an almus. The man duly jumped out screaming—but far from being terrified out of his wits, the shepherd calmly reached into his dehl, withdrew a large, wicked knife and advanced rapidly on the pseudo-almus, who turned and fled, desperately trying to tear the clinging rubber mask from his head and explain loudly in American that it was only a joke. The penny dropped only just before there was a very nasty accident.

Tom's method of catching snow leopards was the same as that used by the scientists in Siberia. Two baited traps were set high in the mountains behind the camp. The other ten traps were at intervals up a long valley, about one and a half miles away, which the cats sometimes used as a highway.

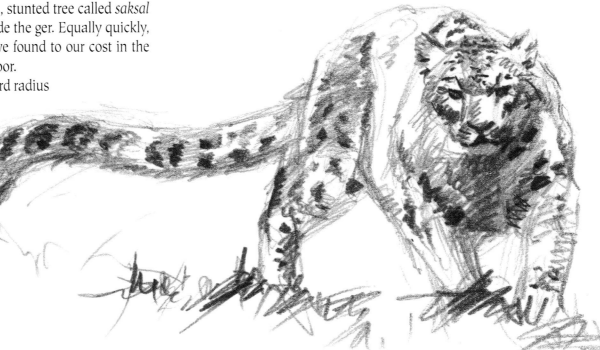

This trap was set for snow leopards on a trail near Tom's base. Rocks were strategically positioned so that the cat would be obliged to place its paw squarely on the pressure pad, which would spring the trap and flip a wire noose around its leg.

No sooner had we arrived on our first day than Tom was off to check his traps, he and Dave and I going to the higher of the two, a thousand feet above the camp, and Terry and Bhat going to the other, more accessible one. Tom was like a mountain goat, climbing with apparent ease to the small saddle between two peaks where the trap was located. Thank goodness I was in shape and could keep up. I had the greatest admiration for Dave, who gritted his teeth and made it to the top despite a hip replacement operation not many months before.

We found that something had disturbed the bait, and Tom reset the trap. It could have been a lynx or even a wolf, both of which I would have been more than excited to see.

From the saddle, we side-tracked across a steep mountainside. These were ancient rocks, fractured and loose, and much of the time we were sliding on scree; easy to turn an ankle. The valley was dramatic, with steep sides soaring up into the clouds. We worked our way up the ravine, check-ing and resetting each of Tom's ten traps, and then returned to camp, a round trip of about four miles. This was what he needed to do every day.

• • •

As daylight broke a few days later, we hiked off to check the traps in Death Valley, as I had named it. Light snow had started falling, and as we worked our way up we glimpsed a group of ibex, high in the crags with cloud swirling about them. Tom had caught these noble members of the goat family in his traps before. They are prime prey for the snow leopard.

There used to be argali sheep there until quite recently, but foreign trophy hunters and tribesmen had driven the last few away. These were the snow leopards' favourite but are now replaced by domestic sheep, which does not endear the cats to the local people and gives conservationists an additional problem when defending the leopards.

Little squeaks amongst the rocks along the trail proclaimed the presence of pikas—small, mouse-like rodents—and occasionally we disturbed a covey of chukar partridges. Marmots also were common. All these creatures were snow leopards' prey.

The bait at the highest trap had been half-eaten and the trap sprung. Tom hardly dared say that it looked like a snow leopard, and I refused to even think about it. After lunch back at base, we climbed to the other baited trap and searched for scat and scrapes—places where the cat had scraped its back feet after urinating in order to mark its territory.

With the aerial up and the headphones operating, we listened to the bleeps from one of his collared leopards somewhere on a hillside across the valley. With such an uninterrupted line of sight, it was possible to isolate a comparatively small area in which the cat was located. The changing frequency of the bleeps told us that it was moving about but, despite exhaustive quartering of the whole area with binoculars, and despite there being no serious cover, we still could not see it. They have the most superb camouflage.

The wind there howled through the valley almost constantly, but that particular night was a veritable hurricane. We were woken with the ger being lifted bodily off the ground and the huge, central, anchoring boulder swinging like a pendulum at the end of its rope. Everything was battened down, and we sat in the dark and rode out the storm.

The temperature read -4°C but at least the wind had dropped a little. Before dawn, we trudged through light snow to climb the 700-foot-high ridge west of the camp. Tom had left already to visit the highest trap, and from our ridge we were instructed to check his position through binoculars to ascertain if there had been any action. If he waved his coat, we were to come running.

I trained my glasses on the small saddle 1,300 feet above us where the trap was located. Tom had not arrived but I caught my breath; without question, I saw a large feline pacing up and down. It may have been a lynx but, for my money, it was definitely a snow leopard. I turned to Dave, Terry and Bhat, still thirty yards behind, and leapt in the air with both fists raised. They knew immediately. I set off up the mountain like the proverbial goat with adrenaline pumping, oblivious to gasping lungs and aching legs, praying that Tom would not tranquillise the cat before I arrived.

I came over the brow and was face to face, at a distance of just ten paces, with a growling, snarling, live, wild snow leopard. My frozen fingers shook as I fumbled with the camera, hoping that I would not screw up, and started taking photos. What film did I have in the camera? Was there enough light? The read-out

was telling me not. Help! Please let these work! I was overwhelmed and could not believe this was happening.

Tom appeared a short while later and asked me to attract the snow leopard's attention. I moved a bit closer and it crouched low, lips drawn back in a ferocious snarl, ears flat against its head as it let out a deep warning growl. I will never forget those furious, cold, yellow eyes boring into me. Tom had assembled a ten-foot-long, telescopic, aluminum jab-stick on the end of which was a syringe full of Telazol, a dissociative anesthetic. It was bitterly cold and there was a raw spot on the leopard's leg where the snare cable had rubbed, so Tom didn't want to wait for the others to catch up. Quietly, he approached the cat from behind and administered the drug in its rear end. Almost instantly, it started to slow down and look drowsy.

Soon, Tom and Idre were able to lift it onto a large, flat rock. Its eyes were wide open; it was conscious but incapable of any coordinated movement. The others arrived. Bhat decided to christen the animal 'Michael Jackson' and then burst into hysterical laughter. We all felt a bit like that.

The cat was weighed and measured, and samples of its fur were taken. The fur was deep and incredibly

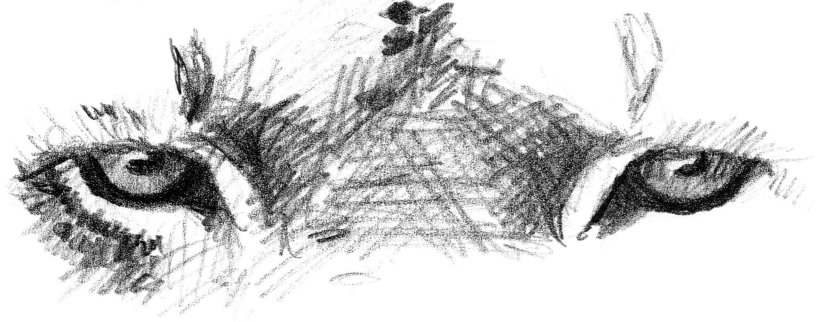

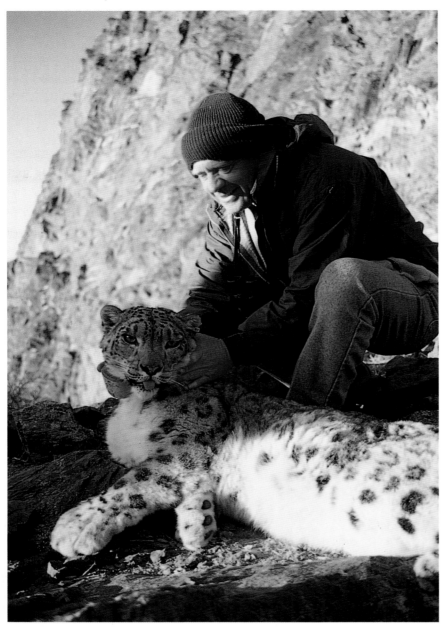

Touching the tranquillised snow leopard was one of my most memorable experiences; these rare and elusive cats are the stuff of legend.

soft, and the colour a perfect camouflage for its environment of snow, rock and sage-brush. Each hair was triple-coloured—grey, ochre and white. He was a male aged six to eight years, in prime condition. The most distinct feature was his tail, thirty-nine inches long—almost as long as his body—and wonderfully fluffy. His total length, nose to tip of tail, was ninety inches. Also worth noting were his feet; they were very large in proportion to his body, enabling him to walk in deep snow without sinking

For forty-five precious minutes, I was able to study this splendid animal at will, to sketch, photograph, feel and examine every inch—it was a unique experience. Then the effects of the drug started to wear off, and we backed away to watch. He came round fast but staggered a lot and fell over before being able to make any progress. Twenty yards on, and the camouflage was wonderful. If I had not known he was there, I would have walked right past. I determined that this characteristic of the snow leopard especially must be portrayed in my painting.

• • •

There were times before when I felt this way: the heady sensation of experiencing something very, very special and unique, the bounce in the step, the silly grin. It was like this after I spent my first hour sitting with a family of mountain gorillas in the Rwanda forest, and when I stood on Mount Kilimanjaro's highest peak on a morning when not a single cloud was in the sky. Intoxicating. The last few thousand feet of Kilimanjaro are steep scree, and my descent down this was a series of wild, giant, exuberant steps. Something similar happened in the Altai Mountains after we had left the snow leopard.

As we dutifully checked out the remainder of Tom's traps up Death Valley, I mentioned the fact that something was missing: snow. There had been a dusting overnight but only small pockets were left lying between the rocks and scrub; so Tom decided that after a celebration breakfast, we would drive high into the mountains and find snow.

The breakfast was memorable: scrambled (powdered) eggs mixed with tinned salmon, black beans and a salsa made from decidedly part-worn tomatoes, and chilies to make the eyes water, all washed down with coffee and scotch whisky. Bhat and Idre made their customary nauseating tea, but

when they took down part of the sheep's carcass to remove the required chunks of fat, a mass of maggots was found crawling beneath it. Prudently and unanimously, it was decided that the shelf life of that particular piece of mutton had expired and that we should visit the nearest nomads to replenish our supplies. We needed a new sheep.

First, however, we drove high into the mountains to find snow. There was plenty, and a gale-force, howling, freezing wind blew clouds of fine, white powder off the peaks. The scenery was breathtaking, but I could endure only a few minutes in those conditions away from the shelter of the jeep.

Down at a more hospitable altitude, we stopped at the nearest Mongolian nomad family: man and wife and two daughters, one of which sat on the family dog for fear that it would savage us. It is insulting in that country to pass by such a dwelling and not stop to chat and partake of refreshment, so we were welcomed inside their ger and offered mare's milk and a rock-like cheese made from camel's milk.

That particular family did not have a sheep for sale, but we caused much amusement taking turns to ride the family camel. Terry showed them the snow leopard on the play-back screen of his video camera and they were intrigued, but I am not sure they really believed that what they were seeing had happened just a few miles away from their home.

By early afternoon, we had reached the Gobi. Ahead of us was a dramatic mountain, standing alone and rising 3,000 feet from the desert floor, with towering cliffs and, on the windward side, huge dunes which had reached as high as the mountain's flanks and were pouring their sand over the edge. This was the 'Mother Mountain', a place of deep religious significance to the nomadic peoples. Here were crystal-clear streams, cool, deep pools and waterfalls; here, Tom had found tracks of snow leopards.

As we approached, the mountain was semi-obscured by a cloud of wind-blown, red dust from a rutted plain where the Russians had started and soon abandoned a vast cotton-growing scheme. The fragile topsoil had been ripped by their ploughs and now was being steadily blown away. A youth on a camel, tending his flocks, directed us to the nearest encampment, where we were able to purchase, for 6,000 *togrogs* (fifteen dollars), from a leathery-faced, snaggle-toothed nomad, a fine, fat ewe for our larder.

After the obligatory refreshments, we set off back to base with the ewe bleating plaintively in the rear of the jeep and resting its head on my shoul-

155

der to gaze with bulging eyes at the passing scenery. This did not go unnoticed, and soon I was being ribbed unmercifully about my latest flame and 'wasn't it amazing how a few days in the wilderness could affect a man's tastes?' and 'what was this strange fascination that artists had for the female sex?' and so on. In camp, without thinking, I sat on a rock by the stream and shaved off four days' growth of beard followed by a teeth-chattering wash in the icy water. Now the ribaldry really started.

Terry lost his glasses and went into an uncharacteristic decline. He couldn't see a thing and thought he may have left them at one of the nomads' gers earlier in the day. Tom promised him the jeep to retrace his steps the next day but that did little to lift his gloom. Our sleep that night was disturbed frequently by the resident mouse, which ran over my head in the dark and did the same to some of the others. Maybe it was searching for the maggot-ridden mutton.

The sheep died the Mongolian way—a four-inch slit in the sternum and a hand plunged in to grab and tear loose the heart. A crude and brutal method, but everything in this harsh country must be saved and that included every drop of blood from a slaughtered sheep. At least, it was out of its misery and, in a much different way, I was out of mine. I am determined that, in my next life, I will not be a Mongolian sheep.

Terry found his glasses at the first ger we had visited the previous day. The family had wrapped them carefully in a velvet cloth and placed them in a carved, wooden box. He was overcome with gratitude.

The skies turned a menacing, dark grey. Perhaps I should have kept my mouth shut about the snow: a big storm looked imminent.

I heard some directions which were completely in character with this part of Mongolia. On asking the way to a certain nomad's ger, the man was told: 'Cross this steppe 'til you reach the dead camel, then turn north...'

We woke to a landscape hidden under a foot of snow. This was the day that the BBC had asked to visit Tom's base and carry out some filming. They arrived in the afternoon from their own camp, which had been erected five miles away on the edge of the Gobi. Some came by jeep; others rode on camels, which looked very dramatic as they approached through a driving blizzard. They spent time filming the traps in Death Valley and bitterly rued the missed opportunity of our snow leopard experience.

They invited us to their camp for a typical Mongolian feast that evening, so I suggested to a very skeptical Dave Usher that it might be fun to ride there on the camels. The saddle was a crudely carved piece of wood strapped to the animal's back between its two humps. There were stirrups at either end of a loose leather strap but it was necessary, at all times, to maintain

equal pressure on each side; otherwise, one foot would end up high in the air and the other would dangle ineffectually at extreme leg's length. Steering was supposedly by means of a single rope tied round the camel's muzzle.

I was half-way on when it decided to move, lurched to its feet and set off at a canter. Desperately, I tried in vain to readjust the stirrups so that my feet were at the same level. Equally desperately, I tried to slow the animal's breakneck pace by hauling on the rope, but to no avail. Lean backwards, lean forwards, stand in the uneven stirrups, anything to stop my bouncing uncontrollably on the wooden block—but nothing worked, and my futile and pathetic efforts to look like Lawrence of Arabia came to naught. I glanced across at Dave, who was hugging the front hump with both arms—in no way would I be so undignified.

The camel handler on a third animal was a pint-sized Mongolian completely enveloped in the strangest garb, which turned out to be a rubberized, one-piece NBC (Nuclear Biological and Chemical) warfare suit which had been left behind by the departing Russians. Certainly, it kept out the snow but was aesthetically very disappointing for a wild tribesman riding his camel across the steppes.

I knew I was in trouble. Sure enough, when my steed dumped me at the BBC camp, I found I had lost a large area of skin from my rear end and knew that I would suffer over the next few days sitting in jeeps and aircraft. Dave had not suffered at all, and I wished too late that I had followed his undignified example. Later that night, my wounds were dressed to the accompaniment of much laughter, endless squalid remarks and the popping of flash bulbs. You could say I was the butt of everyone's jokes.

The Mongolian feast was a somewhat cosmopolitan affair. We ate (yes, you've guessed it) mutton. This time, the whole carcass was squeezed into a ten-gallon milk churn, together with a quantity of water and some large, smooth pebbles. The lid was securely fastened and the whole container placed on the fire—rather like a primitive pressure cooker. Then, the pebbles were first removed and passed round the ger from hand to hand—it was supposed to bring good luck and health if you could endure the heat and hold one for a sustained period. I hoped it would cure my derrière. The meat followed in large chunks and did not seem to have been improved by the

cooking method; it still had the toughness of an animal which had walked hundreds of miles around the Gobi Desert. We washed it down with an extraordinary variety of alcohol—nothing traditional, just any bottle that the assembled visitors could provide. We even drank some Irish *poteen*. Then the Mongolians sang their songs of the desert, and we sang anything which came into our heads.

• • •

Our last day in the Altai Mountains started with an emotional farewell to Tom, who was visibly upset to see us go. He provided his jeep and Bhat, and a driver from the BBC camp—called Bhat Magna—for the long drive back to Altai. We needed to be there the next day to catch the only flight out that week. More snow had fallen, so we travelled a longer way round to get through the mountains and prudently decided to join the BBC convoy.

At last, it set off as the 'Mother Mountain' and the snow-covered Gobi were bathed with dawn's pink light. All efforts to persuade the drivers to

keep the ten vehicles together were ignored and soon we were strung out over many miles, with vehicles breaking down and many stops to mend flat tyres. It was a miracle that we all met up in the early afternoon to refuel at the ragged town of Tseel.

From there, conditions became steadily worse. More snow fell, and the track was all but obliterated. As evening drew near, it disappeared completely. We were on top of a high ridge, the wind was screaming across the landscape, the temperature had dropped to -14°C and all the vehicles were stuck in deep snow. Whilst we tried to dig ourselves out, the Mongolian drivers disappeared on foot to all points of the compass to try and find where we were. I had visions of spending a freezing night jumping up and down in the snow to keep warm, missing tomorrow's flight and all our subsequent connections in Ulaan Baatar and Moscow and having to spend a week in the squalor of Altai.

Then there was a shout; someone had found a line of telegraph poles and knew that they followed a maintenance track, so we dug and pushed frantically, managed to find the track and were soon sliding down to lower altitude and less snow.

Night came, and the jeep in front kept leaving the road. The driver was dog-tired and falling asleep. We had a council of war and decided to drive ahead and leave the limping convoy behind. Soon we could see no lights behind us or, indeed, anywhere. Small doubts began to enter my mind: had we been wise? Then we reached a fork in the track. 'Where are we, Bhat?' An eloquent shrug of the shoulders. Bhat Magna was equally clueless. I tried to recall the lie of the land from a map I had seen. The moonlight was bright, and snow-capped mountains showed in the distance. We took a gamble and turned right, guessing and hoping that Altai lay somewhere beyond the end of those.

On and on and on through the night. At 2 A.M., we stopped near a ger and ordered Bhat to ask the way, hoping that, at that hour of the night, he would not be treated as a robber. To our enormous relief, they said that Altai was just down the track, and sure enough, a few miles further on, there it was. We checked into a cheap and odourous hotel to catch a few hours' sleep before flying out the next morning. My last conscious thought was that we would probably be flying without the BBC and the tourists but, miraculously, they turned up just before dawn.

● ● ●

We had two days to kill in Ulaan Baatar before our departure for Moscow, so we became typical tourists, visiting the Russian monument on a hill at the edge of the city—a concrete monolith covered with sculpture and scenes depicting the heroic struggle of the proletariat. None of the people had the classic, round faces and slanted eyes of the true Mongolian. At a song and dance theater, we were treated to an extraordinary variety of traditional Mongolian music, song and dance. I had heard mocking reference to the Mongolian nose flute but had never really believed it existed until this time. Here was a man who sang one song from his mouth in the normal way but, at the same time, produced through his nose a completely different tune in a kind of nasal hum which harmonized with the one from his mouth. There were no tricks—it really happened.

Another man sang and did not draw breath for at least five minutes. In actual fact, he was breathing through his nose but simultaneously singing a continuous note through his mouth. Then came a tiny dancing girl who tied herself into such extraordinary, double-jointed contortions that I had to look away.

From the calm serenity of a Lamist monastery, we visited the city's notorious Black Market, a ten-acre, walled enclosure with open stalls where it was

One of the ancient, symbolic dragons guarding the entrance to a museum which was formerly the Khan Palace in Ulaan Bataar.

possible to buy anything from horses to harlots, sewing machines to silks, cashmere, precious stones, silver, carpets and all manner of famous brand-named hats and sweat-shirts produced illegally in a neighbouring country and smuggled across the border. There were dense crowds which shoved and jostled, and more evil-looking characters per acre than I have seen anywhere else in the world: thugs, thieves, pickpockets, pimps, pushers—they were all there, eyeing us like a pack of ravenous hyenas.

• • •

Our MIAT flight left Ulaan Baatar in the early morning and had to refuel at Novosibirsk in Siberia. As we started to descend, I looked below and casually noted a solid blanket of cloud. Suddenly, as we flew lower, I noticed a factory chimney sticking out of the 'cloud'. I glanced behind at Dave, and he had seen it, too. That was no cloud; that was fog, but the pilot continued his descent apparently with every intention of landing. I was seriously alarmed when he nosed into the fog which was so thick that the end of the wing was barely visible. As I peered downwards, I was sure I saw tussocks of grass and pools of water but definitely no runway.

What did I feel? I should have been terrified, but instead I was angry. What a waste. I would never get the chance to boast to the world about the snow leopard. All this happened in a second or two, and then the pilot lifted the nose and soared out of the murk. Later, it was alleged that the Russian traffic controllers had urged him to land and that, indeed, he was trying to do so some distance from the runway.

We diverted to Barnaul and sat on the runway for seven hours, surrounded by armed Russian militia, forbidden to move more than a few yards from the aircraft. The Russians would refuel the aircraft only on receipt of cash or proof that funds had been telexed through from Mongolia. It was suggested that a hat be passed round but, in the end, the pilot hitched a ride into town, where he could telephone home to request a money transfer.

Needless to say, our British Airways connection to London had long since left Moscow when, at last, we arrived. The MIAT agent fled, knowing full well that he would have been lynched, and we were left with no alternative but to check into a miserable, run-down transit hotel which reeked of cats' pee. The next day, in desperation, we all pooled our resources and bought

We witnessed monks at prayer in this Lamist monastery in Ulaan Elataar.

tickets on the now-familiar Aeroflot, which seemed a paragon of comfort and safety after Mongolian Airlines.

• • •

The painting of the snow leopard was almost as much a challenge as the task of finding the animal itself. There was a conflict of intent: on the one hand, I wanted to maximize the excitement and drama I experienced, which would entail a bold approach to the subject; on the other, I was determined to portray the snow leopard's superb camouflage. The two aims were rather incompatible, but I ended up with a compromise: the drama was achieved by showing the magnificence of the scenery at the location where the cat was trapped, whilst the leopard itself remained subtly obscure in a foreground of mixed snow, rocks and sage-brush. I tried to emphasize the high mountains in which it lived. The background was exactly the view from where we caught the cat, looking down into the valley and Tom's ger; in fact, I painted in a small, white dot to show it.

Tom has kept in touch and assures me that Michael Jackson—or 'Blue' as he is now called—still roams the mountains in that area, giving out a strong signal from his collar.

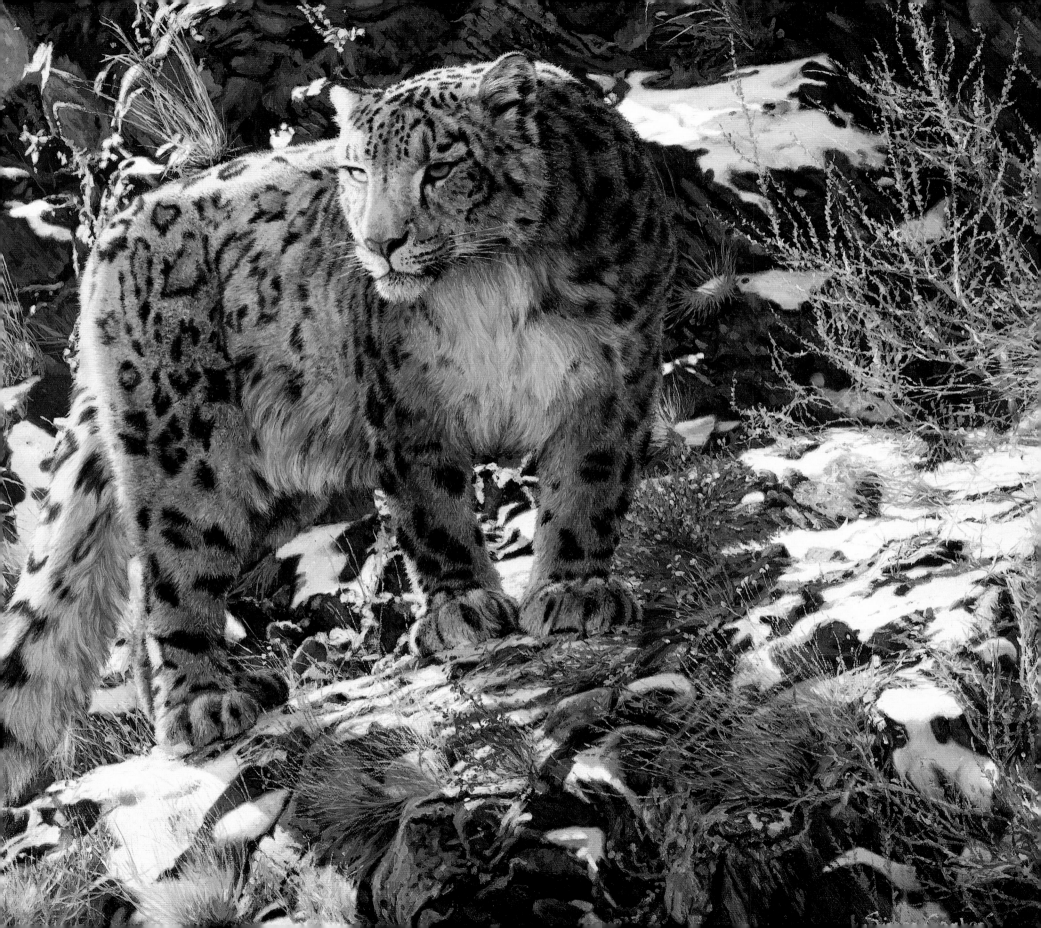

EPILOGUE

The excitement of travelling the world was over for the time being. The ten big oil paintings had all been completed, together with several smaller pieces and almost a hundred drawings and sketches. Now it was time to show what I had achieved, and planning started for a series of exhibitions.

The first opened at Nature in Art, a wildlife art museum in the U.K. situated only a few miles from my home. I wandered around the galleries in a daze. This was the first time I had seen all the cats together, and I was amazed and not a little in awe at how much I had done.

The show moved from there to the Big Horn Galleries in Carmel, California. Mid-morning on the opening day, a truck pulled up outside the gallery. A ramp was lowered, and down it padded an enormous, black-maned, male lion. He was led through the doors and into a roped-off area where he lay down and gazed haughtily at the people thronging to see him. This was Josef. I had met him first in Kenya some years previously, when he 'acted' in a TV commercial. His owner was a close friend and promised that Josef could come to my Carmel exhibition from his home in Salinas. Josef, who had since claimed fame by being the role model for the movie *The Lion King*, posed perfectly for over an hour whilst I stood at an easel in one corner and painted his portrait. What a way to open a show on 'Great Cats'.

Carmel was the location where the draw was carried out to see who would buy the Great Cat originals, and a brother and sister managed to buy the entire collection. Although I was disappointed in a way that others had not been able to acquire some of the paintings, I was delighted that the whole collection would remain intact.

• • •

March 1997. Dave Usher was my guest on safari in Kenya, and we were enjoying the last of a matchless ten days in Africa's wilderness.

'This is what will probably happen: those wildebeeste and zebras must cross this stream bed and they'll do so just down there, where there's a gap in the bushes. The lioness, if she gets her act together, should move down the line of bushes in the valley in time to intercept. Then we'll see some action.'

The big man gave me a long look, a well-known smile maybe of anticipation or, more likely, of humourous skepticism, playing on his lips. Standing up in the roof hatch of my safari Land Rover, we put binoculars to our eyes and watched the drama unfold.

An hour earlier, we had driven into Nairobi National Park as a brief finale to the safari. That night, Dave and his friend, Gaye Anderson, would fly back to the United States. As we emerged from the bush-covered high ground immediately after entering the park, the plains to our front were thronged with herds of wildebeeste and zebras. It was early evening, and the animals were becoming restless as cooler temperatures replaced the stifling heat of the afternoon. Suddenly, to my right, a tawny shape caught my eye.

'There's a lion,' I said in a matter-of-fact voice, just to show off what a cool guide I was. At first, neither saw it. Then both exclaimed that my eyesight must be phenom-enal. That is not the case; it's a question of practise and knowing what to look for—the colour of the cat, the flicker of an ear, the smallest variation

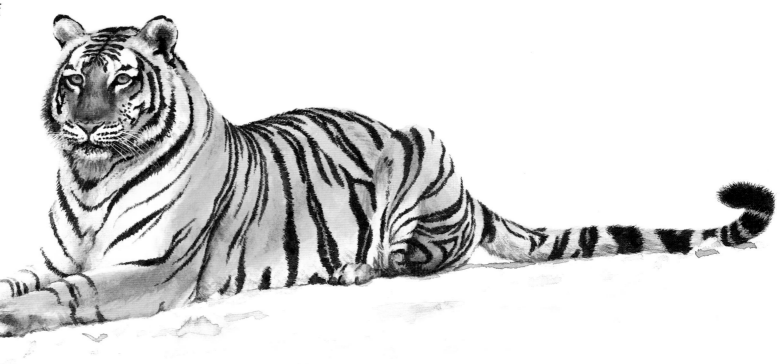

in the natural pattern of that particular stretch of corn-coloured grass, which draws the eye like a magnet.

The plains animals were unaware of the lion. She herself was crouched low, staring fixedly towards them but too far away for anyone to get excited. Dave was intrigued. A dozen questions: Is she hungry? Will she stalk from there? Will the zebras see her? How close must she get before the final charge? He was disappointed when I suggested that we move on but mollified when I explained that nothing would happen there for another hour, at least. Maybe at dusk, when the lioness could take advantage of the long evening shadows. So we drove off.

An hour later, we returned by a different route. The sun was setting, and we were now across a small valley from the herds. Some had crossed to our side already and I knew that the last group, the ones closest to the lioness, would not be left behind. Hence, my confident prediction.

The leading zebra stallion approached the bushes with great caution, a few steps forward, ears cocked to catch the slightest sound, then forward a little more before checking again. Painstaking, but this was survival. At last he crossed, cantering with relief up the near-side bank. The others followed in single file, wildebeeste and zebras mixed, the pace increasing as more animals reached the safety of our side, no-one wanting to be last to cross.

Suddenly, there was a flurry of dust and one single bellow of pain. Bingo! A wildebeeste was down, and all the others galloped away in panic. It had happened exactly the way I called it. Dave looked at me, grinning and shaking his head with amazement. I didn't tell him that this was probably the first time I had ever gone public with such a bold prediction and had it happen exactly that way.

Now, the light was fading fast. We had to hurry to reach the gate before 7 P.M., but just as we were leaving the plains, Dave said urgently, 'Stop! Stop!' Thirty yards from the road, a lion and lioness stood silhouetted by the setting sun. She moved against him, rubbing her body on his great, shaggy mane, and twitched her tail high in the air. Then, blatantly sensual, she crouched on the ground and the big male mounted her. The coupling was brief and ended with a climax of impressive snarls before she rolled onto her back in evident satisfaction.

What a finale. It had been a near-perfect safari, but this was a classic way to end: within a period of fifteen minutes, to witness the two extremes of existence, conception and death, acted out by one of the world's great predators.

• • •

Four days later, Dave Usher died, victim of a tragic, senseless accident. He had made this three-and-a-half-year Great Cat adventure possible. He enjoyed those wild trips and was able to witness the culmination of all my travels and research. His interest, enthusiasm and energy were immensely stimulating; and his friendship and loyalty, priceless. I deeply regret that he will never read this book and learn what a truly outstanding opportunity he gave me.

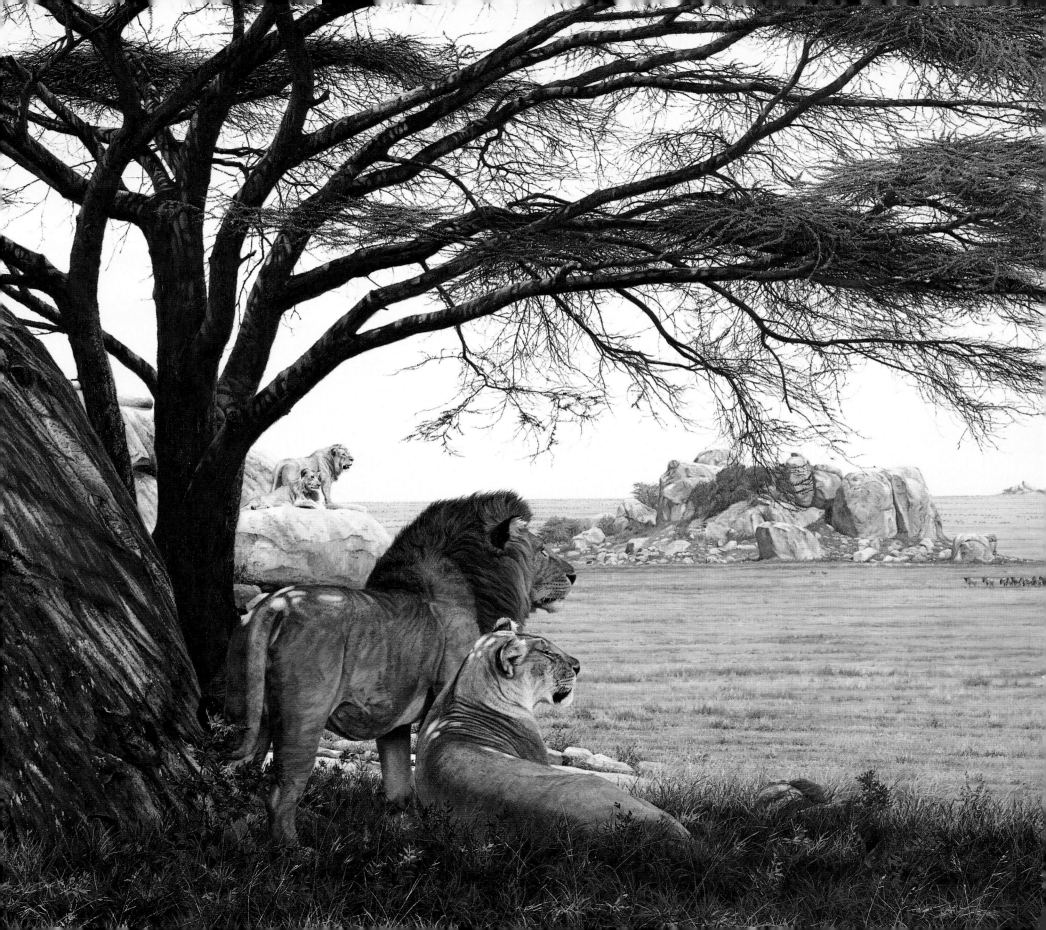

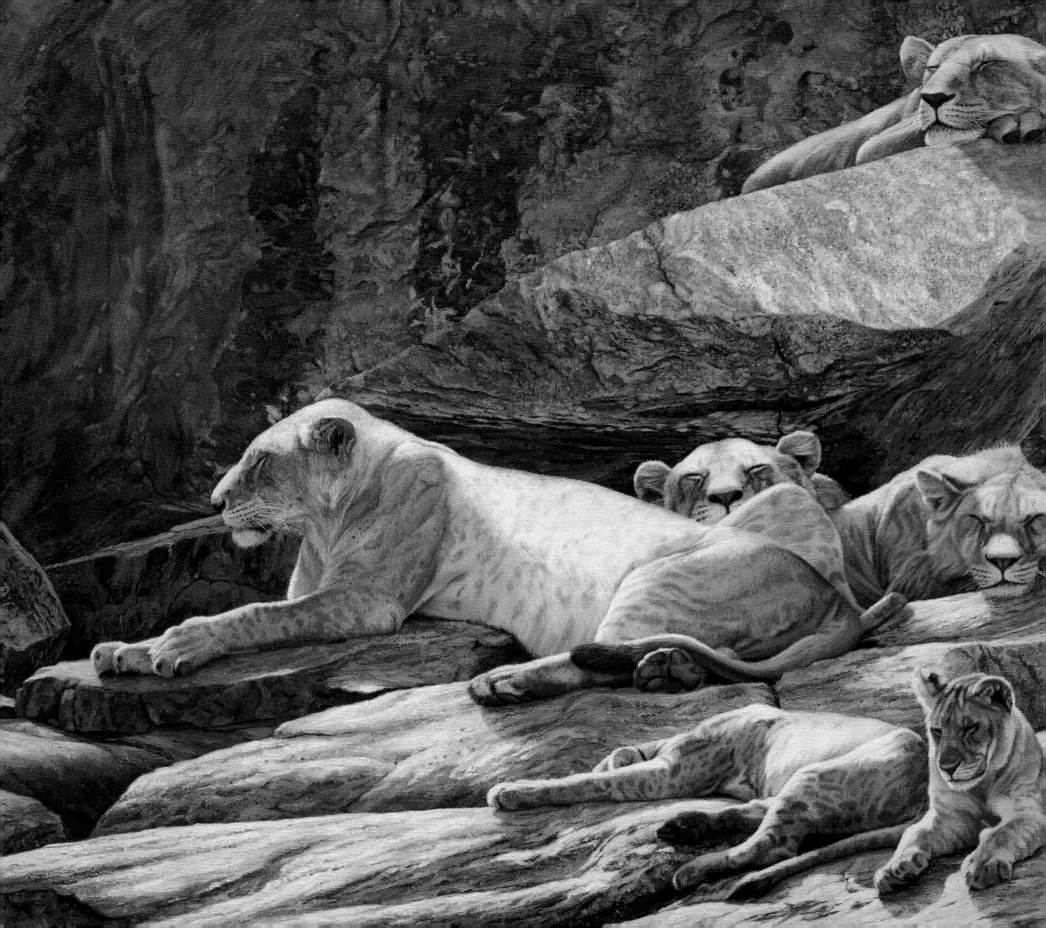

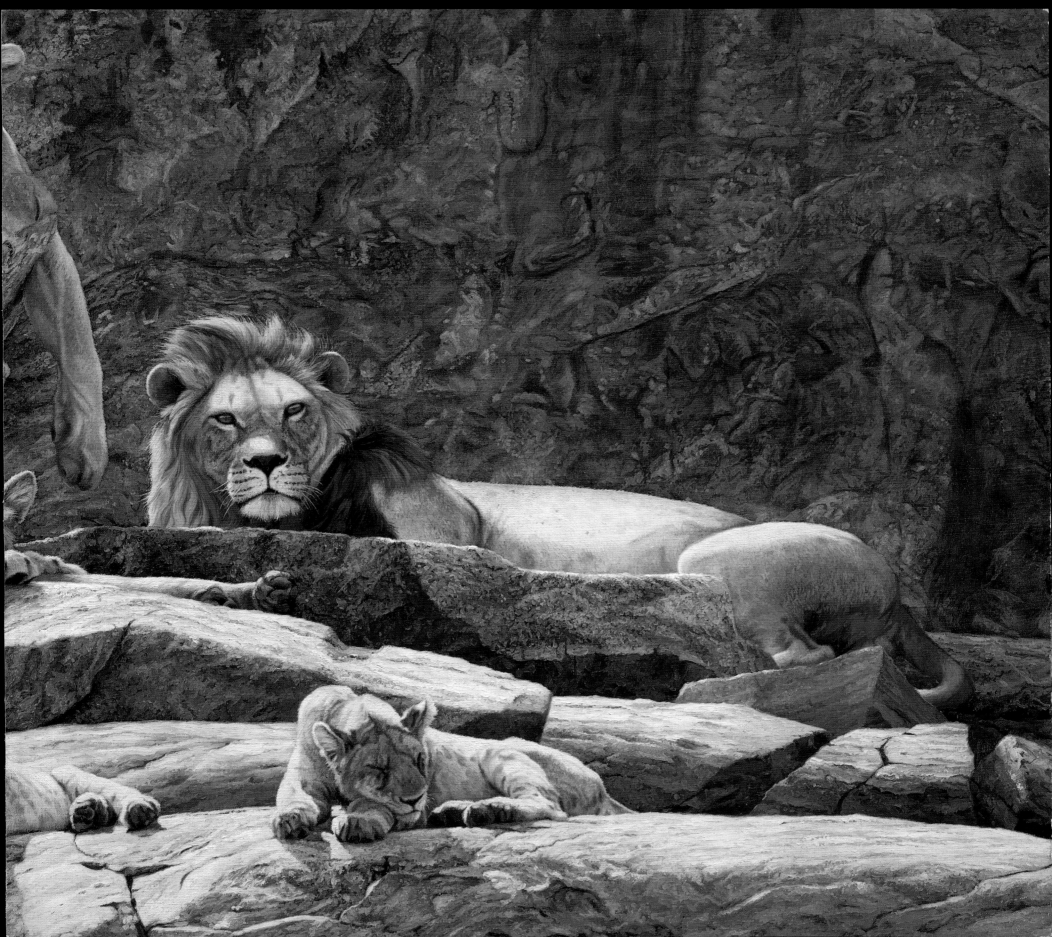

LIST OF PAINTINGS

MAJOR WORKS

30–31 JUNGLE PHANTOM
The clouded leopard is a nocturnal, arboreal animal, and probably, along with the snow leopard, the most elusive of the big cats. How could I demonstrate this cat's evasiveness? At the very least, it had to be in its treetop environment.

46–47 INDIAN SUMMER
The magnificent Bengal tiger is endowed with such a richly coloured coat of black, gold and white that I felt compelled to portray him in a scene of similar opulence, a carpet of dried leaves against the vertical light and shade of a sunlit bamboo thicket.

64–65 EYES OF WARNING
The jaguar is a tough, powerful cat: a solitary inhabitant of South America's jungles, a lover of water, an eater of just about anything that moves. Water had to feature in my painting, and, somehow, an indication that this was an animal not to be messed around with.

82–83 PRIDE
Lions are, indeed, animals of proud bearing, so this title has a double meaning. They are the only cats in my series which congregate habitually in groups. It seemed appropriate, therefore, that the painting should portray a pride, a male and his wives.

96–97 SERIOUS INTENT
There are numerous adjectives to describe the cheetah—elegant, graceful, lithe, haughty, disdainful, enigmatic. The challenge for me was to capture and reproduce some or all of those in the painting. Somehow, that task seemed easier if there were more than one animal pictured.

108–109 GOLDEN SILHOUETTE
This leopard was the only one of my cats actually painted in situ. The canvas was dragged around Kenya, collecting authentic red dust from Tsavo National Park and the white, powdery talc of the Elementeita plains where I spent my boyhood.

120–121 SNOW TRACKER
This painting of the cougar of North America made me realise the subtlety required to paint snow and that rarely is it actually painted white. Colours from trees, rocks, animals and the sky are delicately reflected on its surface and present an interesting challenge to the artist.

140–141 SIBERIAN WINTER
Here was not just the challenge to portray the largest cat in the world; here was raw emotion—to resurrect Leana, the sad victim of a poacher's rifle, and her four cubs, and hopefully to capture their existence for posterity.

160–161 MOUNTAIN MYTH
Never, even in my dreams, did I expect to see a wild snow leopard. But it happened. A miracle. So, imagine the agonies I went through in trying to compose this painting and share some of that reality and excitement, the beauty of the animal, the rugged terrain and the many superlatives surrounding that memorable morning in Mongolia.

166–167 LION ABOUT
One of the things I love about cats is their ability to relax, and here was a chance to depict that. I had as much fun painting the rock in the background as I did the lions themselves. As I concentrated on its detail, I began to see shapes and forms of other animals and people etched into this stone surface by wind, sun and water.

OTHER PAINTINGS